6/02

03

Essential
PRE-RAPHAELITES

This is a Parragon Book
This edition published in 2001

Parragon
Queen Street House
4 Queen Street
Bath BA1 1HE, UK

Copyright © Parragon 2000

Created and produced for Parragon by
FOUNDRY DESIGN AND PRODUCTION
a part of The Foundry Creative Media Co. Ltd,
Crabtree Hall, Crabtree Lane
Fulham, London, SW6 6TY

ISBN: 0-75253-590-0

A copy of the CIP data for this book is available from
the British Library, upon request.

The right of Lucinda Hawksley to be identified as the author of
this work has been asserted in accordance with Section 77 of the
Copyright, Designs and Patents Act of 1988.

The right of Dr Juliet Hacking to be identified as the author
of the introduction to this book has been asserted in accordance
with Section 77 of the Copyright, Designs and Patents
Act of 1988.

Printed and bound in China

Essential
PRE-RAPHAELITES

LUCINDA HAWKSLEY

Introduction by Dr Juliet Hacking

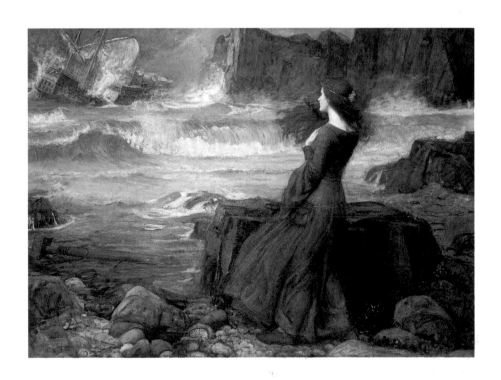

p

CONTENTS

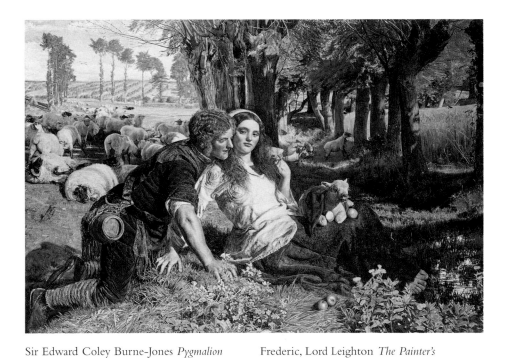

INTRODUCTION

*T*O CONTEMPORARY MINDS, Pre-Raphaelitism appears as a quintessentially English art movement, and this was exactly what was intended by the young men who formed themselves into the Pre-Raphaelite Brotherhood in 1848. In the autumn of that year Dante Gabriel Rossetti, his brother William Michael Rossetti, William Holman Hunt, Thomas Woolner, Frederic George Stephens and James Collinson joined John Everett Millais at his parents' house in London's Gower Street. Here they examined engravings after early Italian frescoes and saw in them the sincerity and seriousness of purpose which they perceived to be missing from English art. Everywhere the old order was under threat: February had witnessed revolution in Paris and in April the Chartists had marched through the streets of London demanding universal suffrage. However excited the Pre-Raphaelite brethren were by such events, it was artistic reform rather than political revolution that they wanted. Six of the seven were artists who were opposed to the methods of training promoted by the British Royal Academy Schools. Famously dubbing Sir Joshua Reynolds, the first president of the Royal Academy, as 'Sir Sloshua!', the PRBs announced themselves opposed to sombre palettes, meretricious effects and conventional subject matter. Initially ridiculed for their pretension, by the end of the 1850s intense colouring, careful draughtsmanship and a new symbolic vocabulary would be acknowledged as the defining characteristics of contemporary English painting.

The term Pre-Raphaelite is commonly used to refer to examples of art and design produced throughout the second half of the nineteenth century. But what exactly do we mean by 'Pre-Raphaelite'? It is difficult to identify a common denominator between, for example, the sentimental appeal of John Everett Millais' The *Huguenot* (1852), the moralizing symbolism of Holman Hunt's *The Light of the World* (1853) and the sensual langour of Dante Gabriel Rossetti's *Monna Vanna* (1866). It is even more difficult to do so when faced with the ethereal figures of

Edward Burne-Jones, the modern-life imagery of Ford
Madox Brown and the arts-and-crafts furnishings designed
by William Morris. None of these men were present at the
meeting in Gower Street, nor were any of the many female
artists, such as Elizabeth Siddal, Joanna Boyce and Marie
Spartali Stillman, to name but a few who worked in a
Pre-Raphaelite idiom. To understand the connections
between the range of diverse practices that are called
Pre-Raphaelite, it is helpful to see the movement as having
two dominant strands. The first began in the early 1850s
and is identified with the paintings of Millais and Hunt and
the art criticism of John Ruskin. The second began in the 1850s and is
identified with the art of Dante Gabriel Rossetti and his admirers. Both
sprang from the meeting in Gower Street in 1848.

Having returned to their studios, the Pre-Raphaelite artists
developed a style of painting in which an intense brilliance was
achieved by applying thin layers of oil paint over a white 'ground'. It
was in 1849 that the first paintings executed in this manner appeared at
exhibition: Millais' *Isabella* (1848–49) and Hunt's *Rienzi* (1848–49)
were both shown at the Royal Academy and Dante Gabriel Rossetti's
Girlhood of Mary Virgin (1848–49) was shown at the Free Exhibition on
Hyde Park Corner. Despite depicting very different subjects, all three
paintings celebrate youthful opposition to a prevailing social, political
or symbolic order. Millais' painting depicts a scene from Keats' poem,
'Isabella, or, the Pot of Basil' which relates a fourteenth-century tale of
love cutting across the classes. Hunt's painting depicts the moment at
which the hero of Bulwer Lytton's novel *Rienzi* renounces the
contemplative life and takes up arms in order to avenge the death of
his young brother. Rossetti's painting, or rather the sonnet he wrote to
explain its symbolism, proclaims the right of the artist to replace
conventional symbolism with his own. Despite such youthful
pretensions and the inclusion of the monogram PRB, the critical
response to these paintings was, on the whole, favourable, and all three
artists found buyers for these early works.

It was in 1850 that the meaning of the monogram PRB became known and the suggestion that a secret, possibly Roman Catholic, sect was at work caused considerable consternation amongst the critics. When the annual exhibition of the London Royal Academy opened in May of that year, the stage was set for England's first ever clash between the establishment and an artistic *avant-garde*. Much of the controversy centred upon a painting by Millais, *Christ in the House of His Parents* (1849). Charles Dickens made a satirical attack on the movement as a whole, and Millais' painting in particular, in his journal *Household Words*. What particularly offended Dickens was the name of the Brotherhood.

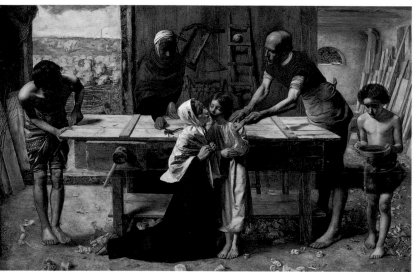

It was commonly believed that Raphael was responsible for claiming 'beauty' as a defining element of art and that, ever since Raphael's time, the purpose of art had been to reflect the striving of the human soul towards the ideal. To call oneself Pre-Raphaelite was, for Dickens, to turn the idea of artistic progress on its head. And to paint Christ as 'a hideous, wry-necked, blubbering, red-headed boy, in a bed-gown' was, for the author, a deliberate attempt by the artist to gain notoriety rather than respect.

In 1851, the art critic of *The Times*, in a contentious review, called attention to 'that strange disorder of the mind or the eyes which continues to rage with unabated absurdity among a class of juvenile artists who style themselves 'PRB'.'

The Pre-Raphaelites may have had powerful detractors, but they were also about to discover a powerful ally. The vitriolic nature of such criticisms led the art theorist John Ruskin, author of *Modern Painters* (1843), to write two letters to *The Times* in defence of their art. Later

that year, Ruskin issued a pamphlet entitled *Pre-Raphaelitism*, in which
he claimed that the Pre-Raphaelite artists alone had followed the
precepts laid down in his writings. According to Ruskin, the artist ' ...
should go to Nature in all singleness of heart, and walk with her
laboriously and trustingly, having no other thoughts but how best
to penetrate her meaning, and remember her instruction; rejecting
nothing, selecting nothing, and scorning nothing; believing all things
to be right and good, and rejoicing always in the truth.'

At a time at which the old religious certainties were under threat
from the discoveries of science, the beauty and symmetry seen in a
plant leaf could be taken as evidence of a higher power. Ruskin's
formulation of art as nature would become one of the most influential
aesthetic theories of the nineteenth century.

The unity of purpose upon which the original Pre-Raphaelite
Brotherhood was founded lasted only a few years. In 1850 James
Collinson reaffirmed his commitment to Catholicism, broke off his
engagement to Christina Rossetti, Dante and William's sister, and gave
up art. In 1852 Thomas Woolner gave up his practice as a sculptor and
emigrated to Australia. Despite the fact that there was no formal
dissolution of the Brotherhood, it was generally agreed that by 1853 the
PRBs had gone their separate ways. 1853 was certainly a momentous
year for Millais. In early spring, Effie, the wife of John Ruskin, sat as a
model for Millais' *The Order of Release* (1852–53), a painting which,
when shown at the Royal Academy exhibition in May, was popular
with both the critics and the public and helped to secure Millais'
election as an associate of the Royal Academy. In the summer of that
year Millais joined the Ruskins for a tour of the Highlands, during
which he intended to paint companion portraits of the couple.
Although the portrait of Ruskin, *John Ruskin at Glenfinlas* (1854) was
eventually completed, that of his wife never was. During the tour
Millais and Effie fell in love; in 1855, after her marriage to Ruskin had
been annulled on the grounds of non-consummation, Millais and Effie
married. The scandal surrounding the marriage did not adversely affect
Millais' reputation: he continued to be popular with the public, the

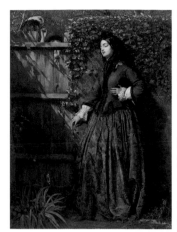

critics and a generation of artists who were now making of the Pre-Raphaelites a fully fledged artistic movement. We see the influence of, for example, *The Huguenot* (1852), and Philip Hermogenes Calderon's *Broken Vows* (1856), both of which depict the trials of modern-day courtship.

While subjects taken from poetry and literature, in particular Shakespeare, Keats and Tennyson, remained favourite sources for Pre-Raphaelite paintings, in the 1850s a number of artists tried their hand at subjects from modern life. Perhaps the best known of these works is Hunt's *The Awakening Conscience* (1853), in which a young woman is seen rising from the lap of a whiskered young man. Exhibited at the Royal Academy in 1854, the critics could not agree as to the subject of the painting. The fact that the artist had painted the pattern of the carpet with as much care as the face of the young woman, suggested to some that Hunt's only aim was illusionistic imitation. Not so, claimed Ruskin in another letter to *The Times* in which he identified the subject as a kept woman and her lover: 'there is not a single object in that room – common, modern, vulgar ... but it becomes tragical, if rightly read ... the torn and dying bird upon the floor; the gilded tapestry ... the picture above the fireplace, with its single drooping figure – the woman taken in adultery; nay, the very hem of the poor girl's dress ... has story in it, if we think how soon its pure whiteness may be soiled with dust and rain, her outcast feet failing in the street ... I surely need not go on?'

There can be little doubt that Hunt intended the painting to be a moral lesson, not just for the viewer, but also for the woman who modelled for the painting. Hunt had taken it upon himself to educate Annie Miller (who had grown up in a slum yard in Chelsea) above her lowly station in life. When he left London in 1854 for a tour of the Holy Land, Hunt intended on his return to place on her finger the wedding ring she so conspicuously lacked in his painting. As it was,

Annie's lack of progress (and, later, his discovery of her many infidelities) did not please him and they never married. Hunt's faith in the morally elevating role of art did not, however, waver and he went on to paint a number of large-scale religious works which proved to be immensely popular with the reproduction-buying public.

There are many reasons for the increasing respectability of Pre-Raphaelitism in the late 1850s: the popularity of Millais; the growing numbers working in the idiom; the willingness of dealers and collectors to show their works in major exhibitions, all played their part.

In 1855 a number of Pre-Raphaelite paintings, Millais' *Ophelia* (1851–52) among them, appeared at the *Exposition Universelle* in Paris. The French critics were surprised by the bold and novel style in which such works were painted and confessed that what they had least suspected was true: England had its own school of contemporary art. By the end of the 1850s the ranks of this school included William Bell Scott, Walter Howell Deverell, William Lindsay Windus, Henry Wallis, Thomas Seddon and John Brett amongst many others.

Ten years after the foundation of the Pre-Raphaelite Brotherhood, no self-respecting Victorian would admit to being ignorant of Pre-Raphaelite art. It was at this moment that the second strand of Pre-Raphaelitism emerged. After the negative reception that greeted his *Ecce Ancille Domini!* (1849–50), Dante Gabriel Rossetti had ceased to make works intended for public exhibition and was known only to a small but loyal band of admirers. In 1857 a number of these admirers, including William Morris, Edward Burne-Jones, Valentine Prinsep and John Roddam Spencer Stanhope, assisted Rossetti in the decoration of the Oxford Union. The frescoes – depicting figures from Arthurian legend – quickly deteriorated but the enthusiasm of the young men for Rossetti, and for art, did not.

For Rossetti it was the image of 'woman', rather than that of nature, which enshrined the mysteries of human existence. In 1850 he had published in *The Germ*, the shortlived Pre-Raphaelite journal; this was an allegorical tale in which an Italian painter recognises the woman with long, flowing hair he sees in a dream as his own soul.

Shortly after, Rossetti encountered his own creative *anima* in the form

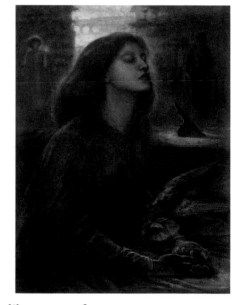

of Elizabeth Siddal. Siddal, who famously posed for Millais' *Ophelia*, had begun modelling after Walter Deverell spied her working in a millinery shop. When she began to take lessons in art from Rossetti she was patronised by John Ruskin. Despite the fact that Rossetti immortalised Lizzie after her death from suicide – painting her as the Beatrice to his Dante in *Beata Beatrix* (c. 1864–70) – the artist had a number of mistresses both during their lengthy courtship and their brief marriage. It was one of these mistresses, Fanny Cornforth, rumoured to be a prostitute, who provided the model for Rossetti's *Bocca Baciata* (1859), a painting which marked a new and significant departure in Rossetti's art. On the back of the painting Rossetti traced the lines from Boccacio: 'the mouth that has been kissed loses not its freshness; still it renews itself as does the moon', implying that sexual knowledge was not to be condemned but celebrated. This work was the first in a series of 'visions of carnal loveliness' painted by the artist in the 1860s: single images of loose-haired, pouting women executed in luscious, Venetian hues.

During the 1860s and 1870s, the desire to liberate art from nature and from morality became a defining element of *avant-garde* practice in Britain. Despite his attempts to distance himself from Aestheticism's most notorious exponent, James McNeill Whistler, Burne-Jones's paintings are frequently identified as an expression of art for art's sake. Burne-Jones, the son of a frame-maker from Birmingham,

originally intended to join the Church but, under the influence of
Rossetti, decided to become a painter. His work was little known
outside a small and select group of admirers until 1877, when he
contributed a number of oil paintings to the opening exhibition of the
Grosvenor Gallery. He was immediately identified by the critics as the
chef d'école of a new manner in art, in which coherent narrative and
accurate draughtsmanship were abandoned in favour of a stylised
abstraction of nature. The androgynous, pale bodies seen in works such
as *The Days of Creation* (1872–76) led a number of established
commentators to claim Burne-Jones's work as symptomatic of the
decadence of the times. Such pronouncements contributed to the
vogue for Burne-Jones's art which quickly spread amongst a younger
generation of art-lovers.

A number of Burne-Jones's paintings were inspired by the poems
of his friend William Morris. Morris, the son of a wealthy bill-broker,
published his first collection of poems in 1858 and, in the following
year, married Jane Burden, another low-born Pre-Raphaelite model.
The house that the architect Philip Webb designed for the couple – the
Red House at Bexley Heath in Kent – was furnished and decorated by

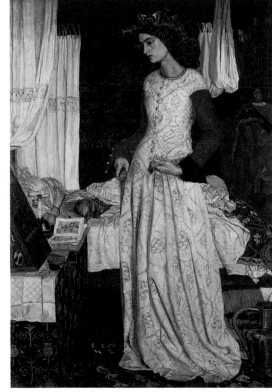

the Morrises and their artist friends.
In 1861 the firm Morris, Marshall,
Faulkner and Company. was founded
and the interior furnishings produced
by this company, later known as
Morris and Co., came to define the
Arts and Crafts movement. 'Have
nothing in your house which is not
either beautiful or useful' was Morris's
rallying cry. He was also an outspoken
champion of the rights of the worker
and, in the 1880s, became involved
with the nascent Socialist movement.
At the end of the century, Morris's
Kelmscott Press published an edition

of 'The Nature of Gothic' from Ruskin's *Stones of Venice* as a testament to the profound influence of both Ruskin and medievalism on the arts of his generation.

The intense fascination with medievalism also provoked, in the last quarter of the nineteenth century, a reaction in the form of a reappraisal of the Classical tradition. Lawrence Alma-Tadema borrowed from an eclectic range of sources to create a distinctly materialistic version of classical antiquity. George Frederick Watts shunned the material world in his large-scale allegories such as *Love and Death* (c. 1874–77). Frederick Leighton, the president of the Royal Academy,

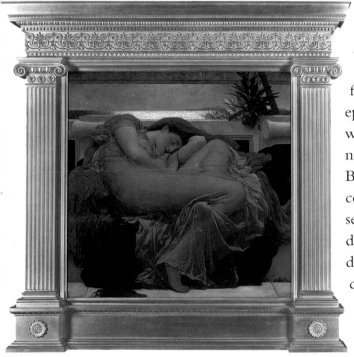

balanced sensuality with Classical draughtsmanship in works such as his *Flaming June* (1895). The paintings of Leighton and Watts are often claimed for a 'Victorian High Renaissance' of epic themes and epic scale; and yet Watts' works from the last quarter of the nineteenth century were, like those by Burne-Jones, identified by contemporary commentators as Symbolist. It would seem that, at the end of the century, the distinction between the moral and the decadent in art was no longer clear. The confusion between the two was a source of anxiety for Anna Lea Merritt, whose *Love Locked Out* (1890) was the first painting by a female artist bought for the nation with public money. Merritt, whose husband died early, said of her painting, 'I feared people liked it as a symbol of forbidden love, while my love was waiting for the door of death to open and the reunion of the lonely pair.'

At the turn of the twentieth century, a number of memoirs and autobiographies appeared which claimed to give authoritative accounts of Pre-Raphaelitism. Even here, however, little agreement as to the

precise nature of the movement was to be found. John Guille Millais quoted his father as saying that Pre-Raphaelite artists 'had but one idea – to present what they saw on canvas what they saw in Nature'. Holman Hunt, on the other hand, stated that the faithful reproduction of nature was the means and not the ends of their art. While Rossetti, it was said, dismissed the movement as nothing more or less than the 'visionary vanities of half-a-dozen boys', the very elasticity of the term Pre-Raphaelite is testament to the profound influence which these 'visionary vanities' exercised, and continues to exercise, on the public. We may not be able to precisely define Pre-Raphaelitism but we can be certain that it was the defining movement of nineteenth-century English art.

DR JULIET HACKING

THE PRE-RAPHAELITE BROTHERHOOD 1847–53

WILLIAM HOLMAN HUNT (1827–1910)
F. G. Stephens, 1847
Courtesy of the Tate Gallery

STEPHENS and Hunt were best friends for years; unfortunately, as happened with so many of Hunt's friendships, the two men fell out irrevocably in the 1870s. In the years leading up to the argument, however, they kept up a devoted correspondence during all Hunt's foreign travels as well as the years they were both in England. It is this correspondence that provides much of the information that we have about the Pre-Raphaelites.

This oil portrait, painted on to wood, was made in the year before the Pre-Raphaelite Brotherhood was formed, when Stephens was Hunt's pupil. It was Hunt who proposed Stephens as a member of the PRB. This portrait is more crudely executed than Hunt's later work, but is nevertheless compelling. The eyes look out boldly at the viewer and the relaxed stance shows exemplary artistic ability on the part of Hunt. *F. G. Stephens* is the ancestor of later Pre-Raphaelite portraits, in particular Millais' *John Ruskin at Glenfinlas* (1854). The face is also similar to the intense face of Christ in Hunt's masterpiece *The Light of the World* (1853); whether this is intentional or not is uncertain, but Hunt did idealise those he loved and Stephens was, for many years, the person he trusted most.

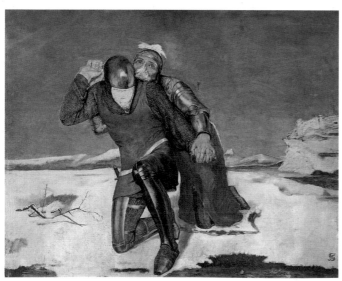

Frederick George Stephens
Morte d'Arthur, c. 1850-55
Courtesy of the Tate Gallery. (See. p34)

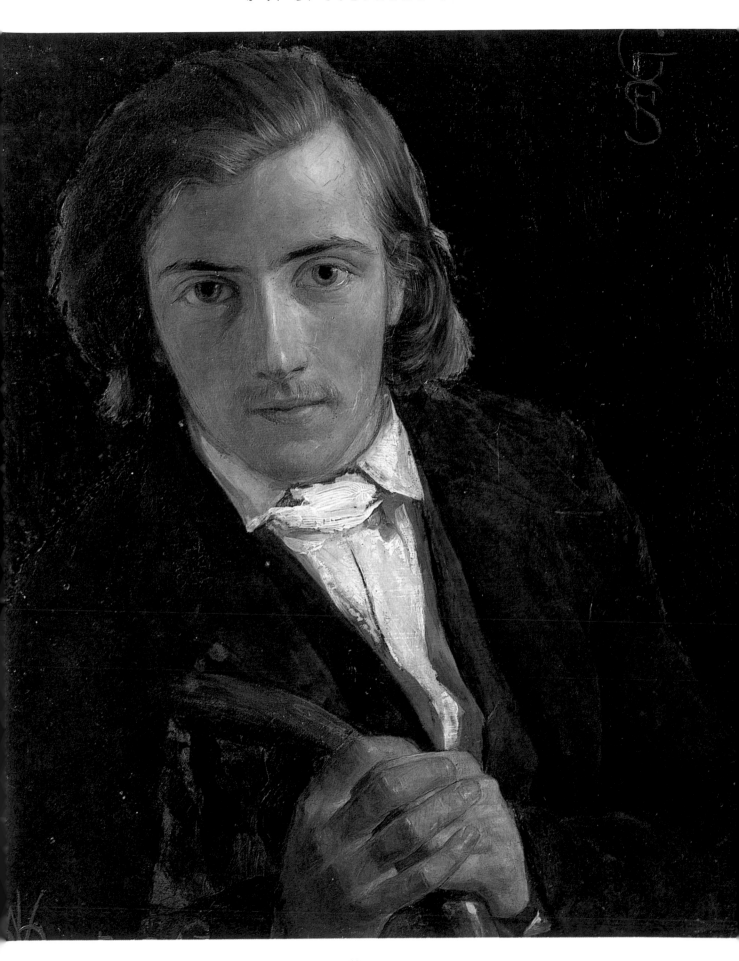

WILLIAM HOLMAN HUNT (1827–1910)
Rienzi, 1849

Private Collection. Courtesy of Bridgeman Art Library

*T*HIS painting, with the full title of *Rienzi
Vowing to Obtain Justice for the Death of His
Young Brother, Slain in a Skirmish Between the
Colonna and Orsini Factions*, was the first of Hunt's
works to include 'PRB' on the canvas.

Hunt took his subject from the 1835 novel,
Rienzi, the Last of the Roman Tribunes, by Bulwer
Lytton. It was exhibited at the 1849 Royal Academy
exhibition (alongside Millais' *Lorenzo and Isabella*)
with the following excerpt from the novel:

*But for that event, the future liberator of Rome
might have been but a dreamer, a scholar, a poet – the
peaceful rival of Petrarch – a man of thoughts, not deeds.
But from that time, all his faculties, energies, fancies, genius,
became concentrated to a single point....*

In 1847, Hunt reputedly sat up all night to
finish Ruskin's *Modern Painters* (1843); in *Rienzi* he
attempted to put into practice all that he had read.
The background in particular was painted in careful
detail in an attempt to satisfy Ruskin's stringent
requirements. As can be seen from some of Hunt's
later work, such as *The Hireling Shepherd* (1851) and
The Awakening Conscience (1854), the artist often
experienced great difficulty with painting his figures
in natural poses. This is evident here in the portrayal
of the soldier on the far left of the painting.

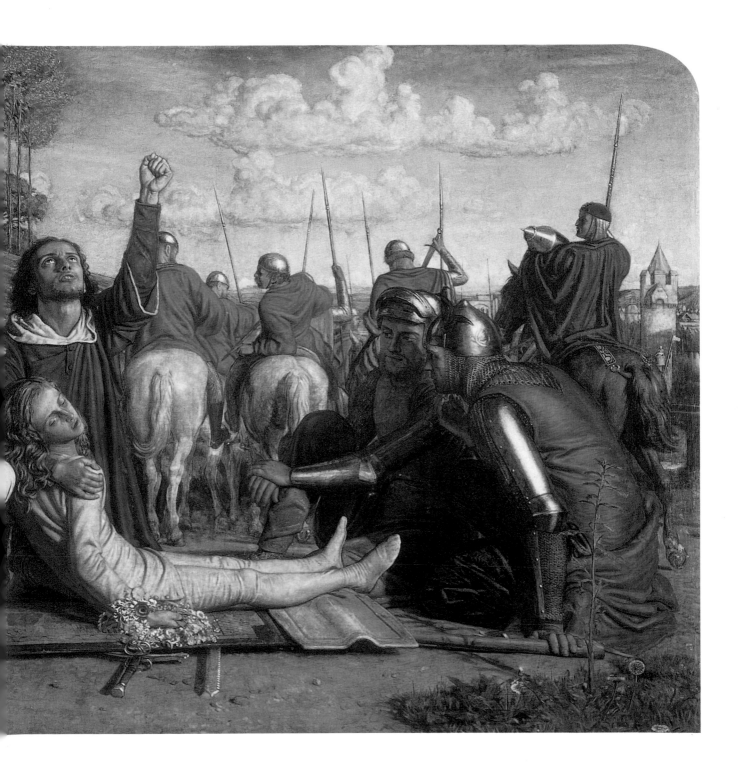

SIR JOHN EVERETT MILLAIS (1829–96)
Lorenzo and Isabella, 1849

Courtesy of National Museum and Gallery, Merseyside

*L*ORENZO *and Isabella* was Millais' first painting inscribed with PRB, which was worked into the wood of Isabella's chair. It was exhibited at the Royal Academy in 1849, alongside Hunt's *Rienzi* (1849). The painting is astounding for an artist so young (Millais was just 20 at the time) in terms of the abundant detail, richness of colour and the fluidity of the brushwork.

The subject comes from Keats' poem 'Isabella, or, the Pot of Basil', which relates how Isabella and Lorenzo fell in love. When her furious brothers murdered Lorenzo, Isabella searched for his body; upon finding it, she took his head, and buried it in a pot, beneath a basil plant. She later died of a broken heart.

Although Lorenzo and Isabella are not seated centrally, the positioning of the diners' heads and the kick, delivered to Isabella's dog by her vicious brother, draw the viewer's eye to the ill-fated couple. The diners were modelled by Millais' friends: Dante Rossetti is the man drinking at the back of the table; William Rossetti is Lorenzo; Walter Deverell and F. G. Stephens sat for two of the brothers – the kicking brother was painted from memory of John Harris, a bully who tormented Millais in his school days. The painting was sold to a tailor for £150 and a new suit. Later it was owned by Thomas Woolner.

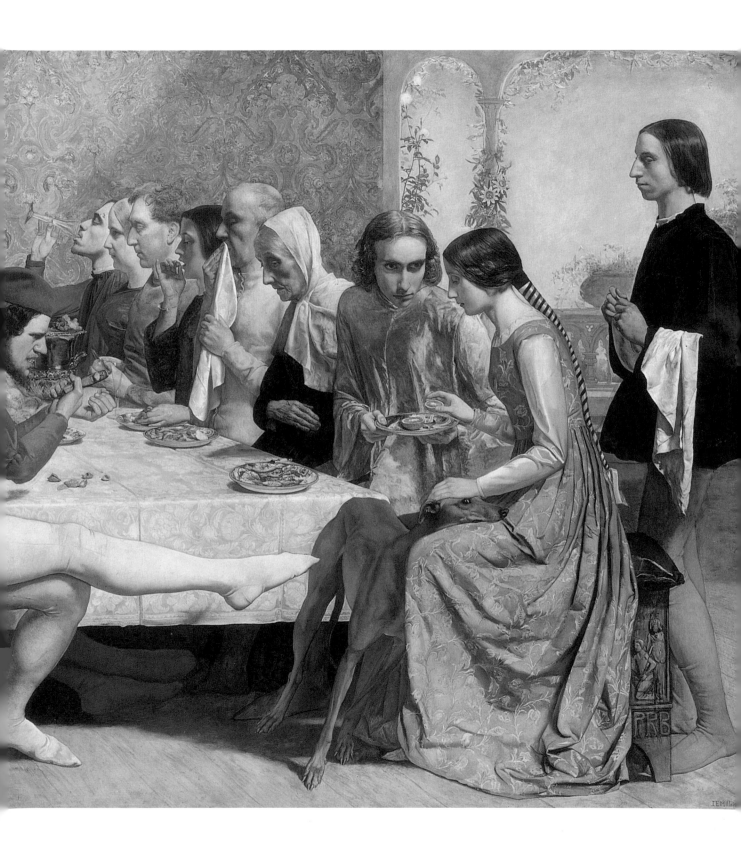

DANTE GABRIEL ROSSETTI (1828–82)
The Girlhood of Mary Virgin, 1849
Courtesy of the Tate Gallery

*T*HE GIRLHOOD is considered to be Rossetti's first true Pre-Raphaelite painting. He began it shortly after leaving the tutelage of Ford Madox Brown and moving in with William Holman Hunt; Hunt oversaw his work on this picture. Christina Rossetti sat for the figure of Mary and Mrs Rossetti sat for the Virgin's mother. Rossetti's next painting, *Ecce Ancilla Domini!* (1850) also depicted Christina as Mary, giving the pictures a strong sense of continuity. Rossetti originally wanted to include *The Girlhood of Mary Virgin* as part of a triptych. In the same way that Madox Brown had to change his plans to paint Chaucer as a triptych, Rossetti eventually came to realise that the task was too enormous.

The Catholic influence of the painting echoes Madox Brown's teaching and Rossetti's own fascination with the work of the Nazarenes. *The Girlhood*, however, is also noticeably different from pictures by both Brown and Hunt, in Rossetti's treatment of perspective. The prominent foreground and the hazy background are in sharp contrast to the carefully defined landscapes of both Rossetti's teachers. This concentration on the foreground figures was a recurring motif throughout Rossetti's career.

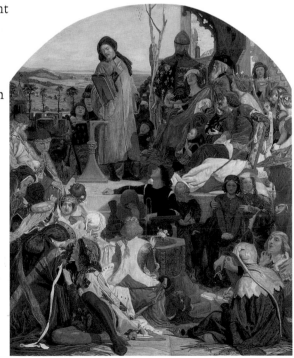

Ford Madox Brown
Chaucer at the Court of Edward III, c. 1845–51
Courtesy of the Tate Gallery. (See p. 58)

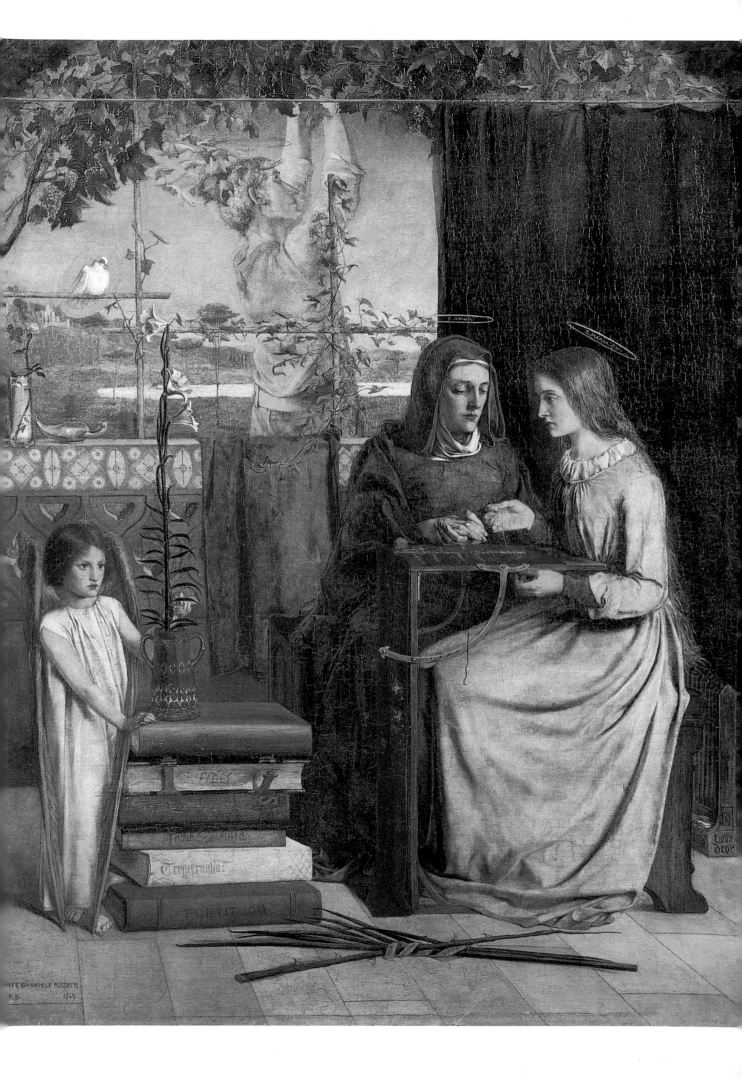

WALTER HOWELL DEVERELL (1827–54)
Twelfth Night, 1849–50
Courtesy of the Tate Gallery

ALTHOUGH Walter Deverell was never an elected member of the Pre-Raphaelite Brotherhood, he was nevertheless an intrinsic part. When Collinson resigned from the Brotherhood in May 1850, Deverell was proposed as his replacement, although no 'formalities' were ever undertaken to swear him in.

One event for which the PRB were to be for ever grateful to Deverell was his 'discovery' of Elizabeth Siddal, whom he saw working as a milliner's assistant. He was too afraid to approach her himself, in case she thought he was propositioning her and refuse to model for him, so he asked his genteel mother to ask on his behalf. *Twelfth Night* (based on Shakespeare's play of the same name) was the first picture in which Lizzie appeared.

This is a preliminary sketch for Deverell's first real Pre-Raphaelite painting. The figures represented are Lizzie as Viola (disguised as Cesario, page to Orsino), a self-portrait of the artist as Duke Orsino and Dante Rossetti as Orsino's jester, Feste. These three figures are well-drawn and detailed; Deverell's background figures seem almost unfinished and flat in comparison.

According to legend, Deverell had great difficulty with painting Lizzie's hair – in a gesture that was to prove highly prophetic, Rossetti painted the hair in for him.

Dante Gabriel Rossetti
Elizabeth Siddal, c. 1854–55
Courtesy of Christie's Images. (See p. 96)

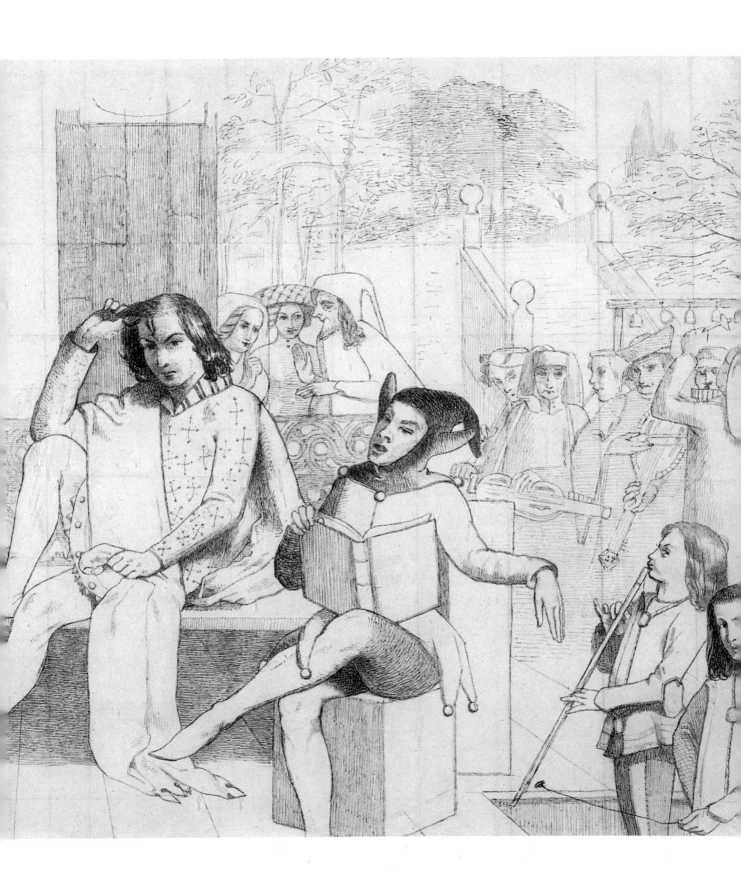

DANTE GABRIEL ROSSETTI (1828–82)
Ecce Ancilla Domini!, 1850
Courtesy of the Tate Gallery

ROSSETTI deliberately used a limited colour range for this oil painting. The predominance of white, symbolic of virginity, is complemented by vibrant blue (a colour associated with Mary, though notably not used in *The Girlhood of Mary Virgin* in 1849) and red, for Christ's blood. Lilies are traditionally the symbol for Mary in Italian Renassiance art, but they are also considered funereal flowers, indicative of Christ's death.

Christina Rossetti posed for Mary but, as with her previous year's modelling, her brother altered her hair colour; in this instance making it auburn to continue the red palette. William Rossetti posed for Gabriel.

This picture received mixed reviews. The most obvious break with tradition was Rossetti's choice of placing Mary in bed – her long nightgown suggestive of a newly-wed bride – woken by the angel; who is normally depicted appearing as Mary prays. Also controversial were Gabriel's lack of wings (the flames at his feet suggest a Classical influence) and his obvious nakedness, glimpsed through the side of his robe. Note also the dove's halo – although the Bible states that animals have no soul (Rossetti was a fervent animal lover, sharing his home with myriad animals, ranging from dormice to an armadillo) – and the differences between Mary's and Gabriel's haloes, which may have arisen because Mary's was painted in 1850 whereas Gabriel's was not added until 1853.

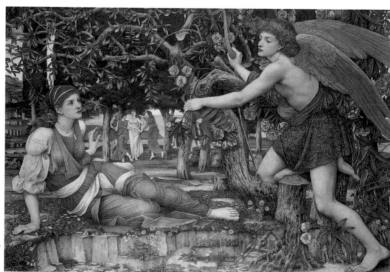

John Roddam Spencer Stanhope
Love and the Maiden, 1877
Courtesy of Christie's Images. (See p. 194)

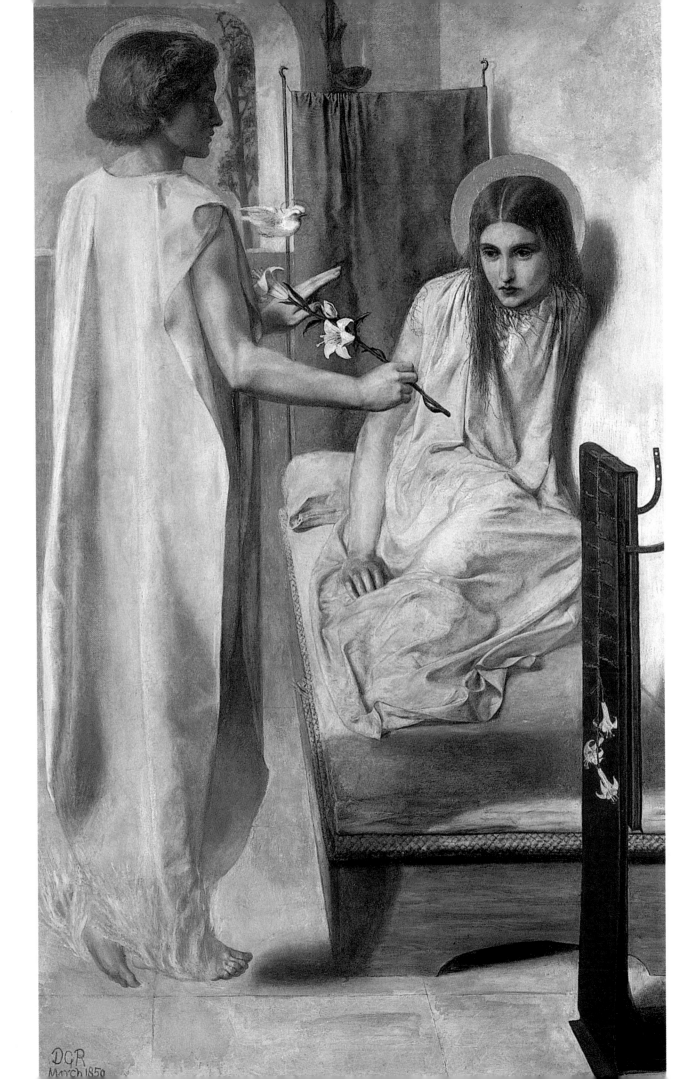

JAMES COLLINSON (1825–81)
An Incident in the Life of St Elizabeth of Hungary, 1850
Courtesy of Birmingham Museums and Art Gallery

his painting is referred to here by the title that Collinson originally gave it, although it is often cited as *The Renunciation of St Elizabeth of Hungary*. It tells of a thirteenth-century girl of the royal house (later to become Queen of Hungary) who underwent a religious revelation while at church and humbled herself before the image of Christ on the cross. Her removed crown can be seen placed on a cushion, emphasising her great humility. Her sister (the crowned figure behind Elizabeth) looks openly embarrassed by the pious act, as do her attendants. Collinson took his subject from *Chronicle of the Life of St Elizabeth of Hungary*, written by the Comte de Montalambert and translated into English in 1839.

It is not surprising that this subject appealed to the deeply Catholic Collinson – although it wasn't so popular with the largely Protestant critics or public. *An Incident in the Life of St Elizabeth of Hungary* was also Collinson's most Pre-Raphaelite painting.

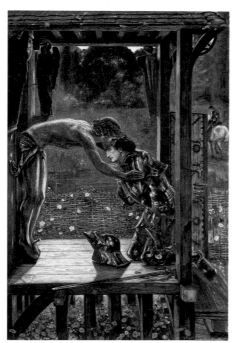

Collinson was the first member of the Pre-Raphaelite Brotherhood to abandon its fraternal ranks. Disappointed in love with Christina Rossetti, who had been his fiancée, Collinson renounced art in order to become a Jesuit priest.

Sir Edward Coley Burne-Jones
The Merciful Knight, 1863
Courtesy of Birmingham Museums and Art Gallery. (See p. 140)

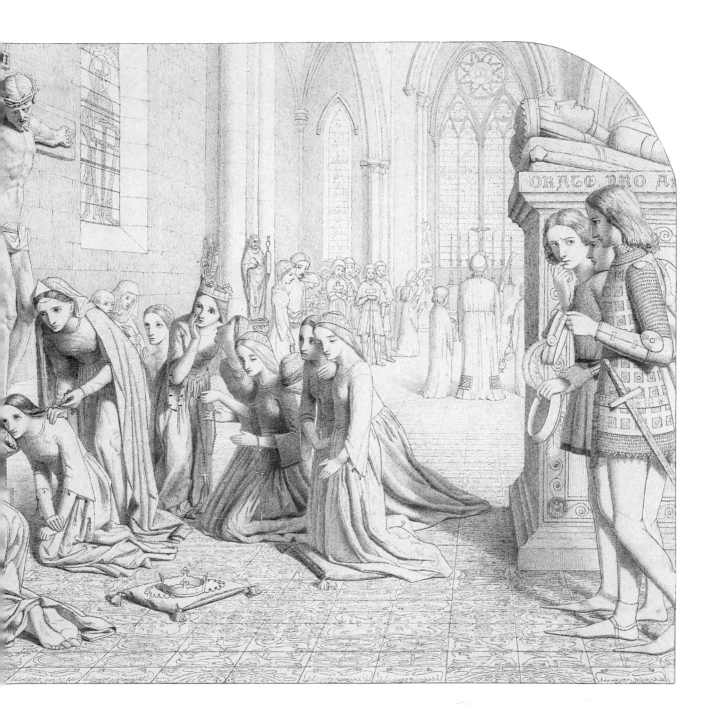

SIR JOHN EVERETT MILLAIS (1829–96)
Christ in the House of His Parents 1850
Courtesy of the Tate Gallery

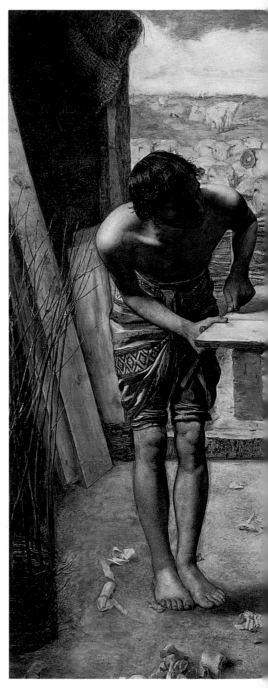

THIS picture, also known as *Christ in the Carpenter's Shop*, was unfortunately timed: its first exhibition came almost immediately after the journalistic revelation of what 'PRB' meant – the movement was distrusted by the general public and viewed as subversive and arrogant. As a result, Millais' painting was denounced by most contemporary art critics and was further publicly censured by a scathing review from Charles Dickens. He was to describe the characters in the painting as 'a hideous, wry-necked, blubbering red-headed boy, in a bed-gown' (Jesus) and 'a kneeling woman so hideous in her ugliness that ... she would stand out from the rest of the company as a Monster, in the vilest cabaret in France, or the lowest gin shop in England' (Mary).

The conventional Victorian public dutifully followed their critics' lead and declared it a failure; it was the first of Millais' pictures to be insulted and he felt it deeply. Hunt's *A Converted British Family...* (1850) suffered the same treatment. In later years, both pictures came to be regarded as masterpieces.

Millais' picture was also criticised on religious grounds: some attacked it for what they believed were traces of Catholicism (in particular the prominence of the figure of Mary); others called it blasphemous for daring to depict the holy family in such a down-to-earth manner.

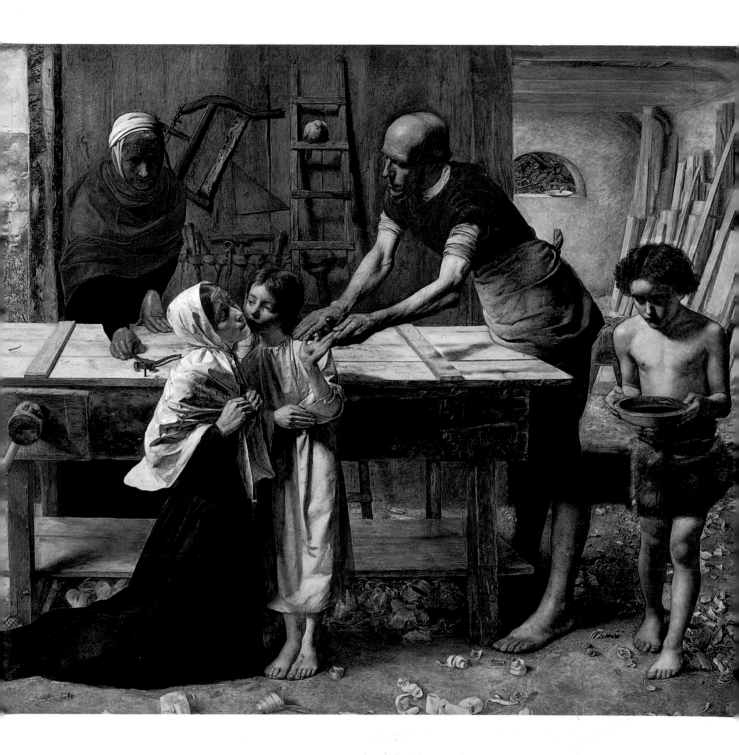

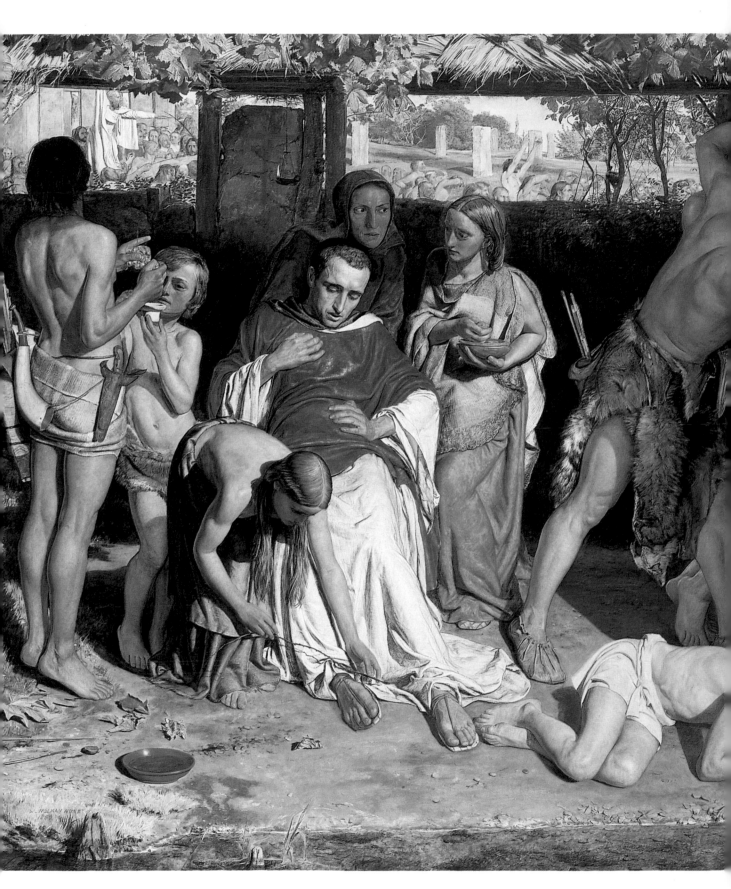

WILLIAM HOLMAN HUNT (1827–1910)
A Converted British Family Sheltering a Christian Priest from the Persecution of the Druids, 1850

Courtesy of Ashmolean Museum, Oxford

THIS painting superbly demonstrates the brilliance of colours obtained by the Pre-Raphaelite method of painting on a 'wet-white ground'; the luminosity of the priest's face in particular. *A Converted British Family…* was Hunt's first picture to be exhibited after the public discovery of the meaning of 'PRB'. The journalist who broke the news was tipped off by Alexander Munro. The sculptor had been told – but sworn to secrecy – by Dante Rossetti. The public backlash caused by the revelation, and complaints of too much nudity in the picture, led to it being heavily criticised; as a result, Hunt's potential buyer retracted his offer. It was later bought by Thomas Combe, one of the Pre-Raphaelite's most important patrons. He paid £160 for it.

Lizzie Siddal modelled again for the central, red-haired woman. The thorns being removed from the priest's gown and the sponge prepared to bathe him are reflective of Christ on the cross. The vine growing above the wattle hut is also symbolic of the wine used in the Christian mass ceremony. The priest holds his side in pain as though pierced, as Christ was by a soldier's spear. The fishing net is a symbol of Christianity, but is also representative of Druidism – the Druids banned fishing as they believed fish were sacred.

FREDERICK GEORGE STEPHENS (1828–1907)
Morte d'Arthur, c. 1850-55
Courtesy of the Tate Gallery

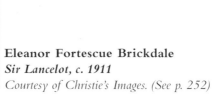

*D*ESPITE devoting five years to this picture, Stephens left *Morte d'Arthur* unfinished. Disillusioned with his ability as an artist, he gave up painting in the late 1850s and moved solely into art criticism. He also attempted to destroy all his artistic works – today only five of his paintings and one drawing have been traced.

Stephens' enthusiasm for Arthurian legend was one he shared with all the Pre-Raphaelite Brotherhood, however his *Mother and Child* (worked on concurrently with *Morte d'Arthur*) shows a keen awareness of his contemporary world as well – perhaps one of the reasons why he was more successful as a journalist than an artist. This success included working as chief art critic for the influential magazine *The Atheneum*, a post he held until he was 73 years old.

Stephens was elected to the PRB by his teacher, William Holman Hunt. In keeping with his membership, he appears in several important Pre-Raphaelite works: he was the model for

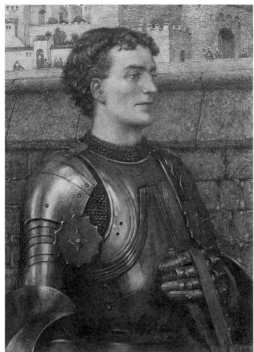

Ferdinand in Millais' *Ferdinand Lured by Ariel* (1849) and the model for Jesus in Ford Madox Brown's *Peter Washing Jesus' Feet* (1852). He also contributed writing and drawings to *The Germ*. After his painting days were over, Stephens began collecting works by other Pre-Raphaelite painters.

Eleanor Fortescue Brickdale
Sir Lancelot, c. 1911
Courtesy of Christie's Images. (See p. 252)

35

WILLIAM HOLMAN HUNT (1827–1910)
Valentine Rescuing Sylvia from Proteus, 1851
Courtesy of Birmingham Museums and Art Gallery

*T*HIS was one of Hunt's most popular early paintings – the Victorian public enjoyed pictures of subjects they could understand and this scene from Shakespeare's *Two Gentlemen of Verona* fufilled that essential criteria. It won first prize at the Liverpool Autumn exhibition of 1851, earning Hunt a welcome £200. The model for Sylvia was Lizzie Siddal, who had also modelled for Deverell's *Twelfth Night* (1849–50).

This picture has also been hailed as a masterpiece of Pre-Raphaelite art, due to Hunt's faithful adherence to Shakespeare's prose and his detailed consideration of the wooded background. He achieved this by painting *Valentine Rescuing Sylvia from Proteus* outdoors, carefully choosing an area of the Surrey countryside in which to set up his easel. He insisted that it was necessary to paint outdoors in order to achieve the light he wanted, knowing that he

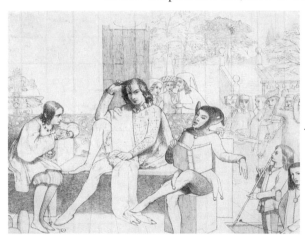

Walter Howell Deverell *Twelfth Night, 1849–50*
Courtesy of the Tate Gallery. *(See p. 24)*

could never recreate such colours in the studio in the same way that he would see them outdoors. This philosophy was to stay with him throughout his life; it would take him round the world in search of different forms of natural light.

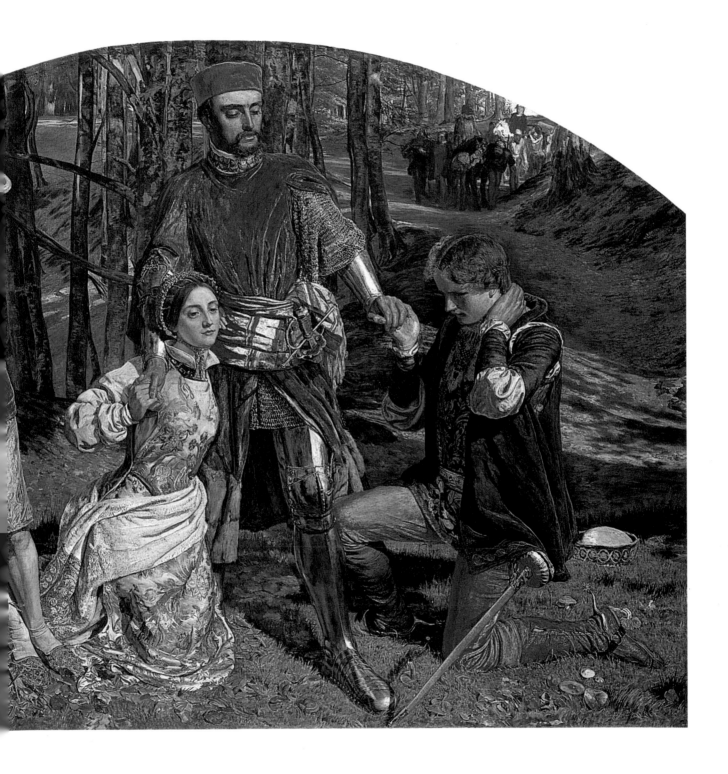

JAMES COLLINSON (1825–81)
The Writing Lesson, c. 1851
Courtesy of Christie's Images

COLLINSON'S first exhibited picture was *The Charity Boy's Debut* (1847). Dante Rossetti, who saw it on show at the Royal Academy, so admired it that he made a point of befriending the artist. It was Rossetti who recommended Collinson as a member of the PRB – a recommendation that was helped along somewhat by his engagement to Christina Rossetti.

Other paintings by Collinson include *Italian Image-Makers at a Roadside Alehouse* (1849), *Answering the Emigrant's Letter* (1850) and his later picture, *Siege of Sebastapol, by an Eyewitness* (1856), but the artist was never again to recreate the strong sense of Pre-Raphaelitism inherent in *An Incident in the Life of St Elizabeth of Hungary* (1850). *The Writing Lesson*, a sentimental, domestic subject, owes more to the Victorian demand for such art than to the ideals shared with the Brotherhood. Charles Dickens was the country's most popular novelist at the time Collinson was painting and Dickens' fictional portrayal of such children as Oliver Twist (1838) and Little Nell (1841) led to a surge in popularity for sentimental art featuring children.

When Collinson abandoned the priesthood in 1854, he tried to re-enter the art world, although he was fated not to enjoy the adulation gained by his former colleagues. Much of his unsettled career was blighted by the fact that he suffered from narcolepsy, a little-understood affliction causing him to fall asleep at any time without warning.

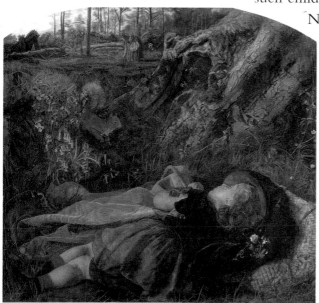

Arthur Hughes *The Woodman's Child, 1860*
Courtesy of the Tate Gallery. (See p. 172)

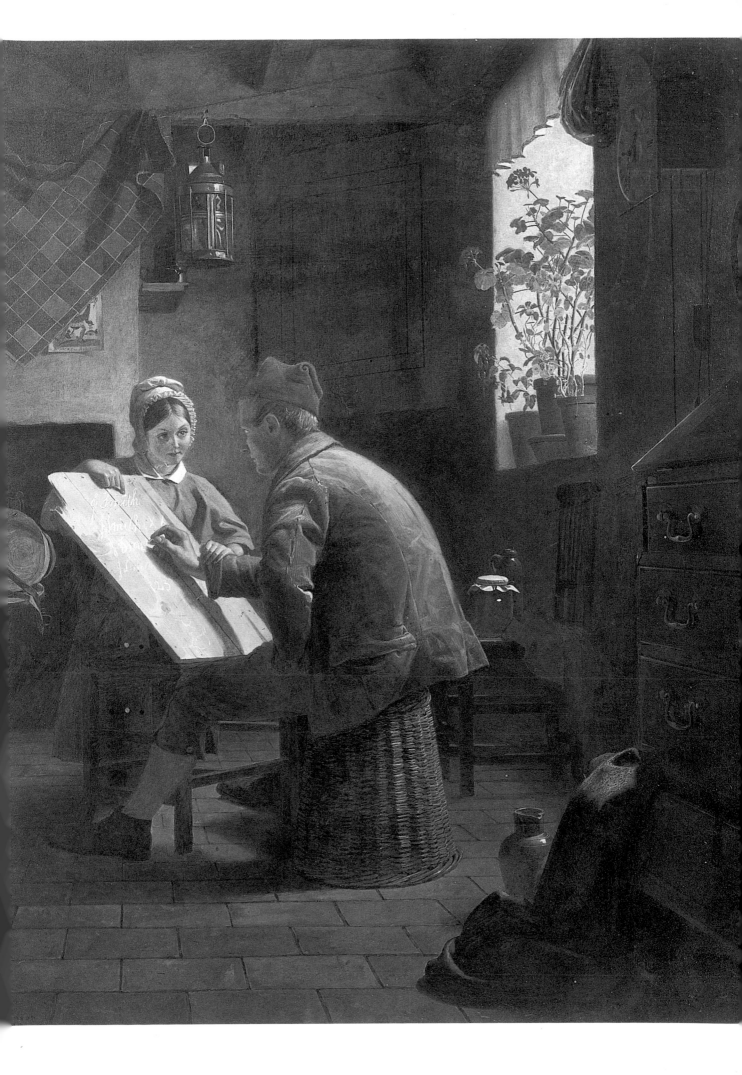

WILLIAM HOLMAN HUNT (1827–1910)
The Hireling Shepherd, 1851
Courtesy of Topham

*U*NTIL the last years of his life, Hunt was renowned for having perfect eyesight; this was borne out by his meticulous attention to detail and his clarity of line and colour. This, however, is one of his strangest pictures, bordering on the grotesque while pertaining to represent a pastoral idyll. The colours jar the senses, clashing with one another and removing the painting from the usual Pre-Raphaelite desire for reality in nature and the properties of natural light.

The subject is taken from Shakespeare's *King Lear*, from Edgar's song about a shepherd neglecting his flock. The symbolism is obvious: the shepherd's flirtatious mission, to show the shepherdess not an exquisitely coloured butterfly, but a death's head moth, leaves him unheeding of the chaos about to erupt. Likewise, instead of protecting the lamb in her lap, the shepherdess has unwittingly allowed it to eat a green apple – something that will shortly make it ill. On close inspection, the flock of sheep are in trouble. One is so fat that it is struggling to get back to its feet, lying pathetically on its well-rounded side with its legs waving in the air. Sheep can also be seen straying into the wheat field.

SIR JOHN EVERETT MILLAIS (1829–96)
The Huguenot, 1851–52

Courtesy of Christie's Images

THE longer, more explanatory title of this painting is *A Huguenot, on St Bartholomew's Day, Refusing to Shield Himself from Danger by Wearing the Roman Catholic Badge*. It harks back in history to Paris of 1572, when many hundreds of French Protestants (Huguenots) were massacred by Catholic hordes. It was decreed that all Catholics should wear a white band on one arm and a cross in their hats to avoid the slaughter.

Millais portrays a Catholic woman's desperate attempt to shield her Huguenot lover, and his determined refusal to deny his religion. The crushed red flower at their feet is symbolic of his certain death.

This painting was one of Millais' best received and it won the Liverpool Prize. From this time onwards he was constantly asked to paint 'another Huguenot' (his 1860 painting *The Black Brunswicker* was a direct result of this public pressure). The popularity of *The Huguenot*, along with Collinson's defection from the Brotherhood, Woolner's 1852 emigration to Australia and Hunt's desire to leave England to paint in the Holy Land, effectively signalled the beginning of the end for the PRB, indicating a more concerted effort by each artist to look to his own, individual career, whilst remaining conscious of the Brotherhood's aims.

Philip Hermogenes Calderon
Broken Vows, 1857
Courtesy of the Tate Gallery. (See p. 190)

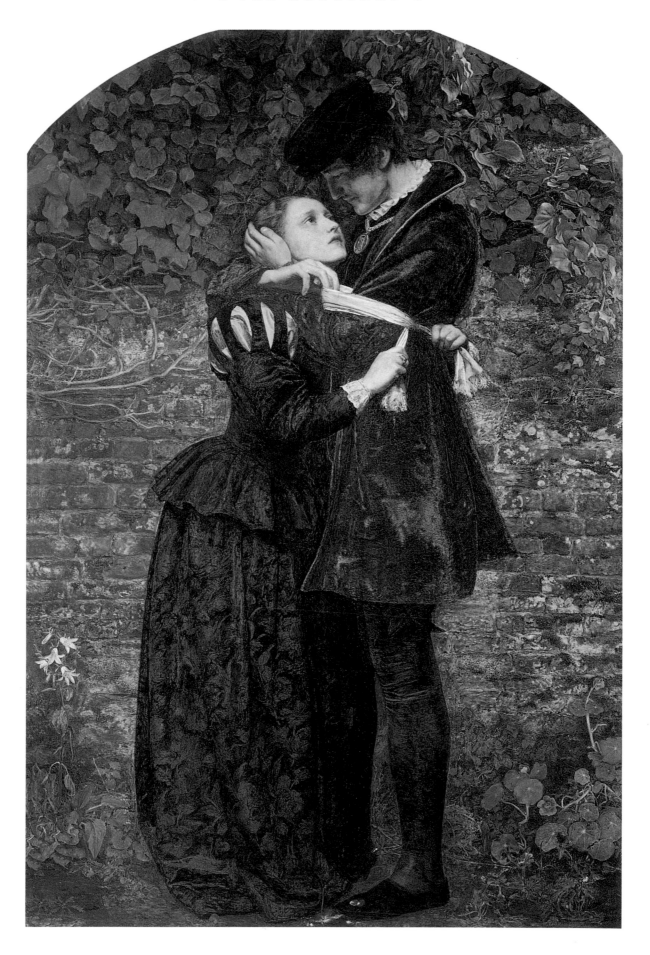

WILLIAM HOLMAN HUNT (1827–1910)
Our English Coasts, 1852
Courtesy of the Tate Gallery

*O*UR *English Coasts* (also known as *Strayed Sheep*) was highly praised by Ruskin for its use of natural light. The picture also won the Birmingham Prize in 1852.

The brilliance of light employed in this painting has led to its comparison to the works of Turner. Note how the ear of the lamb at the front is shot through with light, as the artist attempts to convey the transparency of thin flesh; also the changing colour of the landscape, moving through various shades of green and purple, conveying the end of a sunny English afternoon.

Unlike Hunt's other landscape-with-sheep picture, *The Hireling Shepherd* (1851), the sheep portrayed here are not engorged to the point of explosion. The sheep lying down slumbers contentedly rather than struggling to return its bloated body to an upright position.

When Brown painted *The Pretty Baa-Lambs* (1852) he imported sheep to his garden every day; when Millais painted the sheeps' heads in *Christ in the House of His Parents* (1850), He used severed heads, fresh from the butcher, to perfect the detail. Knowing Hunt's penchant for painting outdoors, it seems likely he favoured the former method – although he did once boil down a horse's carcass, in an enormous pot in his garden, in order to obtain a skeleton to draw from.

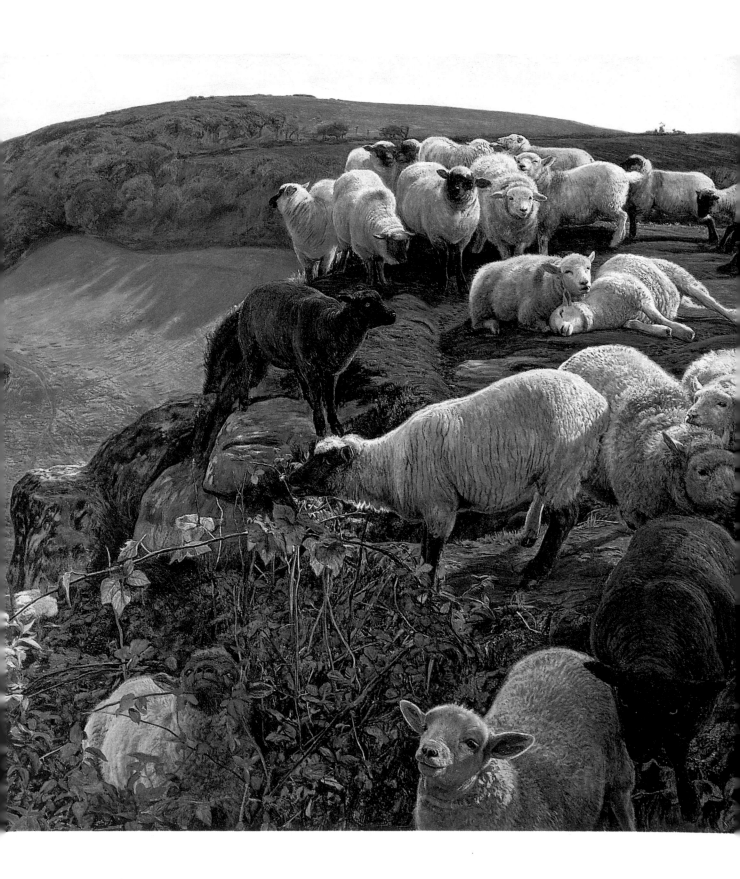

SIR JOHN EVERETT MILLAIS (1829–96)
Ophelia, 1852

Courtesy of the Tate Gallery

*O*PHELIA was painted (in oil on canvas) at the height of Millais' Pre-Raphaelite fervour; at a time when he remained passionately true to the ideals and beliefs of his youth. The picture is almost frighteningly realistic – something today's viewers tend not to notice as the picture has become so well known. At the time it was groundbreaking in its realism. Arthur Hughes also exhibited an *Ophelia* in 1852; it is a stunning – but fantastically unreal – composition that looks like a stage figure.

Elizabeth Siddal was the model for Millais' Ophelia. To achieve his desired effect of billowing dress and chaotically floating hair and flowers, Millais asked Lizzie to lie in a bath of water, warmed by a row of candles placed beneath the bathtub. Unfortunately, at one session the candles went out; Millais was too absorbed in his work to notice and Lizzie was too professional to disturb her pose and tell him how cold she was – it is claimed that this contributed dangerously to her ill-health, suffering as she did from tuberculosis and neuralgia.

The picture was an instant success. The critics adored Millais' latest offering and William Rossetti declared it the most like Lizzie of all the pictures for which she posed.

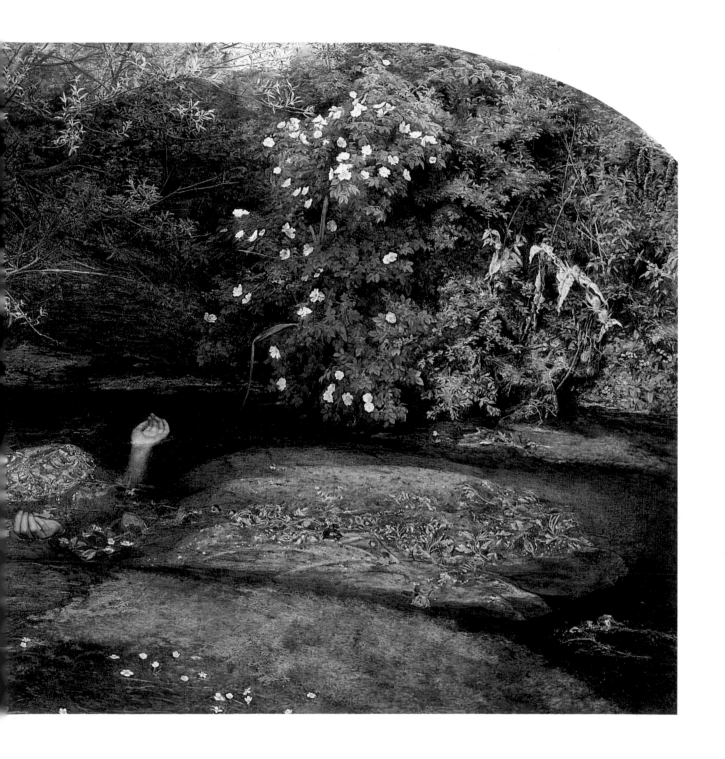

WALTER HOWELL DEVERELL (1827–54)
A Scene from 'As You Like It', 1853
Courtesy of Birmingham Museums and Art Gallery

DEVERELL, a Shakespeare afficionado, made many sketches to illustrate the play *As You Like It*. The scene he chose to recreate in oil tells of how Celia pretends to officiate at the 'marriage' of Orlando and Rosalind (disguised as a boy). Deverell's sister, Margaretta, posed as Rosalind and their brother, Spencer, took the part of Orlando. According to legend, the models were expected to stand in a Surrey wood – in all weathers – for hours on end. At times the trio were soaked as the artist ignored their protestations and continued painting, his precious canvas protected by an umbrella.

A preliminary pencil sketch of Orlando's face shows a good-looking, lively man; sadly it appears that Deverell was unable to translate this vitality into the more difficult medium of oil paints. The finished version of Orlando looks awkward and lifeless in comparison.

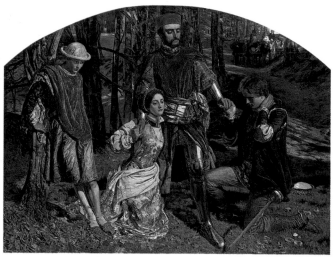

The Deverell family, orphaned of both parents, lived in a constant state of financial worry, reliant on Walter's income. When he died at the age of 26, his friends attempted to help. Rossetti is said to have given the final touches to *A Scene from 'As You Like It'* so that the Deverell family could sell it after Walter's death.

William Holman Hunt *Valentine Rescuing Sylvia from Proteus, 1851*
Courtesy of the Birmingham Museums and Art Gallery, (See p. 36)

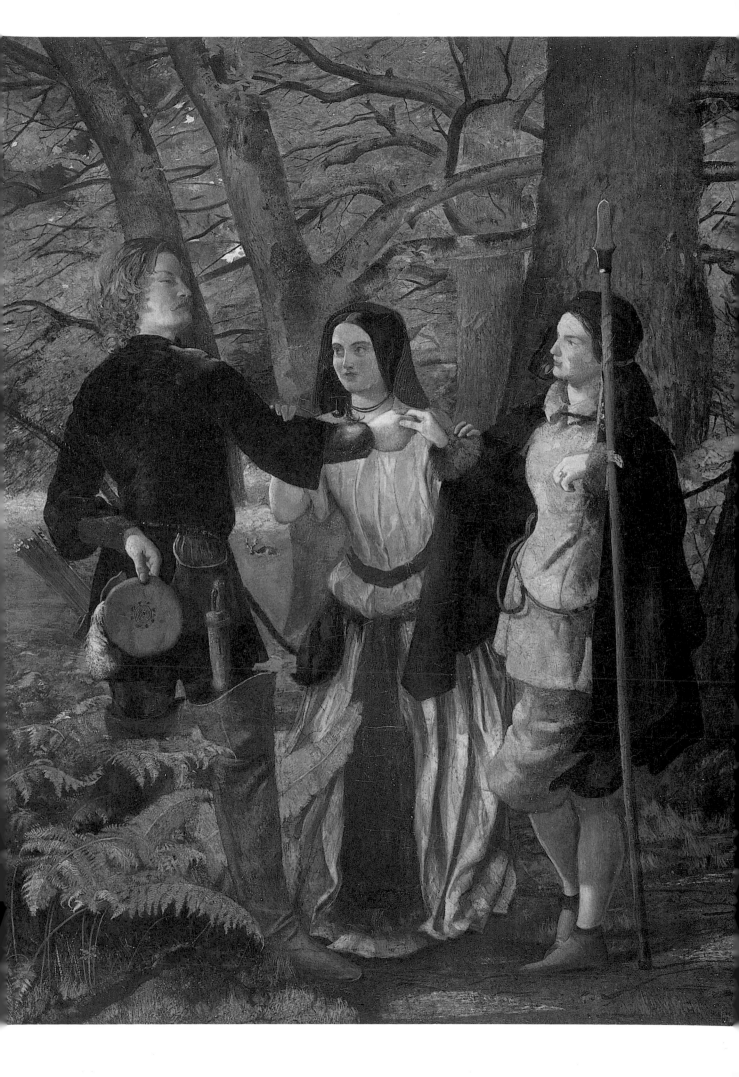

WILLIAM HOLMAN HUNT (1827–1910)
The Light of the World, 1853
Courtesy of Jeremy Marks (Woodmansterne Ltd)

*T*HE *Light of the World* was inspired by a quote from the Bible's *Book of Revelations*: 'Behold, I stand at the door, and knock: if any man hear my voice, and open the door, I will come in to him, and will sup with him, and he with me.' The painting, often described as Hunt's greatest achievement, is filled with symbolism: the seven-sided lantern is indicative of the seven churches mentioned in *Revelation*; the lack of an outside handle on the door shows that it can only be opened from within; the weeds growing against the door indicate that it has not been opened for some time; the fallen apples represent of the fall from grace in the Garden of Eden.

After the exploration of the properties of painting solely in natural sunlight in *Our English Coasts* (1852); Hunt's desire to experiment with the varied effects of natural light led him to paint this at night, or in a specially blackened studio, allowing him to experiment with the light afforded by only the moon and candles. For months he laboured with the picture, gaining himself a reputation as a madman with the local people who only saw him at night. When it was finished, the painting was lauded far and wide – it was seen in America, Canada, New Zealand and Australia as well as Britain.

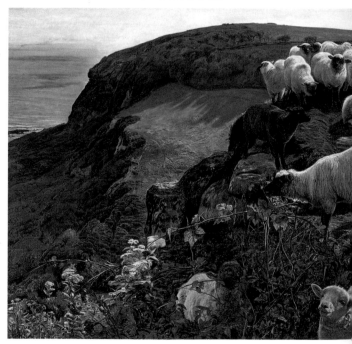

William Holman Hunt
Our English Coasts, 1852
Courtesy of the Tate Gallery. (See p. 44)

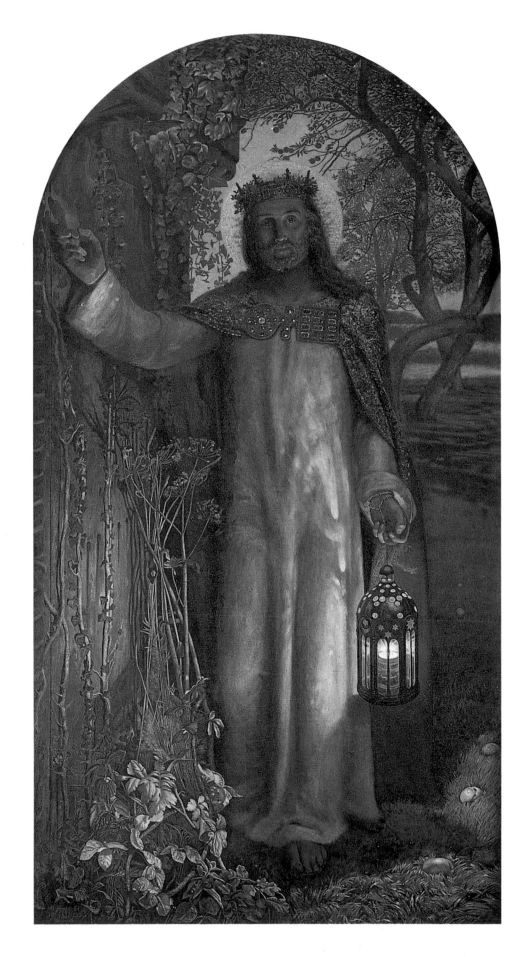

SIR JOHN EVERETT MILLAIS (1829–96)
The Order of Release, 1853

Courtesy of the Tate Gallery

*T*HE *Order of Release* went down in the history books as the first painting to require a bodyguard to protect it from adoring fans. It was exhibited at the Royal Academy in 1853, and secured Millais' position as the decade's most revered artist.

The picture tells of a Scottish Highlander's release from prison during one of the many wars waged between the Highlanders and the English army. The determined, resigned facial expression of his wife suggests that his order of release was obtained at the expense of her honour; the husband's humilated, defeated stance suggests he knows the sacrifice she made. The model for the soldier's wife was Scottish Effie Ruskin; later to become Effie Millais. It was during the painting of this picture that she and Millais fell in love and she confided to him the travesty of her marriage to Ruskin.

The Order of Release marks the end of Millais' Pre-Raphaelite idealism and the start of his commercial career. When Queen Victoria fell in love with the Highlands and chose to make a royal home at Balmoral, Scotland became very fashionable. Centuries of attempts to force the Anglicisation of the Scots changed into appreciation of the country's diverse and rich history. It became a place of great romance, helped by the popular writings of Sir Walter Scott.

Elizabeth Siddal
Sir Patrick Spens c. 1857–60
Courtesy of the Tate Gallery. (See p. 180)

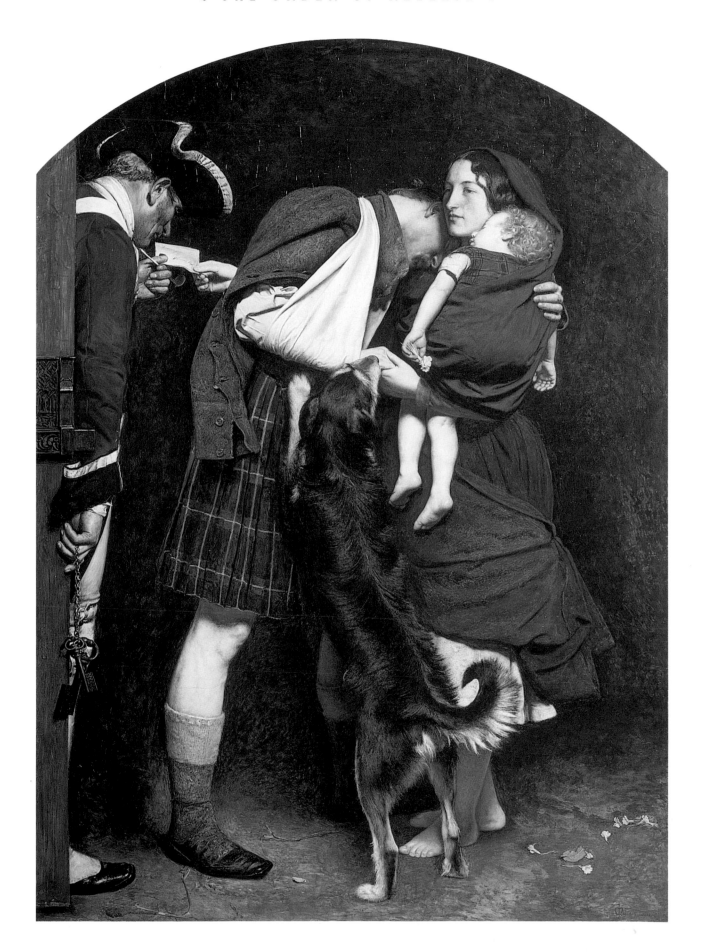

DANTE GABRIEL ROSSETTI (1828–82)
Found, 1853–62

Delaware Art Museum. Courtesy of the Bridgeman Art Library

*F*OUND was commissioned in 1853, although Rossetti's patron, Frances MacCracken, lost interest in 1855. Rossetti had great trouble with this picture; he gave it up and returned to it several times. In later studies for this painting, the model used was Rossetti's mistress, Fanny Cornforth.

The picture tells of a country girl who left her home to come to London; as was common, lack of work and social welfare forced her into prostitution. Here, she has been 'found' by a farmer – her first love – who recognised her while travelling through London on his way to market. His calf, bound in net to prevent it falling from the cart, is symbolic of the woman's predicament. Rossetti found a quotation from the Old Testament to accompany his picture: 'I remember thee; the kindness of thy youth, the love of thy betrothal.'

Eager to dispel any rumours of plagiarism after *The Awakening Conscience* (1854), Rossetti wrote to Hunt, reminding him that this subject was one he had intended to portray since the early days.

Rossetti was both fascinated and appalled by prostitution. Although he frequented prostitutes in his later years, he also offered help, both practical and financial, to women caught in the trade. One of his earliest poems, 'Jenny', was famously about a prostitute:

Lazy, languid, laughing Jenny
Fond of a kiss and fond of a guinea.

William Holman Hunt
The Awakening Conscience, 1854
Courtesy of the Tate Gallery. (See p. 88)

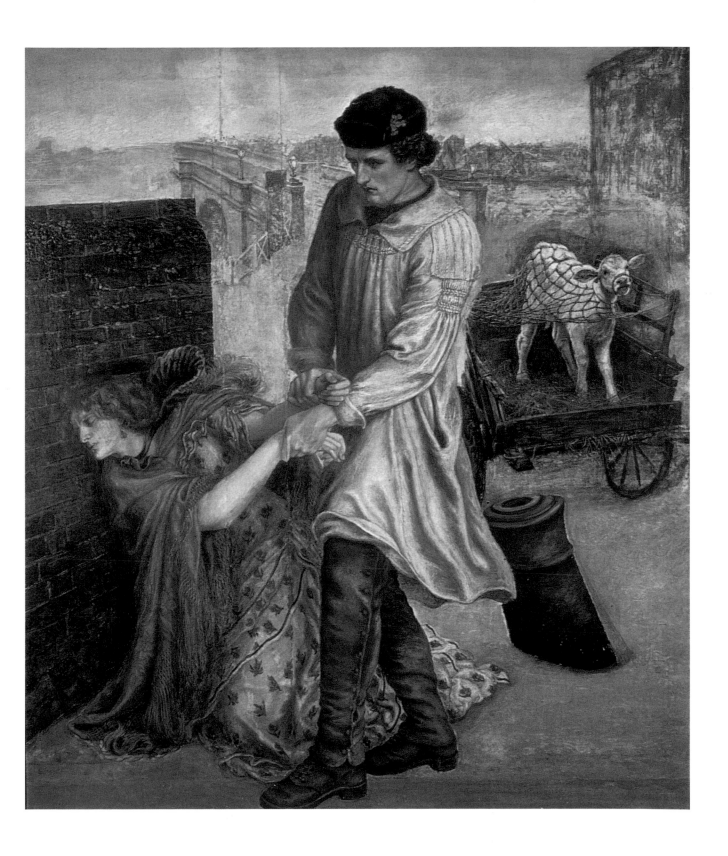

DANTE GABRIEL ROSSETTI (1828–82)
Study for Delia, c. 1853–55
Courtesy of Birmingham Museums and Art Gallery

THE image of a woman sucking her hair was one employed by several Pre-Raphaelite painters, as one of overt eroticism, obviously suggestive of sexual frustration (note Rossetti's accentuating use of black ink to trace the inside of Delia's lips).

In 1866, the year in which Frederick Sandys lived with Rossetti for several months, he drew *If*, an extremely similar composition to this initial sketch modelled by Lizzie Siddal. *If* may well have proved the catalyst for Rossetti's accusations of plagiarism by Sandys. The picture does show a definite Rossettian influence – however this was somewhat inevitable owing to the facts that Sandys was being instructed by Rossetti and that they were using the same models.

Study for Delia was drawn for a watercolour entitled *The Return of Tibullus to Delia*; a story taken from the works of the Ancient Roman poet Tibullus. In the finished piece, the poet bursts unexpectedly into Delia's room, to find her sitting in this attitude, awaiting his return from travelling. The source for this picture comes from a poem Tibullus wrote to his lover, which includes the lines:

So unnanounced, shall I come suddenly ...
Then, as thou art, all long and loose thy hair
Run to me, Delia.

Frederick Sandys
Love's Shadow, 1867
Courtesy of Christie's Images.
(See p. 202)

THE PRE-RAPHAELITE MOVEMENT

FORD MADOX BROWN (1821–93)
Chaucer at the Court of Edward III, c. 1845–51
Courtesy of the Tate Gallery

*B*ROWN began preparatory works on *Chaucer* in the middle of the 1840s, originally intending to paint it as a triptych. This was around the time he first encountered the Pre-Raphaelite Brotherhood and their input was invaluable in the construction of this work. Although never a member of the group, Brown's proximity and adherence to their ideals shines through in *Chaucer*. He also made use of several Pre-Raphaelites as models, including Elizabeth Siddal.

The brilliance of tonal range employed in *Chaucer* is in stark contrast to the strictures of the Royal Academy, in which browns, greens and a set percentage of shadow were stipulated. Brown's canvas is suffused with natural sunlight, accentuated by careful placing of white clothing amongst the models (costumes that Brown painstakingly researched for accuracy).

Due to the clever use of light and form, the eye is naturally drawn to the figure of Chaucer, despite the poet not being placed centrally on the canvas. As can often be seen in Brown's pieces – notably in *Work* (1863) – the painting is intricate in detail with myriad alternative scenes on which to dwell: clandestine lovers, whispered conversations and a wide variety of characters, from a cardinal to a serving girl. *Chaucer* was exhibited prominently in 1865, when Brown was at the height of his fame and prosperity, after many years of struggling. Its popularity derived from a surge of interest in paintings depicting scenes of national importance or heritage.

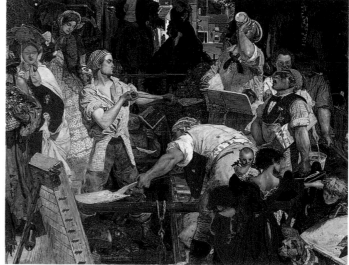

Ford Maddox Brown
Work, 1863
Courtesy of Topham. (See p. 77)

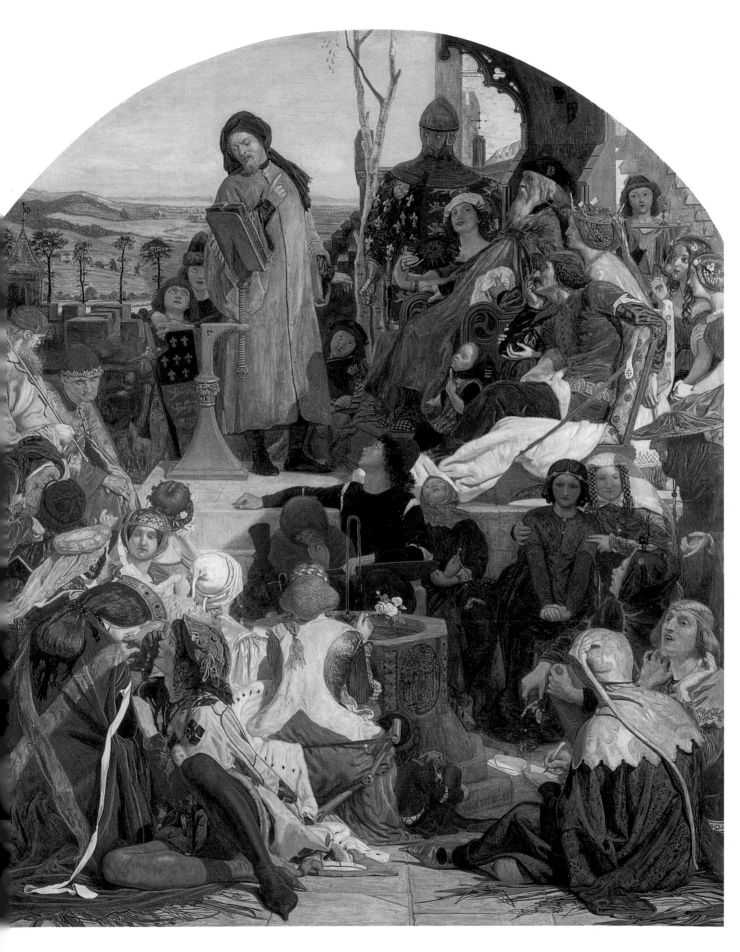

FORD MADOX BROWN (1821–93)
Take Your Son, Sir, begun in 1851

Courtesy of the Tate Gallery

BROWN'S second wife, Emma, and their three-month-old son, Arthur, modelled for this painting. It was begun in oils in late 1851, but never finished, despite being added to over the years. This may be due to little Arthur's untimely death.

The paper on which *Take Your Son, Sir* is painted was added to (in length) several times, extending the picture downwards. Brown's signature can be seen to the right, below the baby, signalling where the intended painting originally stopped. The baby, appearing through a womb-like surround of material, has been made the focal point by the addition of extra paper.

The father (a self-portrait by Brown) can be seen in the mirror behind the new mother's head. There is some contention as to whether Brown intended this to be an autobiographical picture of his family, or whether, in the more popular view, the painting deals with illegitimacy. The use of the word 'sir' in the title suggests the latter, although the father's eagerness to hold the baby suggests the former.

The obvious Madonna and Child imagery is reflected again in *The Pretty Baa-Lambs*, painted in 1852 by Brown.

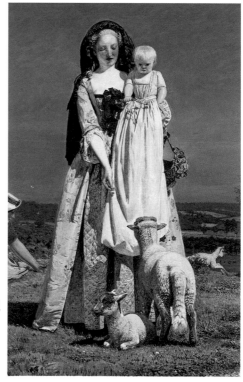

Ford Madox Brown (1821–93)
The Pretty Baa-Lambs, 1852
Courtesy of Birmingham Museums and Art Gallery. (See p. 64)

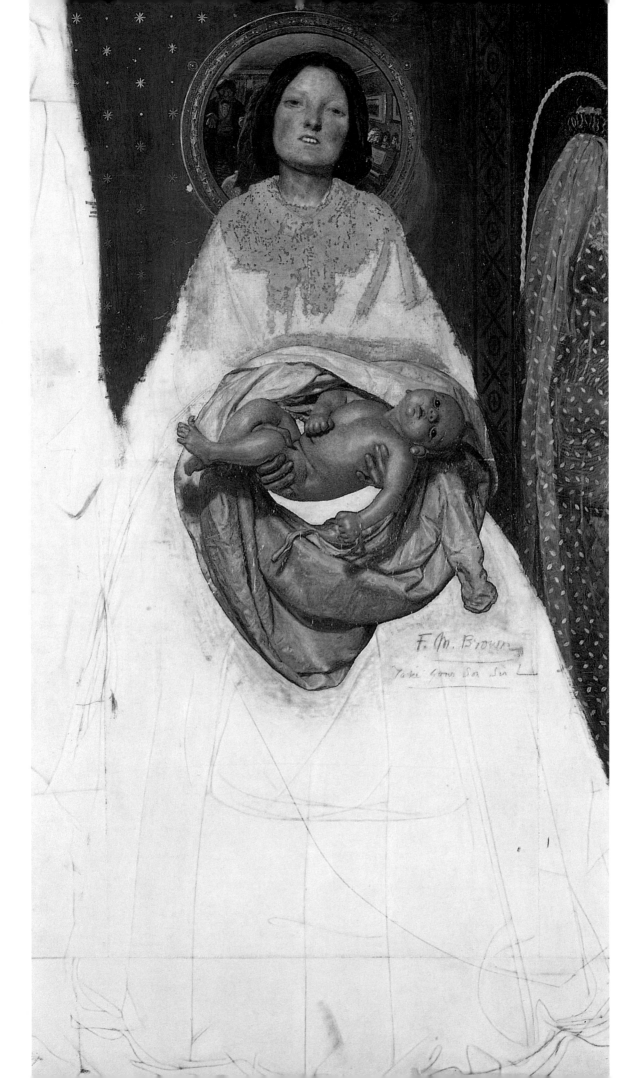

F. M. Brown

Take your Son Sir

FORD MADOX BROWN (1821–93)
Jesus Washing Peter's Feet, 1852
Courtesy of the Tate Gallery

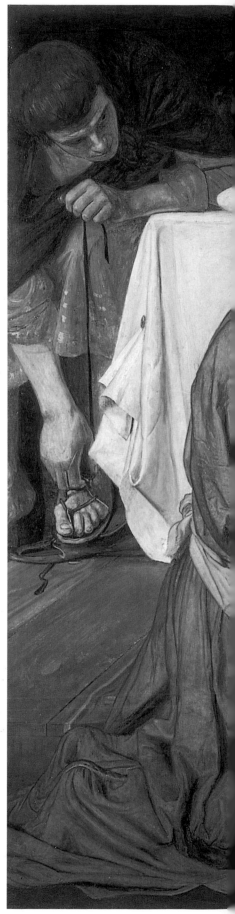

JESUS Washing Peter's Feet was exhibited in the same year that Brown began his masterpiece, *Work* (1863). This picture evokes the same message as *Work*: that of the class system being un-Christian. Brown took the subject for *Jesus Washing Peter's Feet* from the *Book of St John*; his intention was to portray the shocked reactions of the disciples as wrong, suggesting that they should, like Jesus, believe all people to be equal. Similarly, in *Work*, he tried to expose the stupidity of the English class system, ridiculing the upper-class residents for their snobbery towards the labourers – without the labourers' vital work on the sewers the residents could die from cholera. In the same way that Brown depicted the brawny labourers in *Work*, the musculature of Jesus' arms indicates a strong, working man.

Adhering to Pre-Raphaelite tradition, Brown used family and friends as models for *Jesus Washing Peter's Feet*. F. G. Stephens, Dante Rossetti, William Rossetti, Tom Seddon, William Holman Hunt and Hunt's father posed. Lizzie Siddal also modelled.

Jesus Washing Peter's Feet was sent to the Royal Academy, but its unfortunate placing in the exhibition (in bad lighting and away from the crucial 'line') infuriated Brown to such an extent that he stormed out of the Academy and determined to exhibit – and hang – his works under his own initiative in future.

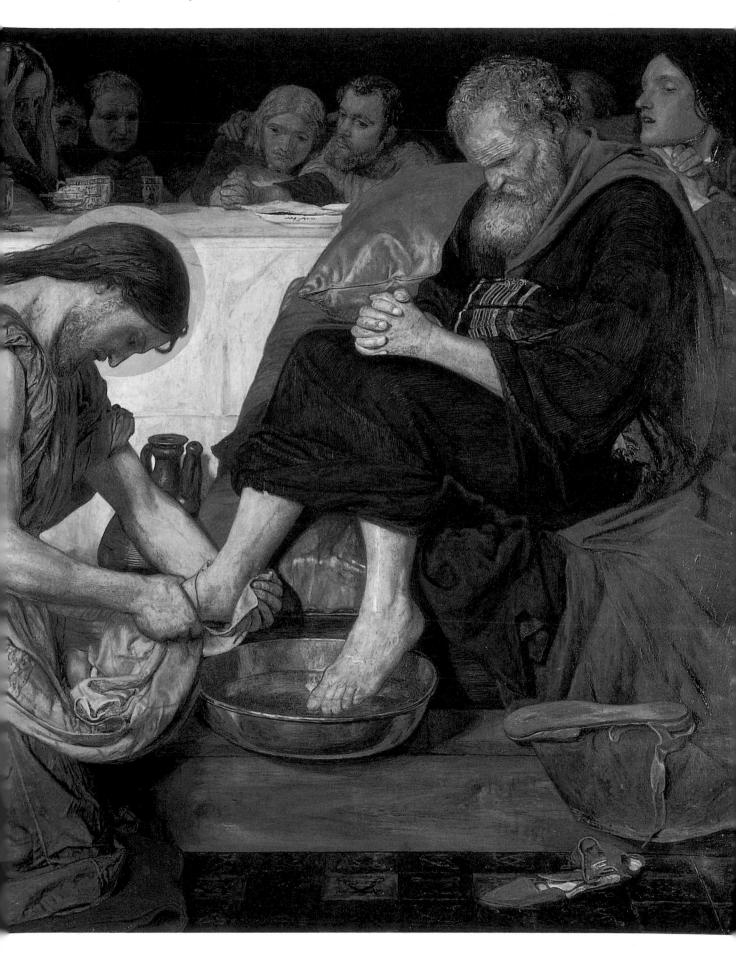

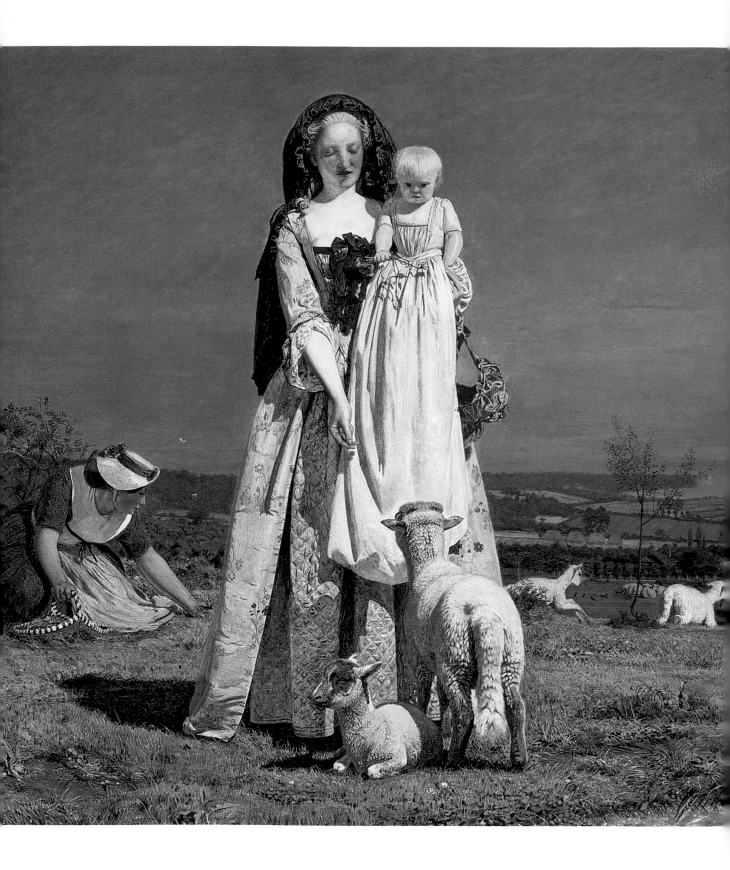

FORD MADOX BROWN (1821–93)
The Pretty Baa-Lambs, 1852
Courtesy of Birmingham Museums and Art Gallery

THIS was the first picture that Ford Madox Brown painted outside and was his premier experiment with the use of sunlight in his art, as championed so fervently by Ruskin. The models for this typically Victorian scene were his wife Emma and their daughter, Catty. The choice of the eighteenth-century costumes worn by the mother and child emphasise how strongly Brown was influenced by Dutch and Flemish art at this time.

It is an often-repeated story that the sheep used in this painting were imported from Clapham Common every day, by cart, and left free to roam around the Brown's small garden, gorging themselves on their grass and flowers. The direct sunlight that Brown exposed himself to every day also took its toll, giving him a severe case of sunstroke. However, the result was favourably received and heralded a new style of painting, along with Hunt's *Our English Coasts*, which was also painted in 1852.

The Madonna and Child image is one that Brown was particularly fond of, and one that he returned to again and again, such as in *Take Your Son, Sir* (1851) or *Waiting* (1854–55).

William Holman Hunt
Our English Coasts, 1852
Courtesy of the Tate Gallery.
(See p. 44)

FORD MADOX BROWN (1821–93)
Cordelia at the Bedside of Lear, 1849–54
Courtesy of the Tate Gallery

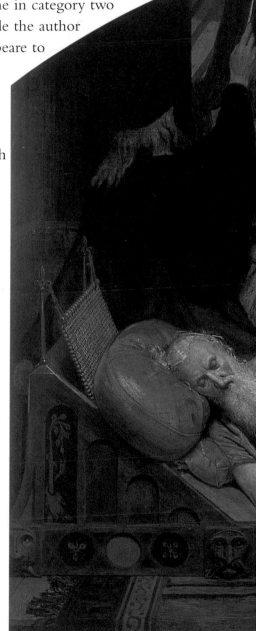

WHEN the Pre-Raphaelite Brotherhood drew up their list of immortals, Shakespeare's name came in category two – just below Jesus Christ and alongside the author of the Bible's *Book of Job*. Rossetti wanted Shakespeare to be placed above Jesus, but was outnumbered.

Ford Madox Brown's fascination for Shakespeare's *King Lear* began in 1843 (reputedly after seeing William Charles Macready playing Lear on the London stage). Brown began to sketch scenes from the play feverishly – producing 16 in one year. Henry Irving, who later played Lear to great acclaim, became the owner of several of these. In 1844 Brown was in Paris, studying the work of European illustrators, it was there that he made his first proper drawing of this subject.

Cordelia at the Bedside of Lear evokes a stage set: the curved top of the picture reminiscent of a stage curtain shaping the audience's view. Each figure is placed for maximum effect as though choreographed and the background scene resembles a painted backdrop rather than a true representation of a landscape (something Brown was capable of doing if he wished). The careful lighting of the two main figures – when the natural light that is actually coming into the tent is doing so from behind – suggests footlights. The figure of the jester, seen looking intently down at Lear, was modelled by Dante Gabriel Rossetti.

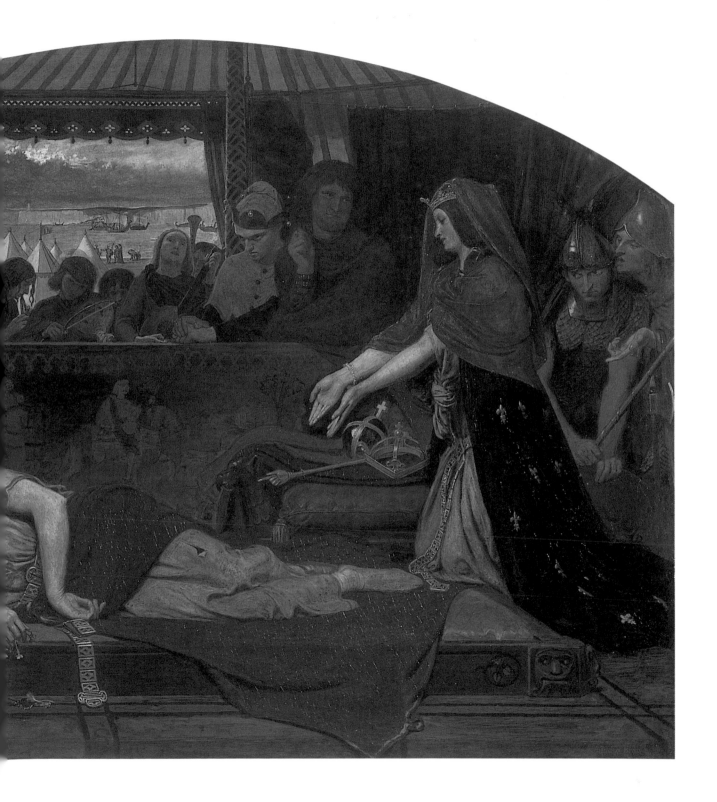

FORD MADOX BROWN (1821–93)
Mauvais Sujet, 1863
Courtesy of the Tate Gallery

THIS watercolour was influenced by a painting of Dante Rossetti's, called *Girl at a Lattice* (1862) and produced while Rossetti was staying at Brown's house. The model for the painting was Brown's maid but, although both girls look very similar, Brown used a model called Mary for his. Her name can also be seen carved onto her desk.

Mauvais Sujet is a very sexual portrait, despite the girl's young age. Her cherry-red earrings and black neck ribbon, the wildness of her hair and the way in which her lips are parted against the apple are all suggestive of sensuality. The apple is also an obvious symbol of Eve and the Tree of Knowledge. It is also a witty portrait, in direct opposition to the usual style of portraits of Victorian girls.

Brown took great interest in finding exactly the right models for his pictures, often scouring the streets in search of the perfect face. As many of his chosen models were extremely poor, the Browns became renowned for their kindness, providing food and clothing as well as payment for modelling long after their models' services had ceased. This charity was maintained despite their suffering financial hardship themselves. It has been suggested that Brown discovered Mary during his search for Irish models to pose for *Work* (1863).

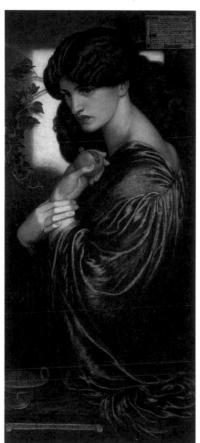

Dante Gabriel Rossetti
Proserpine, 1877
Courtesy of the Tate Gallery. (See p. 122)

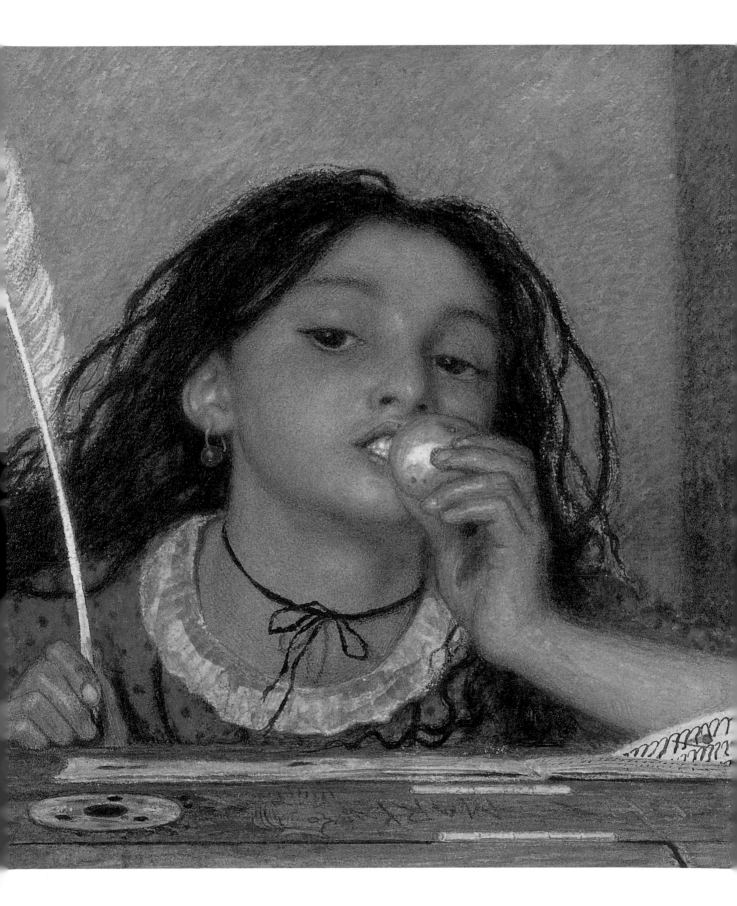

FORD MADOX BROWN (1821–93)
Elijah Raising the Widow's Son, 1864
V&A Museum. Courtesy of Topham

*T*HIS oil painting of *Elijah Raising the Widow's Son* was commissioned by John Hamilton Trist, a distiller turned art patron – it cost him 100 guineas and a case of wine. In 1863, Brown worked on a series of illustrations for the Bible; these were being produced for the famous engravers and publishers, the Dalziel Brothers. Many of Brown's illustrations were later turned into paintings; *Elijah Raising the Widow's Son* (from *I Kings*, 17:23) was amongst these. The scene was also made into a watercolour.

The brilliance of the colour evokes the exoticism of the East. A wonderful palette of orange through to red was employed, making the paleness of the boy's death shroud even more stark. The faces are perfect: the desperate supplication of the mother, the weakness of the revived son and the wise countenance of the prophet.

Typically, Brown researched this painting in detail, checking the clothing and domestic details thoroughly. He made the son's 'resurrection' apparent by careful symbolism: the flowers in his hand come from the ancient tradition of placing flowers into the hands of the dead and the shadow of the bird returning to its nest is indicative of his soul having come back to his body.

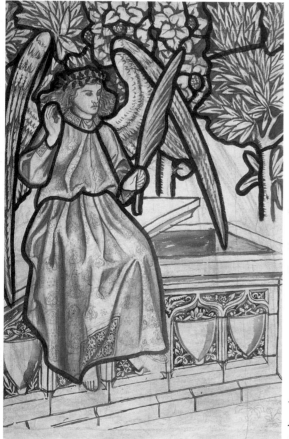

William Morris
Angel of the Resurrection, c. 1862
Courtesy of the Tate Gallery. *(See p. 130)*

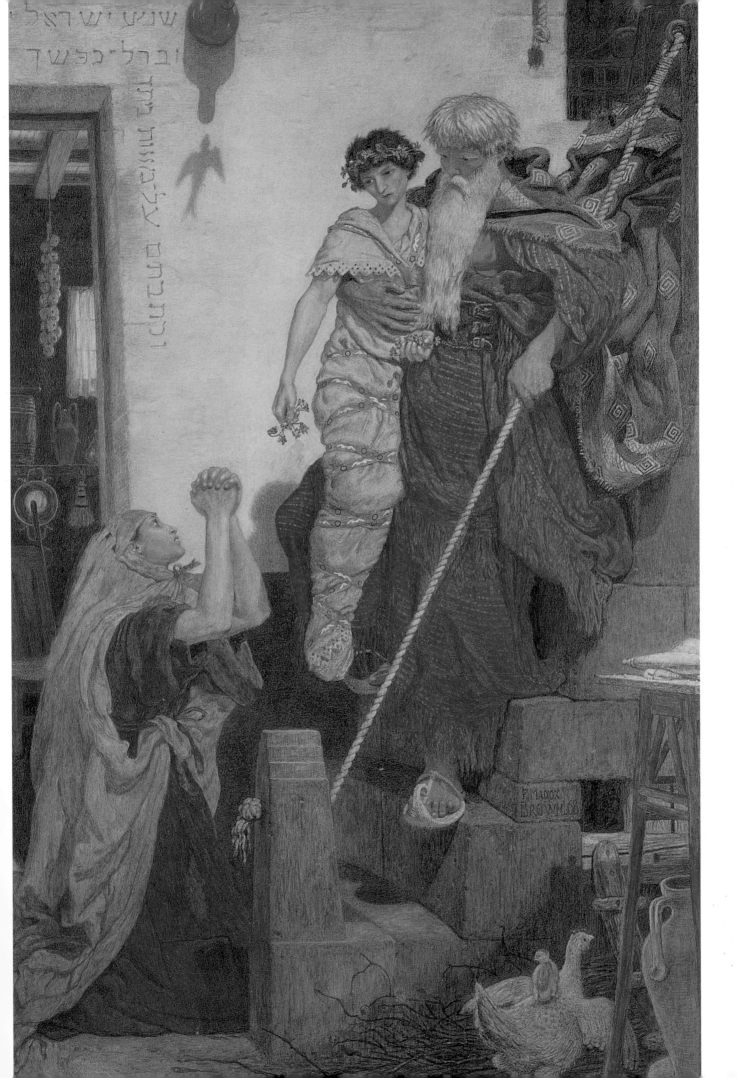

FORD MADOX BROWN (1821–93)
The Last of England, 1855–66
Courtesy of the Tate Gallery

*T*HIS watercolour was inspired by the emigration of Thomas Woolner and his wife to Australia. The couple painted, however, were obviously posed by Ford and Emma Madox Brown. His face shows a pensive determination as he meditates apprehensively upon their projected new life in an unknown world. His wife's face shows both resignation and excitement, suggested by the untidy, bright-pink ribbons of her bonnet, a marked contrast to the surrounding sombre colours. One hand holds her husband's hand tightly; the other holds that of their young child (whose foot can be glimpsed next to its parents' clasped hands).

Ford Madox Brown
Romeo and Juliet, c. 1867
Courtesy of Christie's Images. (See p. 74)

This unity is re-emphasised in the shape of the painting itself: the circle represents the family unit and how they must now be all things to one another. No parents, siblings or friends appear to be going with them, from this day onwards they will have to rely totally on themselves.

This painting proved extremely popular, evoking as it did such a prominent part of Victorian life. As he did later in *Work*, Brown concentrated here on the lower classes, those for whom leaving the country became necessary in order to survive.

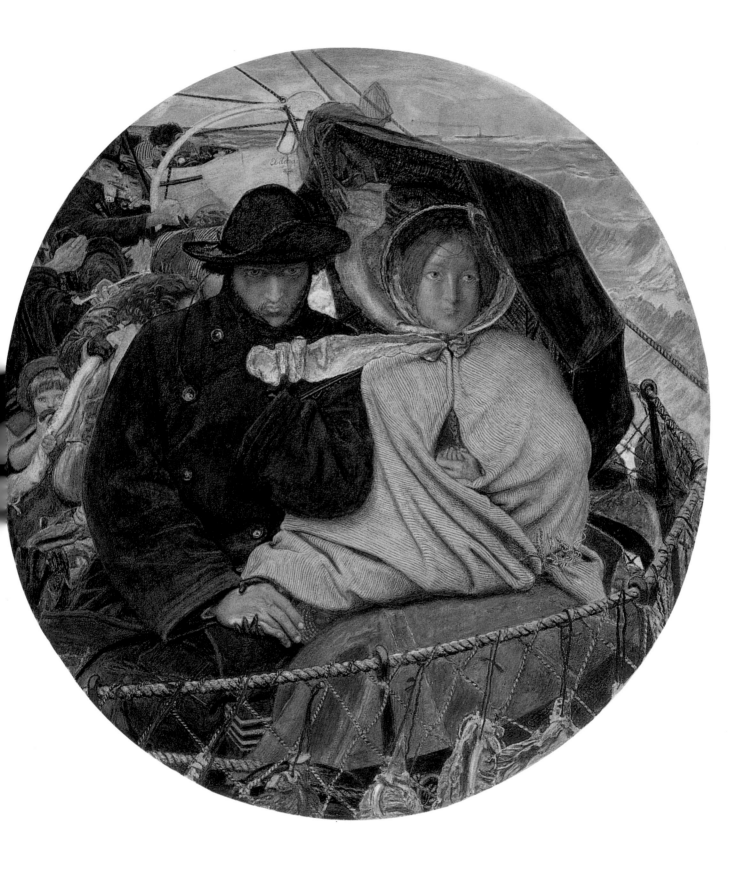

FORD MADOX BROWN (1821–93)
Romeo and Juliet, c. 1867
Courtesy of Christie's Images

ROMEO *and Juliet* was modelled by Emma Madox Brown and Charles Augustus Howell; both much older than the teenage lovers they were intended to portray. This may explain why Brown made their faces so indistinct; it may also have been due to the problems Brown was encountering in his marriage – by this time Emma's alcoholism was unbearable and Brown was suffering an unrequited passion for his pupil, Marie Spartali. It could also have been for financial necessity – hurrying the picture so he could receive payment. Whatever the reason, the painting appears to have received less careful attention than *Cordelia at the Bedside of Lear* (1849–54).

Howell became an intimate of the Pre-Raphaelites through his position as Ruskin's secretary. An intelligent, wickedly humorous and opportunistic man, he became invaluable as a sales agent, confidante and general errand runner. The dénouement of this sucessful career happened when, for reasons unfathomable, he took Maria Zambaco (Burne-Jones's lover) to tea with Georgiana Burne-Jones, the artist's wife. From that time on, many of his former friends dropped him.

Howell continued to live by his wits, however, reportedly spreading news of his own death up to four times in order to hold 'death sales' of his possessions. When he finally did die, in 1890, few people truly believed it.

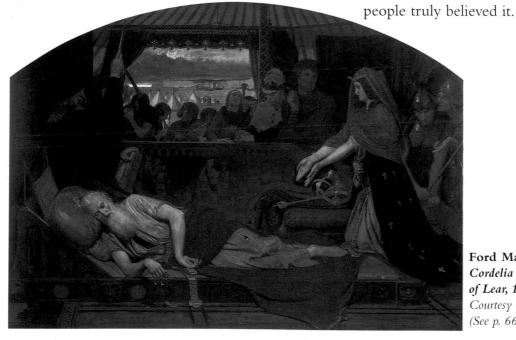

Ford Madox Brown
***Cordelia at the Bedside
of Lear, 1854***
Courtesy of the Tate Gallery.
(See p. 66)

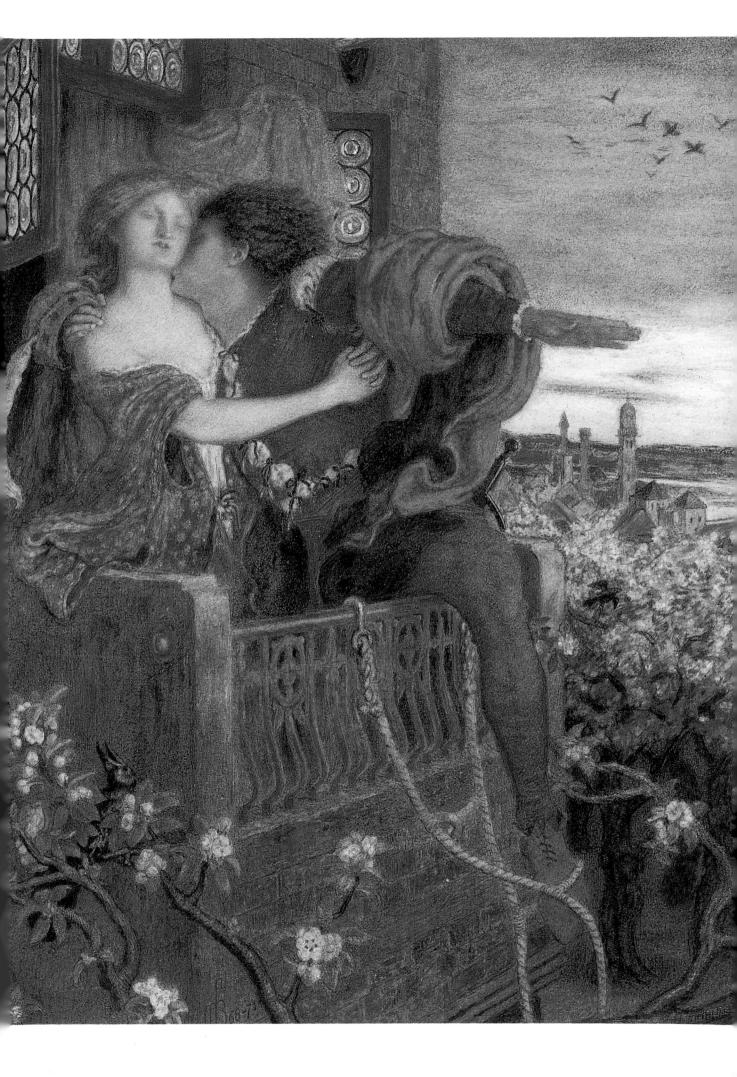

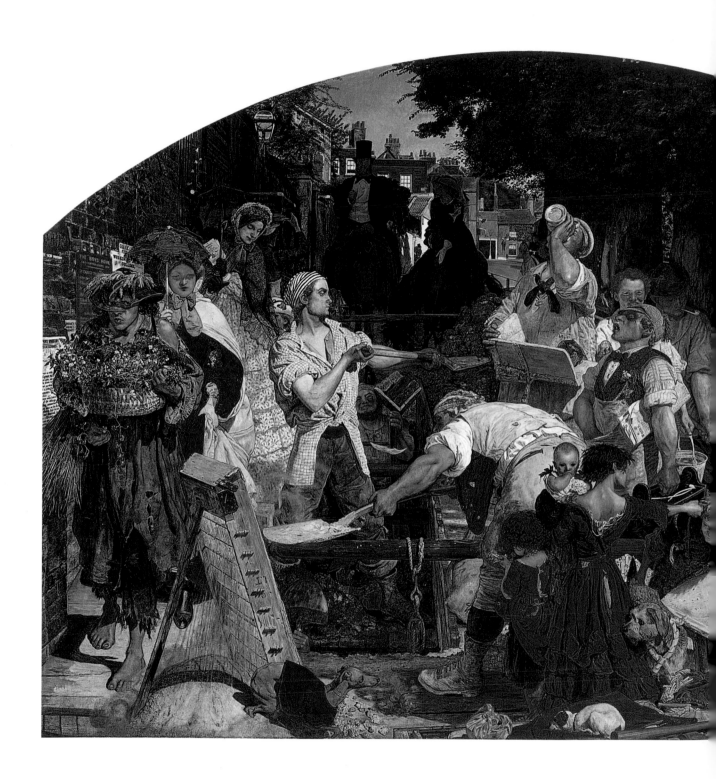

FORD MADOX BROWN (1821–93)
Work, 1863
Courtesy of Topham

*I*N 1852, Brown moved to Hampstead – once the home of Keats. It was a time of extreme personal hardship, as Brown struggled to support two families. The idea for *Work* came to him after observing a group of workmen laying Hampstead's first sewers, following an outbreak of cholera. He became haunted by the idea of a picture that would glorify the labouring man and highlight the equality of all classes. It took 11 years to finish his masterpiece.

The detail in *Work* is astonishing, and is highlighted by the juxtaposition of working- and upper-class people: the tract-bearing matron and her daughter set superbly against the ragged herb seller; the horse-riding father and daughter whose way is barred by the labourers; the richly dressed daughter contrasted with the dirty, motherless children at the forefront of the picture. Brown's use of light is wonderful: the workers' muscles gleam with sweat, while the sunlight beating down on them is almost tangible.

Political intent can be read in almost every centimetre of this painting, at the side stand Thomas Carlyle (hatted) and Dr Frederick Maurice, founder of the Working Men's Clubs; the group wearing placards are canvassing for votes – the list is endless. *Work* was also groundbreaking as the first Pre-Raphaelite painting to raise modern-day labourers to the heights hitherto reserved for biblical, historical or literary figures.

SIR JOHN EVERETT MILLAIS (1829–96)
John Ruskin at Glenfinlas, 1854
Courtesy of Topham

THIS superb portrait was begun in 1853 in Scotland. Millais visited his mentor and friend, John Ruskin, who was holidaying in Scotland with his wife, Effie. During the course of the portrait's evolution, Millais and Effie fell in love. They were married in 1855, Effie having obtained a divorce from Ruskin on the grounds of non-consummation of the marriage (reputedly due to Ruskin's horror upon discovering the difference between a real naked female and those seen in art). Ruskin's portrait was finished off in his London house; according to legend, he posed at the top of the stairs, Millais painted at the bottom and neither said a word to the other.

Despite the sad circumstances surrounding the picture, it is viewed as one of Millais' foremost portraits. Its portrayal of Ruskin is flattering and Millais' handling of the background scenery adheres closely to Ruskin's own thoughts on how art should be expressed, evinced in his book *Modern Painters* (1843) – a work that affected the ideology of the original Pre-Raphaelites deeply. In 1847, William Holman Hunt sat up all night to read *Modern Painters*; it was a seminal part in the development of the Pre-Raphaelite Brotherhood.

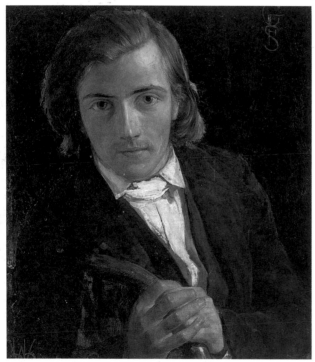

William Holman Hunt
F. G. Stephens, 1847
Courtesy of the Tate Gallery. (See p. 16)

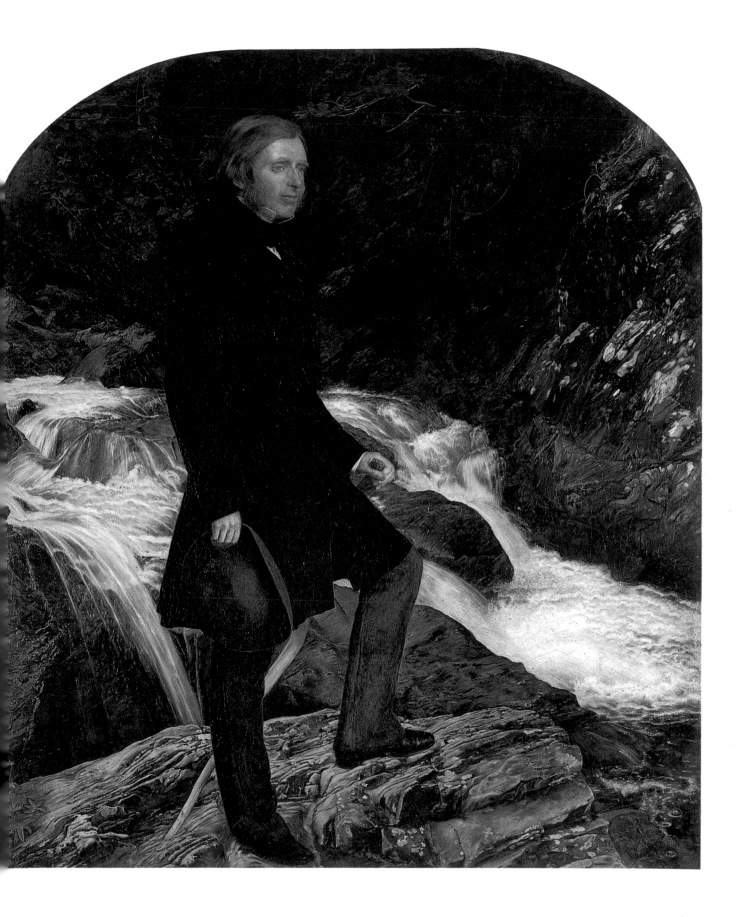

SIR JOHN EVERETT MILLAIS (1829–96)
Autumn Leaves, 1855–56

Manchester City Art Gallery. Courtesy of Topham

*A*UTUMN LEAVES is extremely important when looking at the works of Millais, because of its lack of defined storyline. Unlike the artist's most famous paintings, such as *Ophelia* (1852), *Cymon and Iphigenia* (1848) or *Lorenzo and Isabella* (1849), *Autumn Leaves* has no great work of literature, myth or history as its inspiration. It is a reference to the passing of time; of youth moving inexorably towards the autumn of life. Millais saw it as a intensely spritual: he wrote to F. G. Stephens that the painting was intended 'to awaken by its solemnity the deepest religious reflection'. The four young girls – two wealthy (modelled by his wife's sisters); two poor (modelled by local girls) – will all fade in time. This inevitability of youth growing old is accentuated by the way the sunset is creeping up on the day, making the background of sky appear slightly menacing.

Millais uses the evening light to exquisite effect on the girls' colouring; their plain clothes leading the viewer's eyes to concentrate on the sheen created on their skin and hair. Their cheeks glow with the exertion of activity and the nip of autumn breezes. It is unusual and mesmerising. It is also an indication of Millais' great prowess as a portrait painter.

Frederick George Stephens
Mother and Child, c. 1854–57
Courtesy of the Tate Gallery. (See p. 124)

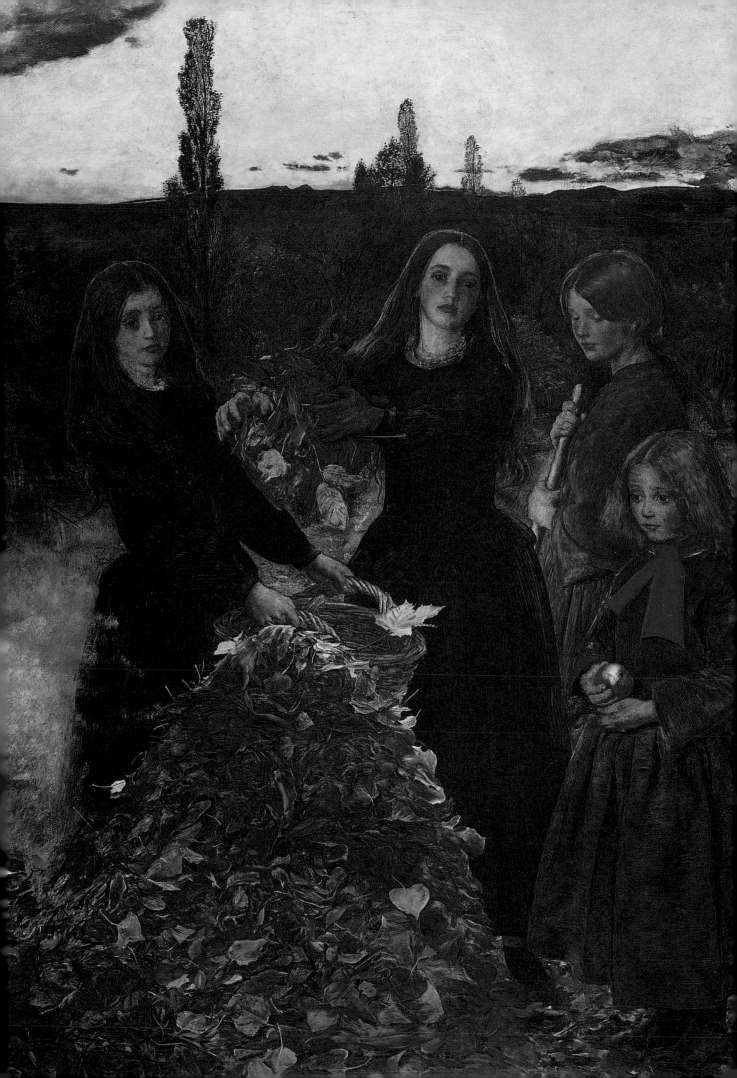

SIR JOHN EVERETT MILLAIS (1829–96)
Sir Isumbras at the Ford, 1857

Lady Lever Gallery, Port Sunlight. Courtesy of Giraudon

T HIS is one of Millais' most highly criticised works and it is difficult to defend it. It is a marked move away from his earlier, precise and realistically painted works. *Sir Isumbras* is an indication of the later, commercial, direction which Millais was to follow.

Unusually, the artist appears to have had great trouble with this composition, perhaps due to lack of care from the beginning. He set the scene in Perthshire, Scotland, home of his wife's family. According to Effie it took him just two weeks to finish the background – usually Millais took several months completing the setting of a picture.

However, the background is not the noticeable problem with this picture; it is the proportion that is wrong. The horse, on which the saintly Sir Isumbras carries two poor children across the swollen water, is inordinately large. According to legend, Millais originally painted it smaller (perhaps in correct proportion to the figures), but a client told him it was too small. As a result, Millais repainted it – with the somewhat disastrous end result seen here. The artist could see the problem however and, it being too late to change again if he wanted to exhibit it that year, asked a friend, Tom Taylor, to write an accompanying ballad about the outstanding size of Sir Isumbras' horse.

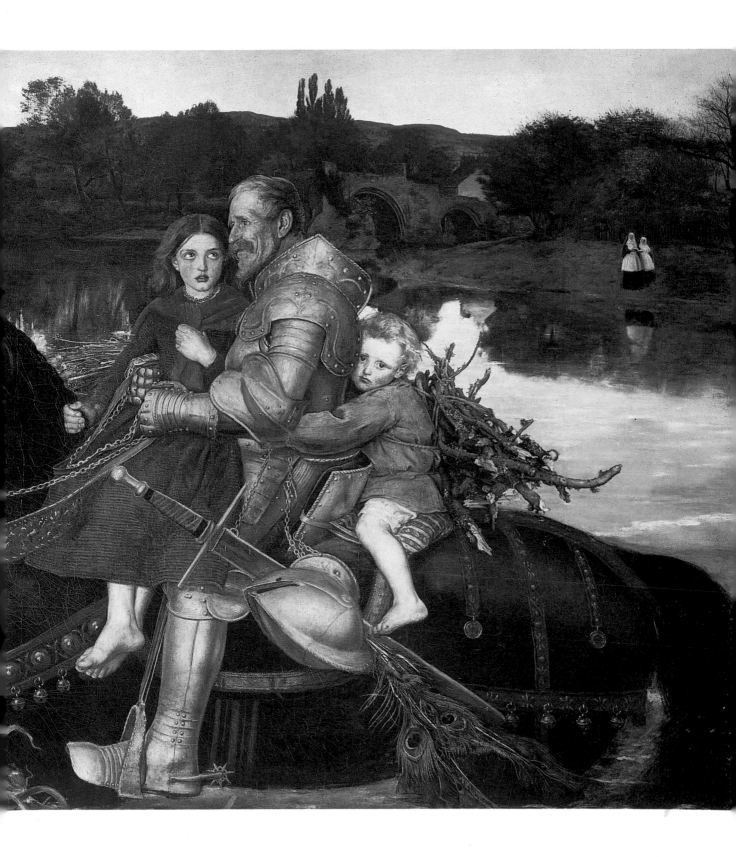

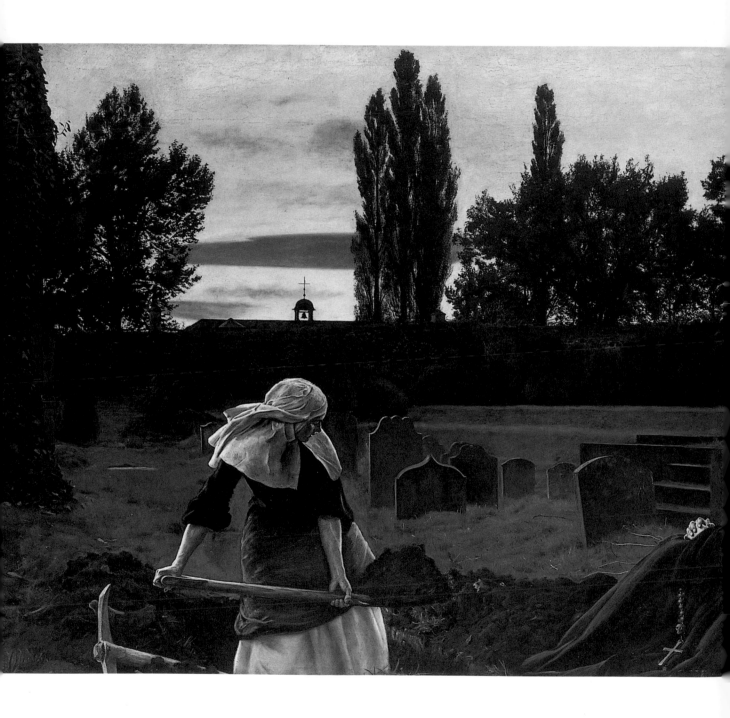

SIR JOHN EVERETT MILLAIS (1829–96)
The Vale of Rest, 1858–59

Courtesy of the Tate Gallery

*T*HE VALE OF REST is known as Millais' last Pre-Raphaelite painting; the last to adhere to the ideals of his passionate, rebellious youth before he moved into a new sphere: to the comfort of acceptance and the approval of London 'society'.

In marked contrast to later paintings, such as *The Boyhood of Raleigh* (1870), or his unpopular painting of the previous year, *Sir Isumbras at the Ford* (1857), *The Vale of Rest* deals with the subjects he later abandoned, such as the mysticism of religion. In this picture, he recreates the visual atmosphere conjured up in the much misunderstood *Autumn Leaves* (1855–56), a painting which, on a superficial level, seems secular, but is actually deeply religious in tone.

The Vale of Rest is strangely compelling in composition, leading the viewer to question why one nun is working so hard and the other sitting so quizzically, seemingly unheeding, or uncaring, of the toil of her colleague. It is almost sinister in tone, giving rise to many questions, all of which are left unanswered. The background is also mysterious, unlike the evocative background to Hunt's *Light of the World* (1853), Millais seems deliberately to have made the looming darkness threatening, again an evocation of *Autumn Leaves*.

SIR JOHN EVERETT MILLAIS (1829–96)
The Boyhood of Raleigh, 1870
Courtesy of the Tate Gallery

*T*HE *Boyhood of Raleigh* was one of Millais'
purely commercial works. It was the type of
subject painting that Millais knew a
Victorian public would love without question:
sentimental, conventional and celebratory of a
national hero.

By 1870, Millais was at the top of the artistic
tree. He was society's most popular portrait painter,
each of his works was guaranteed a masterpiece by
public acclaim and he was commanding huge sums
per picture. The idealistic youth had become an
extremely wealthy – and contented – middle-class
patriarch, who had traded in his earlier artistic ideals
for guaranteed commercial and social success.

Whereas in his youth, Millais could take years
to complete a picture to his satisfaction, now he
could dash them off in a few months or even weeks
– reportedly he completed some pictures within a
matter of days. By the time of *The Boyhood of
Raleigh*, Millais was using different techniques to the
Pre-Raphaelite methods he and Hunt had employed
so enthusiastically. The wet-white background was
time-consuming to create and to work with and he
began working straight onto the canvas, using larger,
looser brushstrokes and less precise lines. Despite
this, the picture remains a testimony to Millais'
natural artistic genius. His ideals were sacrificed, but
his ability was undiminished.

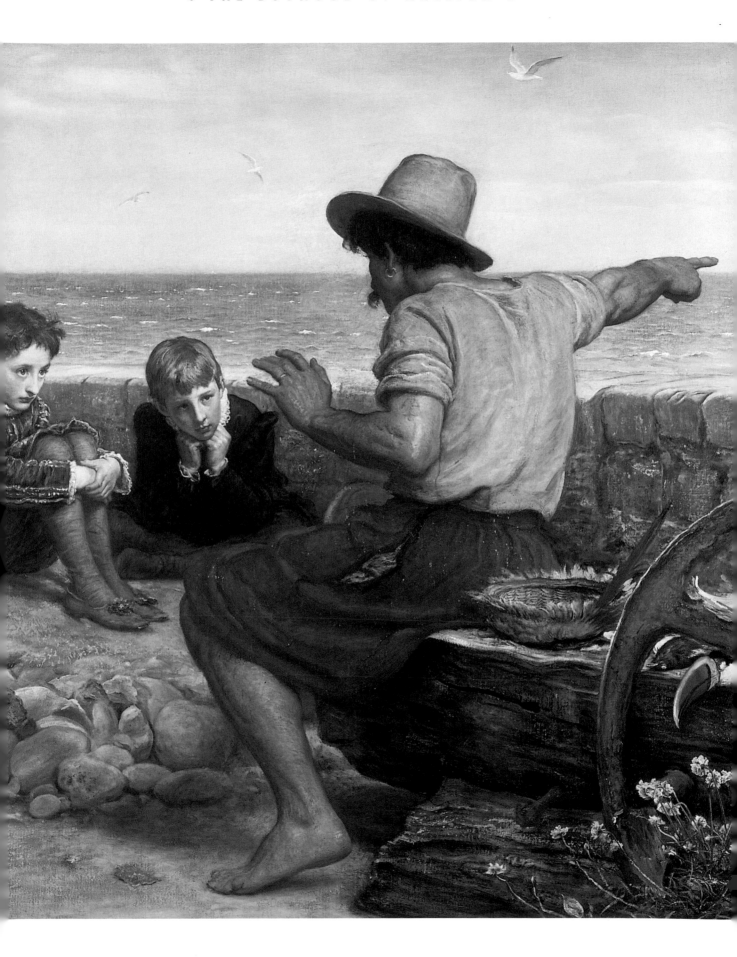

WILLIAM HOLMAN HUNT (1827–1910)
The Awakening Conscience, 1854
Courtesy of the Tate Gallery

ANNIE MILLER, one-time fiancée of Hunt, the lover of
Rossetti and Lord Ranelagh and later a respectably married
matron, posed for this picture. She also appears in other Pre-
Raphaelite paintings, most famously as Rossetti's *Helen of Troy*.

After his discovery of Annie's infidelities, Hunt repainted the
woman's face. In so doing he also removed the expression of guilt-
stricken horror for which the painting was most noticeable when first
exhibited. The expression seen here has far less impact than the
painting's contemporary reviews show.

Ford Madox Brown
Take Your Son, Sir, begun 1851
Courtesy of the Tate Gallery. (See p. 60)

Despite Hunt's obvious imagery – the
rings on each of the woman's fingers except that
reserved for a wedding ring, the evil-looking cat
devouring a helpless bird, the discarded glove,
the unravelling wool – many Victorian viewers
misinterpreted the painting, seeing it as a tiff
between siblings. When reviewers explained the
symbols to the public (contemporary critics also
noted the newness and cheapness of the furniture
denoting a furnished flat for concealing the
mistress of a married man), Hunt's fans were
truly shocked. Not only had an artist famed
for his religious conviction dared to portray a
mistress rather than a prostitute – prostitutes
were non-threatening to families, mistresses
were terrifying – he did so with compassion.
The leering expression on the man's face brands
him a dangerous seducer, whereas his mistress
appears in need of protection.

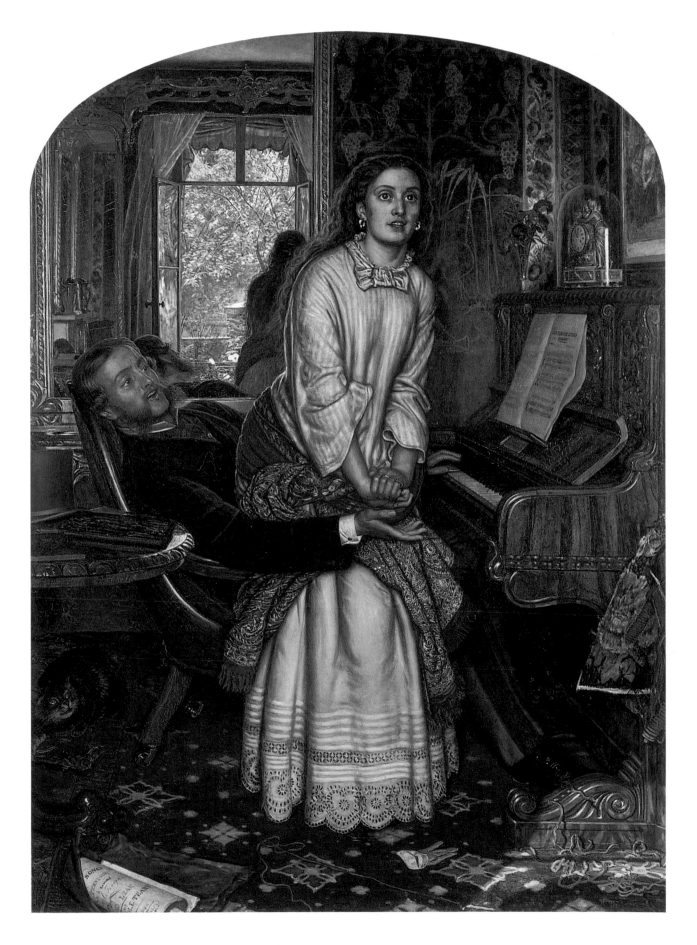

WILLIAM HOLMAN HUNT (1827–1910)
The Finding of the Saviour in the Temple, 1854–60
Courtesy of Birmingham Museums and Art Gallery

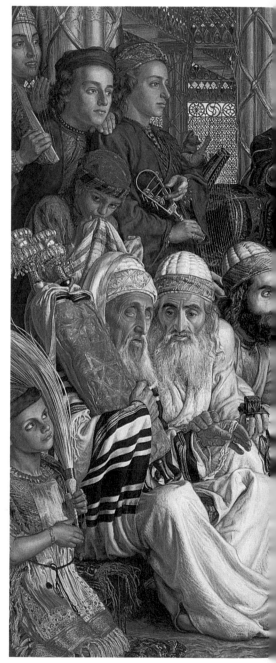

THIS picture took Hunt six years to complete. He began it during his first visit to the Holy Land in 1854 and continued it upon his return to England. It was exhibited in 1860. The composition of the painting was fraught with difficulties, mainly because of Hunt's need for Jewish models. Under Jewish law many of the people he encountered refused to sit for him – even if they had wanted to model for the picture, the local rabbi had banned them from doing so.

Eventually, Hunt managed to convince the rabbi to lift his ban and, by omitting to tell them that they were only providing the background for a Christian picture, he was able to paint in most of the characters. He painted the figures of Mary and Jesus when he returned to England. That they were added at a later date may well account for the fact that they appear almost in a separate dimension from the other figures, as though superimposed over the top of the Jewish elder standing behind them. However, this may also be deliberate, to emphasise their importance. Note that Hunt gives a halo-like glow only to Jesus, not to his mother – Hunt was strongly Christian, but not at all Catholic, in his beliefs – unlike the Nazarene-influenced religious paintings of Rossetti and Brown.

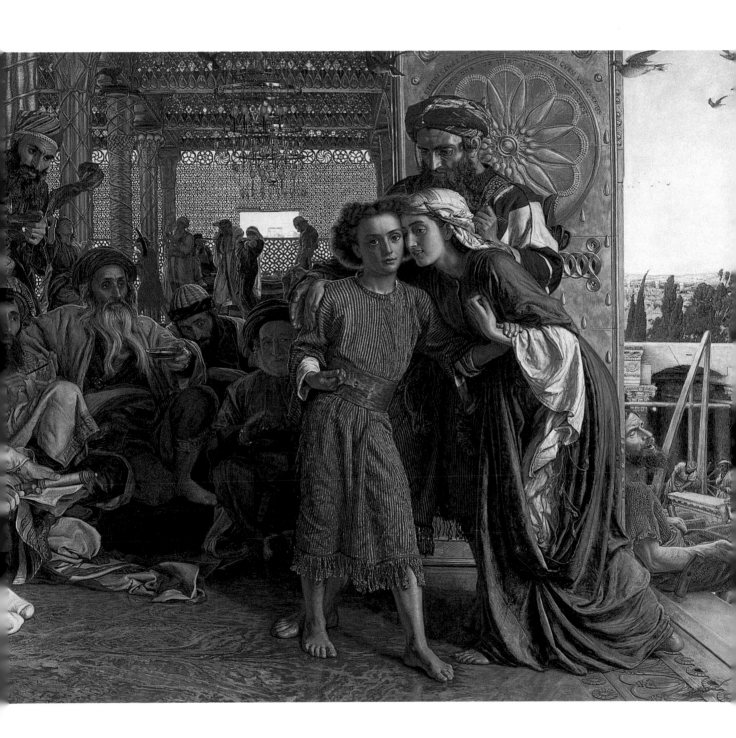

WILLIAM HOLMAN HUNT (1827–1910)
Sketch for: A Street Scene in Cairo: The Lantern-Maker's Courtship, 1861
Courtesy of Birmingham Museums and Art Gallery

HUNT was a voracious traveller who spent large chunks of his life living in countries where most Victorian travellers would never have dreamed of setting foot. The picture was begun in 1854, the year of Hunt's first visit to Egypt and an experience he described as 'the slaking of a long thirst'. He found the sights, sounds and smells of Cairo overwhelmingly exhilarating; his head was alive with colour and ideas. Unfortunately he ran into similar problems as those he experienced with *The Finding of the Saviour in the Temple* (1860) – by Muslim law no local was permitted to sit for him. In the end Hunt drew some rough sketches, then painted the lantern-maker's shop and the surrounding street in Cairo before finishing off the finer details back in England. A young girl who features in the final painting was from Giza, found by Hunt when he left Cairo to view the pyramids; his success in persuading her to model arose mainly from the fact that her home was so remote no one would be likely to find out.

The amorous lantern-maker is attempting to sneak a look at the face of his intended bride – an action strictly forbidden. She is preventing him from doing so by pushing his hand away. Both appear to be very young; although the boy appears excited and triumphant, the girl's eyes are haunting and apprehensive.

William Holman Hunt
The Finding of the Saviour in the Temple, 1860
Courtesy of the Birmingham Museums and Art Gallery. (See p. 90)

WILLIAM HOLMAN HUNT (1827–1910)
Isabella and the Pot of Basil 1866–68
Courtesy of Tyne and Wear Museums Service

*J*UST as Millais had done in his first Pre-Raphaelite Brotherhood picture in 1849, Hunt chose to illustrate Keats' poem, 'Isabella, or, the Pot of Basil'. His inspiration came from the second half of the poem after Isabella has concealed Lorenzo's head beneath a basil plant; the pot's skull handles are indicative of the skull buried within. Isabella is seen here caressing the pot passionately, her hair mingling with the soil in her effort to rejoin him.

In Keats' poem, Isabella pines away and eventually dies; Hunt was unable to portray a wan, thin Isabella because his chosen model, his wife Fanny, was eight months pregnant at the time. She held this pose for hours, in the heat of a Florentine September, despite the discomfort it must have caused her. Their son, Cyril, was born in

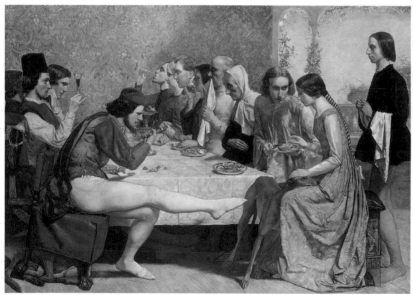

Sir John Everett Millais *Lorenzo and Isabella, 1849*
Courtesy of National Museum and Galleries, Merseyside. (See p. 20)

October 1866, but tragically Fanny was never to recover from the birth and she died on 20 December. Hunt's labours on *Isabella and the Pot of Basil* then became a mourning ritual, as he desperately recreated a life-size version of the wife he had lost after a marriage of just 11.5 months. The picture measures over six feet tall: 187 x 116 cm (73.5 x 45.5 in).

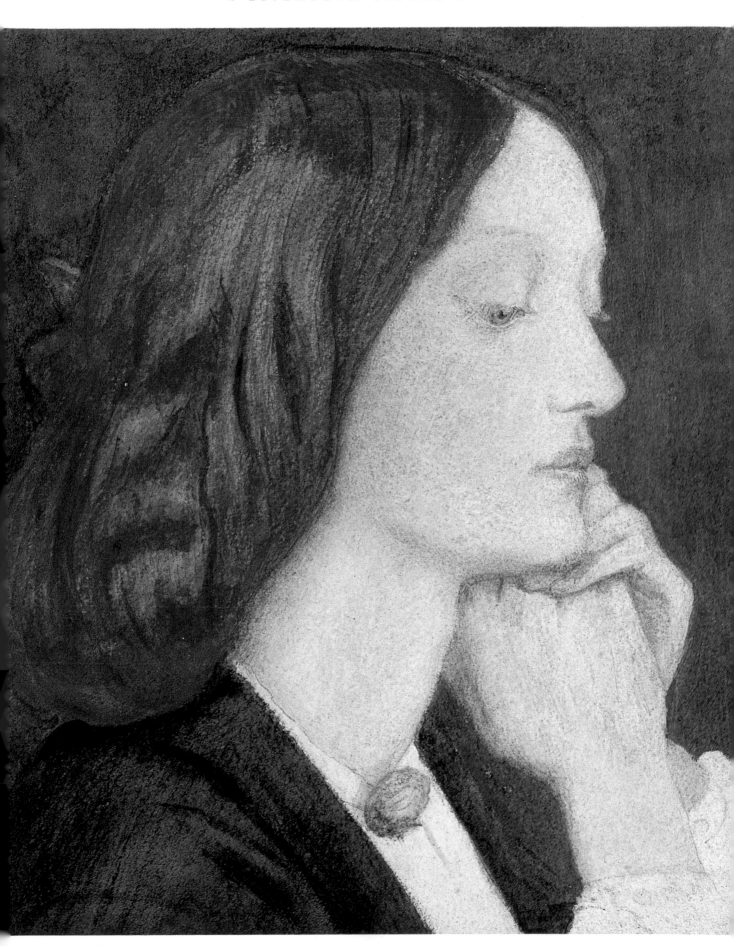

DANTE GABRIEL ROSSETTI (1828–82)
Paolo and Francesca da Rimini, 1855
Courtesy of the Tate Gallery

THE subject for this painting is taken from *Purgatorio* by Dante Alighieri, namesake of Rossetti. Rossetti's real name was Charles Gabriel Dante Rossetti, but his admiration for the poet led him to change it to Dante Gabriel Rossetti, and he proceeded to sign all his works so. This small watercolour triptych – measuring just 24.8 x 44.5 cm (9.75 x 17.5 in) – was never painted in oil. Although Rossetti had been sketching the subject for many years, the watercolour took him just one week to complete. The buyer was John Ruskin.

Francesca was the sister-in-law of Paolo, and both were married, but they fell in love. The story was popular with Victorian painters, and followers of the Pre-Raphaelite ideology in particular, and with other writers. The first panel shows the adulterous kiss that condemns the lovers. Staying faithful to Dante's poem, Rossetti shows them reading about the Arthurian knight Sir Lancelot (his figure can be seen on the book's open page). The central panel depicts two of Rossetti's literary heroes: the Roman poet Virgil and the much-revered Dante Alighieri himself. In the final panel of the triptych the lovers are being blown about violently with the wind.

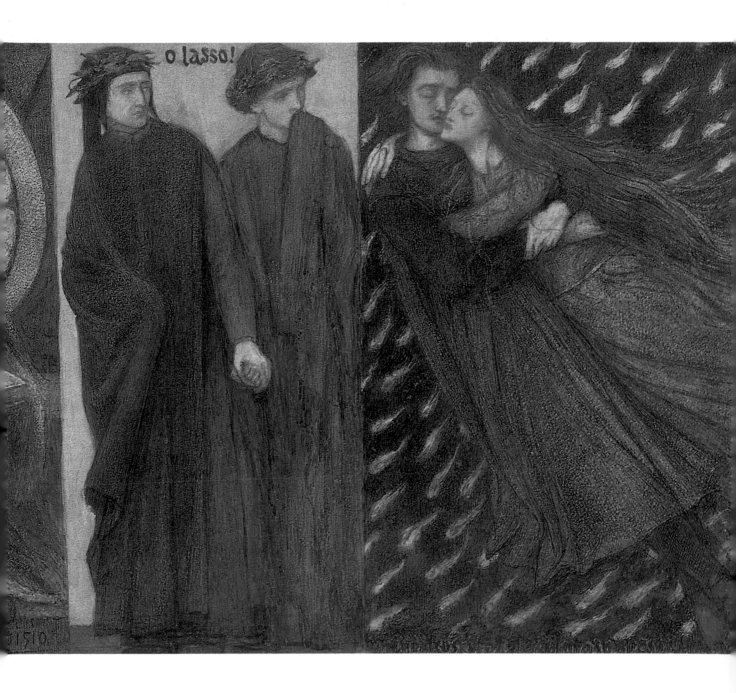

DANTE GABRIEL ROSSETTI (1828–82)
Tennyson Reading 'Maud', 1855
Courtesy of Birmingham Museums and Art Gallery

THIS comparatively early Rossetti picture is an impromptu sketch, made during a party at the London house of the poets Robert Browning and Elizabeth Barrett Browning. The party took place on 27 September 1855, and William and Dante Rossetti were among the guests, as was the current Poet Laureate, Alfred, Lord Tennyson.

When the Pre-Raphaelite Brotherhood drew up their list of 'immortals', Tennyson was included on it. The Brownings' party must therefore have induced a great deal of anticipatory excitement in the Rossetti brothers – sadly Tennyson in the flesh seems to have fallen short of Dante's high expectations. Nevertheless, the artist could not resist the opportunity of drawing the esteemed poet.

Rossetti created this sketch mainly in brown ink, overlaid with black to add definition, such as the knuckles of the hand, and to sharpen the facial features. Reportedly, Tennyson was so absorbed in his reading that he was in total ignorance of what was happening. The picture is hugely valuable for its spontaneity as well as for providing such a vivid account of the historic social gathering. *Maud* (a collection of poems) was published in 1855, so it seems likely that this was the poet's first public reading of his work. The Brownings were also unaware of Rossetti's drawing until he gave them a copy of his sketch a few weeks later.

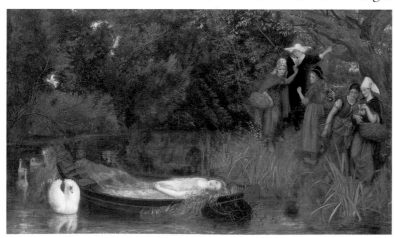

Arthur Hughes
Lady of Shalott, 1858
Courtesy of Christie's Images. (See p. 166)

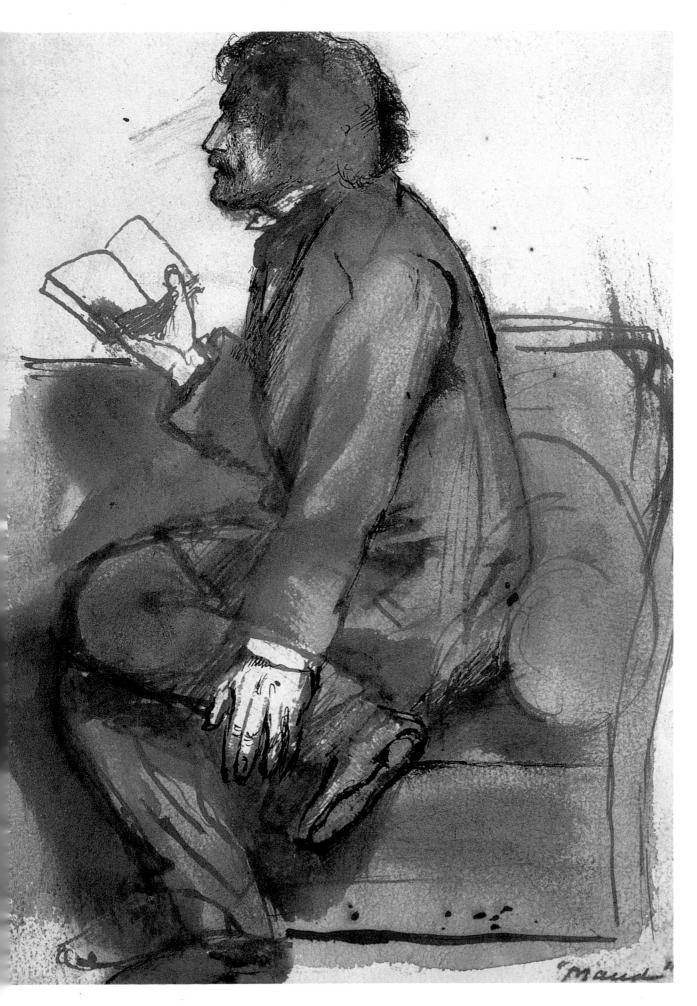

"Maud"

DANTE GABRIEL ROSSETTI (1828–82)
St Catherine, 1857
Courtesy of the Tate Gallery

THIS melancholic watercolour shows St Catherine carrying the wheel on which she was to be martyred. Rossetti used Lizzie Siddal as his model; no doubt, at this time of her life – in almost constant physical and mental pain, and anguished at the obstacles Rossetti continually raised over the question of their marriage – Lizzie's face served the purpose perfectly. The painting bears strong resemblance to William Morris' *Guinevere*, painted in the same year, using Jane Burden (later Morris) as the model. The faces of both Lizzie and Jane wear almost identical expressions and even the positions of the arms are almost interchangeable. This is not surprising when considering that Morris and Rossetti spent the summer of 1857 together, painting the Oxford Union murals.

Rossetti provokes the viewer's sympathy by the callousness of the background figures: the draughtsmen so eagerly devising new methods of execution and the attendant absentmindedly carrying Catherine's gown, while also devouring a cake. It seems strange, however, that Catherine's wheel is so small, considering the method of her execution. It seems out of proportion because the wheel could be the focal point of the painting.

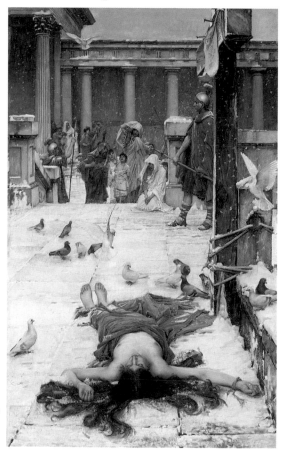

John William Waterhouse
St Eulalia, 1885
Courtesy of the Tate Gallery. (See p. 232)

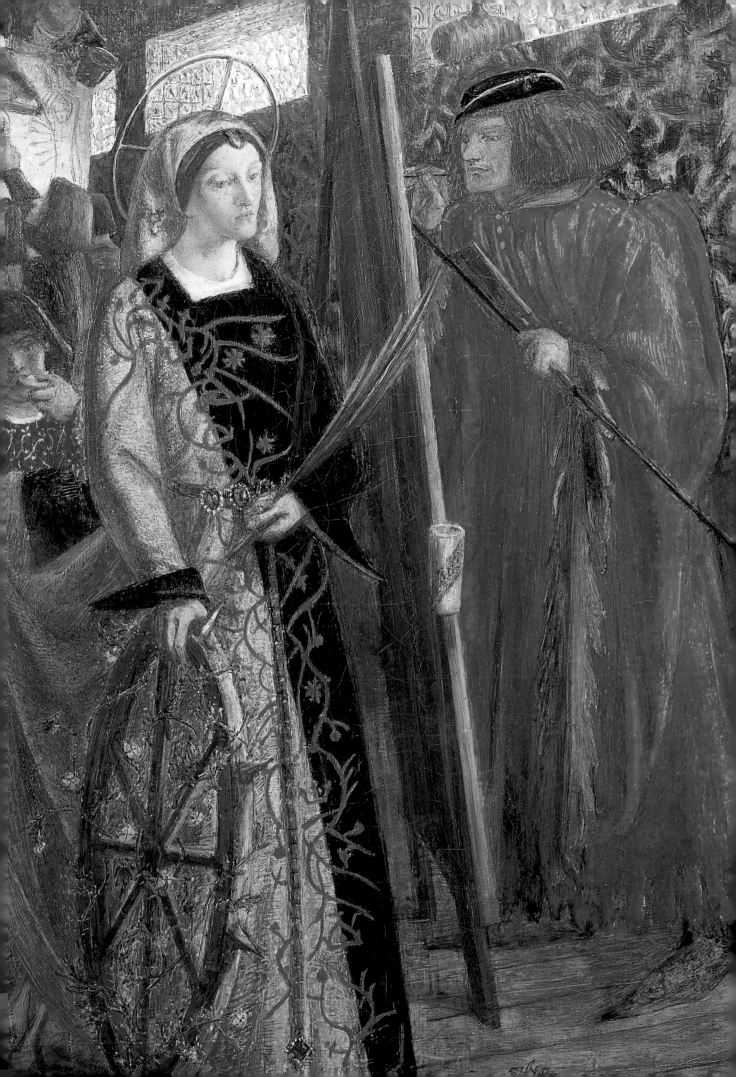

DANTE GABRIEL ROSSETTI (1828–82)
Dantis Amor, 1860
Courtesy of the Tate Gallery

THE colours employed in *Dantis Amor*, in particular the gold, and the use of such vivid and artistically unusual background patterns, makes this oil painting appear extremely modern in comparison to other Rossetti paintings. However, despite being one of Rossetti's middle-period pictures, *Dantis Amor* also has a flatness about it, when compared with *Beloved* (1865–66), that belies his experience.

The winged figure representing Love is a world away from the usual depictions of Cupid or Eros. The arrow looks distinctly deadly and the expression on Love's face is unfeasibly sad. Interestingly, this painting was finished in the same year in which Rossetti and Lizzie were finally married, also a year in which Lizzie's health was getting worse – on the originally appointed day, she was so ill that they had to postpone the wedding because she was unable to walk to the church.

Dantis Amor seems indicative of the state of Rossetti's ideas about love at this time in his life. He and Lizzie made each other indescribably happy as well as sad. Their marriage was doomed from the start – after so many years' accumulation of disappointment and bitterness – and ended tragically with the suicide of Lizzie in 1862.

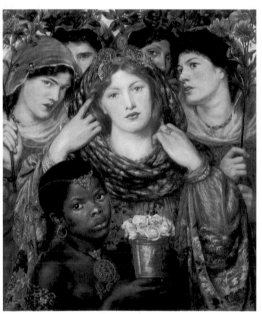

Dante Gabriel Rossetti (1828–82)
The Beloved, 1865–66
Courtesy of the Tate Gallery. (See p. 110)

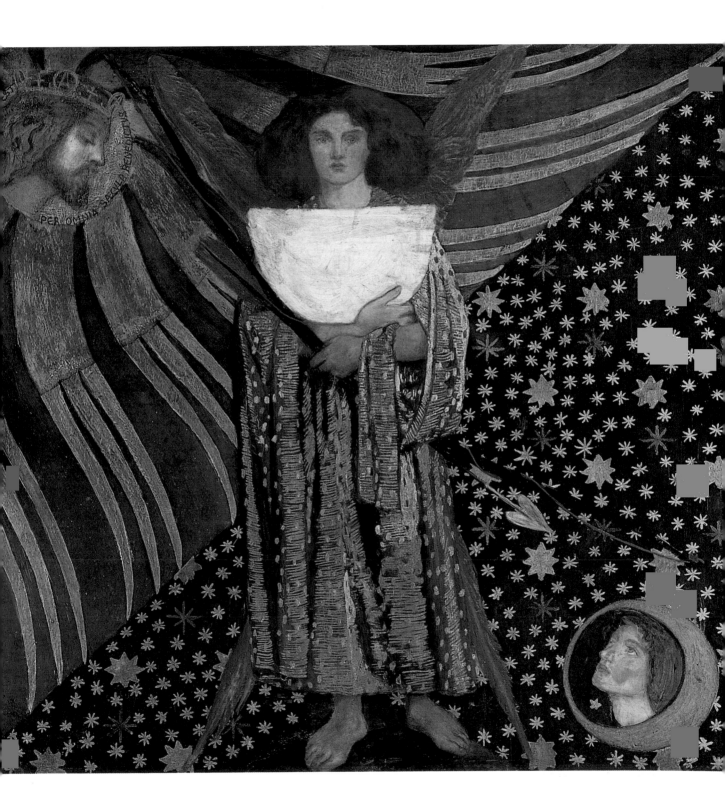

DANTE GABRIEL ROSSETTI (1828–82)
Lucrezia Borgia, c. 1861
Courtesy of the Tate Gallery

ROSSETTI spent the years 1851–59 experimenting with sketches on the subject of Lucrezia Borgia; he was fascinated by the story of the Borgias. In this picture, he was deeply influenced by the works of Algernon Swinburne. It was during the latter part of the 1850s that Rossetti and his circle began to look to seventeenth-century art (Venetian in particular) for inspiration.

Sir Edward Coley Burne-Jones
Sidonia von Bork, 1860
Courtesy of the Tate Gallery. (See p. 134)

Here, Lucrezia Borgia is seen in the act of washing her hands – a symbolic gesture to indicate that she had just poisoned her husband. The model is typical of Rossetti's women. As he so often did, Rossetti has given her a thick neck and masculine-set jaw. Interestingly, her forearms are also very masculine, with prominent muscle definition. This may be due partly to Rossetti's predeliction towards masculinising women, but it is also indicative of her 'masculine' act of murder.

Lucrezia Borgia is not dissimilar to Burne-Jones's watercolour of 1860, *Sidonia von Bork*. Both portray strong women in similar physical attitudes and their clothing is also extremely similar. The two are also reminiscent of earlier Venetian art. Burne-Jones and Rossetti worked closely together at this time and, as Burne-Jones often imitated Rossetti, it is likely that Rossetti began his picture first.

3063. ❋ Lucretia Borgia. By D. G. ROSSETTI. ❋ (1828–1882)

DANTE GABRIEL ROSSETTI (1828–82)
Study for David, c. 1861
Courtesy of Birmingham Museums and Art Gallery

THIS pencil drawing was one of many studies made for a triptych entitled *The Seed of David* (1858–64). Rossetti was commissioned to create this religious piece for Llandaff Cathedral, in Wales.

The triptych has a central panel depicting the adoration of the baby Jesus; William Morris' wife, Jane, was painted as the Virgin Mary and the model for Jesus was Arthur Hughes' baby daughter, Agnes. Interestingly, Rossetti's composition owes much to Hughes' 1858 painting *The Nativity*, in particular the cluster of angels looking down upon the Madonna and child from the stable roof.

The left-side panel depicts a solitary shepherd – symbolic of all humble men – on his way to worship the baby. The right-side panel depicts King David – symbolic of the most exalted of mortal men. It was for the latter that Rossetti sketched this portrait, using his friend William Morris for the model. At this time, Lizzie Siddal was still alive and the two couples often spent time together. It was not until the late 1860s that Rossetti and Jane Morris began their affair. In 1861, Morris still idolised Rossetti as his mentor.

Dante Gabriel Rossetti (1828–82)
The Beloved, 1865–66
Courtesy of the Tate Gallery. (See p. 110)

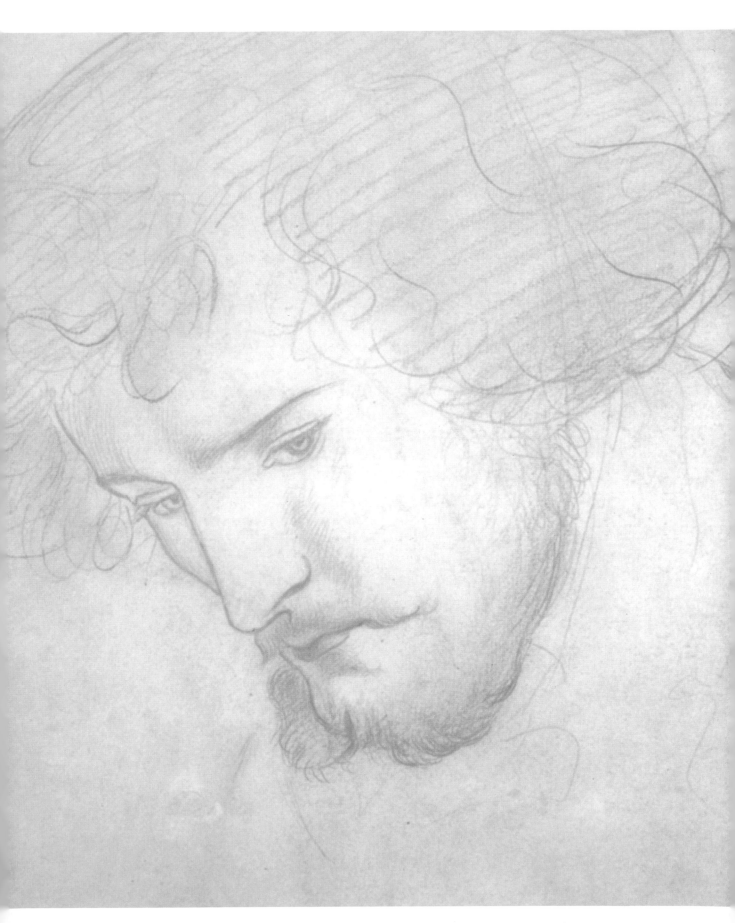

Dante Gabriel Rossetti (1828–82)
The Beloved, 1865–66
Courtesy of the Tate Gallery

*T*HE BELOVED, also known as *The Bride*, illustrates the Bible's *Song of Solomon*. Two passages from this are inscribed on the painting's gilded frame: 'my beloved is mine and I am his' (2:16) and 'let him kiss me with the kisses of his mouth: for thy love is better than wine' (1:2).

The bride, caught in the action of moving back her veil, is attended by four virginal bridesmaids and an African page. All contrast strikingly with the red hair and pale skin of the bride; not just the African skin and features, but also the varying shades of brunette hair and dark caucasian skin tones of all four bridesmaids. It has been suggested that this colour contrast, carefully painted as a frame to the bride's features, was influenced by a controversial painting of Edouard Manet's, entitled *Olympia* (first exhibited in 1865). Rossetti made a visit to Manet while working on *The Beloved*, and the painting also owes much to the works of Titian.

Interestingly, Rossetti arranged the bride in a head-dress which is distinctly recognisable as Peruvian, and in a Japanese gown. Again, this abundance of exotic fabric frames the face of the bride, dominant in the centre of the canvas, with its western-European features. Rossetti ostensibly finished this oil painting in 1866, but continued to make changes to it throughout his life.

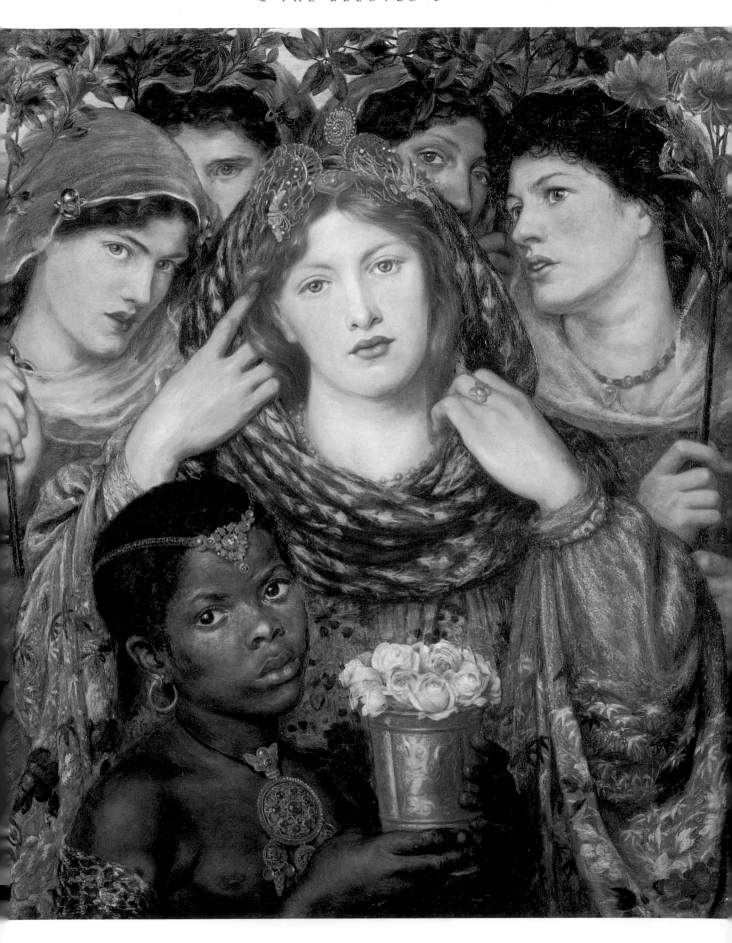

DANTE GABRIEL ROSSETTI (1828–82)
Venus Verticordia, 1867
Courtesy of Christie's Images

THIS preliminary drawing, for the oil painting *Venus Verticordia* (1868), was created with red, black, blue and white chalk on paper. It is the chalk that gives the painting its delicate, almost translucent quality, perfect for recreating the flesh tones of the model and the result is far less oppressive than the harsher oil version. This chalk portrait was painted from two women: the body was posed by someone Rossetti approached in the street; the face was drawn from Alexa Wilding, one of Rossetti's favourite models at this time. She also posed for *La Ghirlandata* (1873) and *The Blessed Damozel* (1871–79).

It was extremely rare for Rossetti to draw nudes, but fitting that he chose to use nudity to portray the goddess of love. She holds an apple – symbolic of female sexuality – and an arrow, suggestive of Cupid's darts of love. The arrow points at her heart, also representing love, and this also allows Rossetti to brush the arrow tip gently against her breast; an arrow tip that is ostensibly of steel, but gently corrugated as if it were a feather. This allowed Rossetti to give himself, and his viewers, an illicit thrill.

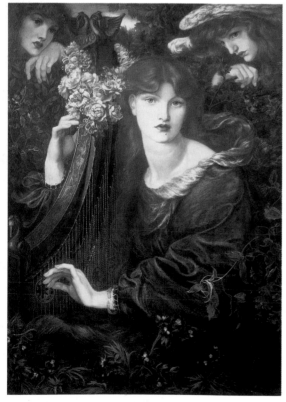

Dante Gabriel Rossetti
La Ghirlandata, 1873
Courtesy of Bridgeman-Giraudon. (See p. 120)

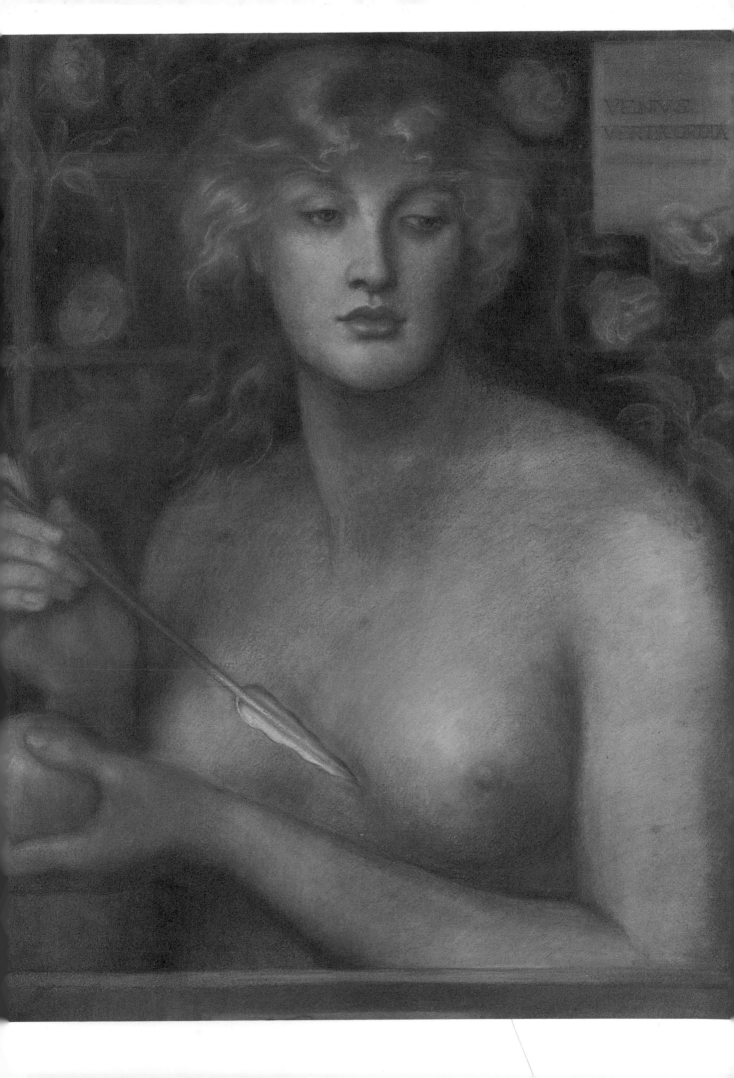

DANTE GABRIEL ROSSETTI (1828–82)
La Pia de Tolomei, c. 1868
Courtesy of Pix

*T*HIS was painted at the start of Rossetti's affair with Jane Morris, who modelled for the picture. As he was to do with *Beata Beatrix* (1870), he chose a tale from Dante (from *Purgatorio*) to illustrate his love for his model. The story tells of a woman whose husband imprisoned and later poisoned her: Rossetti wanted the world to believe the fantasy with which he was deluding himself; that William Morris kept Jane against her will. He continued this theme, as shown in *Proserpine* (1877).

Rossetti not only drew Jane exhaustively, he also choreographed photographic sessions of her and used the photographs as preliminary sketches for drawings. Amongst other representations of her, Rossetti depicts Jane as Proserpine, Queen Guinevere and Desdemona – all of whom were at the mercy of men.

Jane appears disproportionately large in most of Rossetti's pictures. The background is immaterial as long as the viewer focuses on the beauty of her face. In *La Pia de Tolomei* her neck appears almost dislocated, it is so strangely elongated and the whiteness of her skin shines out, defying the viewer to pay attention to any other aspect of the painting. Strangely, Jane's hair colour is misrepresented here. Her natural colour was dark brown, yet Rossetti paints it with an auburn tinge – closer to Lizzie Siddal's hair colour than Jane's.

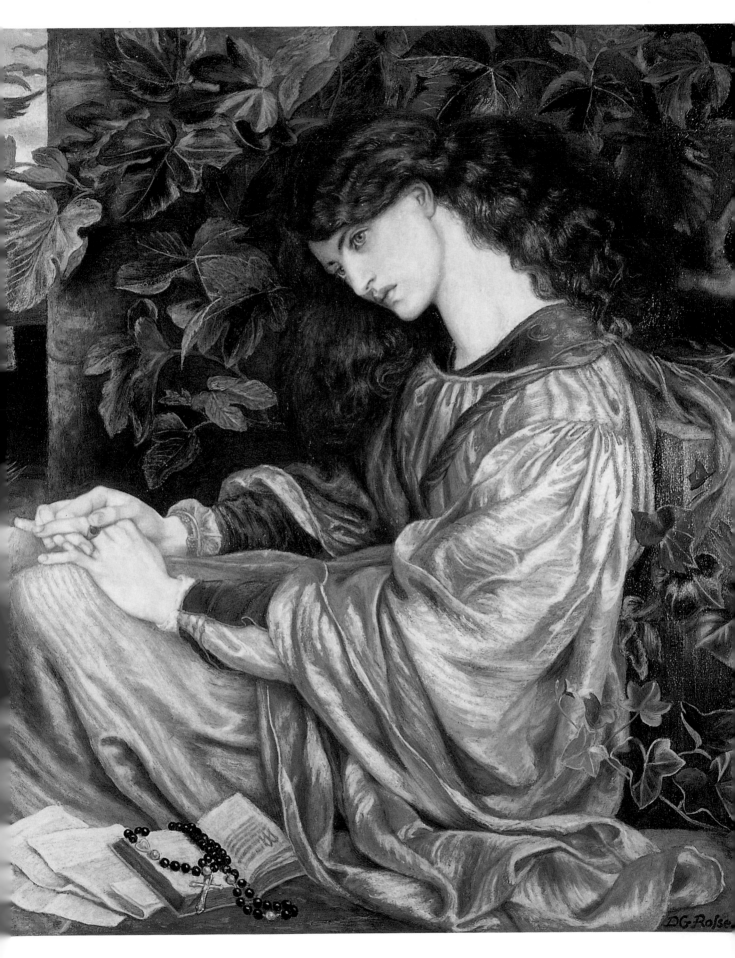

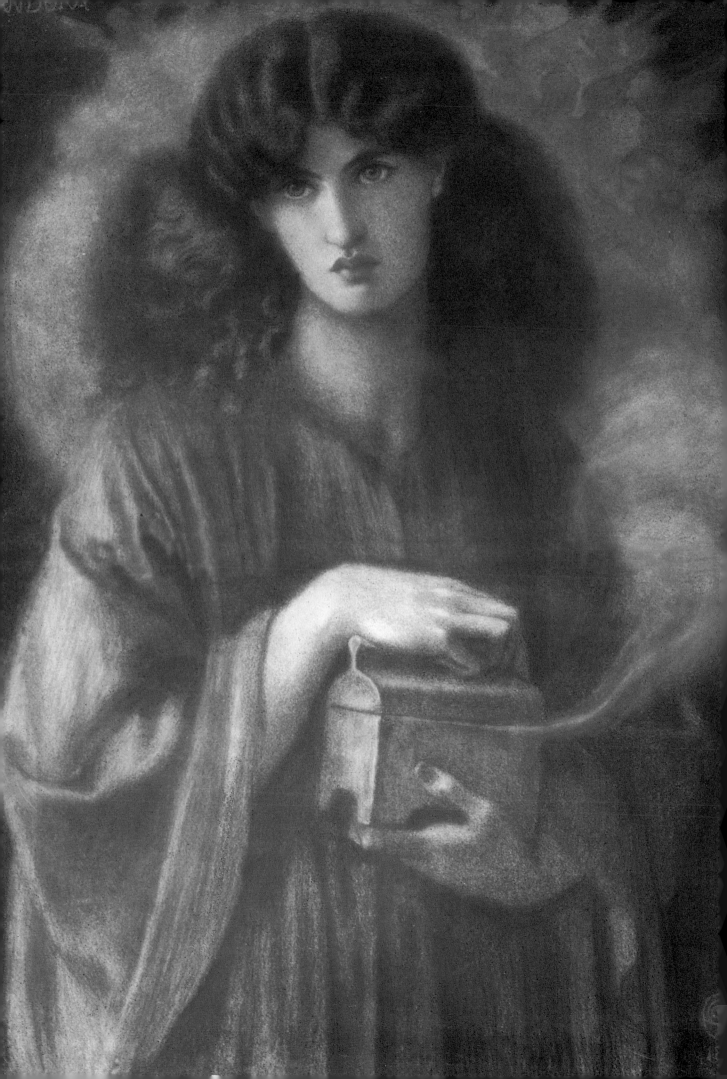

DANTE GABRIEL ROSSETTI (1828–82)
Pandora, 1869

Farringdon Collection. Courtesy of Bridgeman-Giraudon

ACCORDING to Greek legend, Pandora was entrusted by the gods to take care of a box. She was not allowed to know what was inside, and was warned never to open it. Eventually Pandora's curiosity was too strong and she opened the lid; contained within the box were all the evils of the world, which flew out before she had time to slam down the lid. Some legends also state that Pandora managed to trap one element when she closed the box: that was Hope, which was unable to escape because it was at the bottom and was the smallest of all.

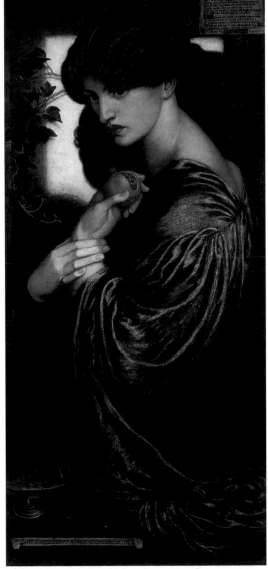

The affair between Rossetti and Jane Morris (who modelled for Pandora) was now at its height. Jane was renowned for her beauty and Rossetti uses it to full advantage in this painting, showing off the slender lines of her hands as well as the beauty of her face. His use of browns and muted oranges is striking, wrapping Pandora in an aura of mystery, rather than portraying the miseries and despair that were thought to emanate from the box. Rossetti showed Jane as an enchantress, ill-treated by the gods, rather than the bringer of evil into the world.

Dante Gabriel Rossetti
Proserpine, 1877
Courtesy of the Tate Gallery. (See p. 122)

DANTE GABRIEL ROSSETTI (1828–82)
Beata Beatrix, 1870

Courtesy of the Tate Gallery

B ASED on the object of the poet Dante's unrequited affections, *Beata Beatrix* was painted from drawings made of Lizzie Siddal. Rossetti had made many drawings of Lizzie in this pose during her lifetime, but after her death the picture became symbolic of his impossible love for her. Partly from guilt of his infidelities, partly from idealised love, *Beata Beatrix* became Rossetti's memorial to Lizzie. The oil painting was commissioned by William Graham, a loyal patron of Rossetti's, who had seen earlier drawings. He paid 900 guineas for it.

Interestingly the finished painting bears little facial resemblance to the drawings of Lizzie; several of her friends also remarked upon this. The face seems harder than in his preliminary drawings and the neck appears strangely out of proportion. Strongly Italianate in style, *Beata Beatrix* has become one of Rossetti's most instantly recognisable works; it has also has ensured that Elizabeth Siddal is forever associated with the earlier Dante's Beatrice.

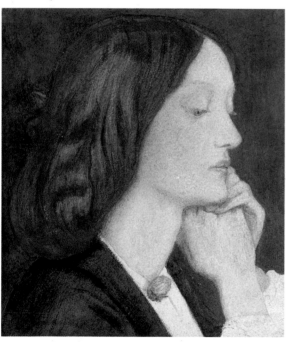

Dante Gabriel Rossetti *Elizabeth Siddal, 1854–55*
Courtesy of Christie's Images. (See p. 96)

There were several replicas made of *Beata Beatrix* – a watercolour, a chalk drawing and a second oil painting (in which the bird flying to Beatrice is a white dove bearing red poppies). Although begun in 1877, the latter remained unfinished at the time of Rossetti's death. Ford Madox Brown, a lifelong friend of the mercurial Rossetti, completed the painting.

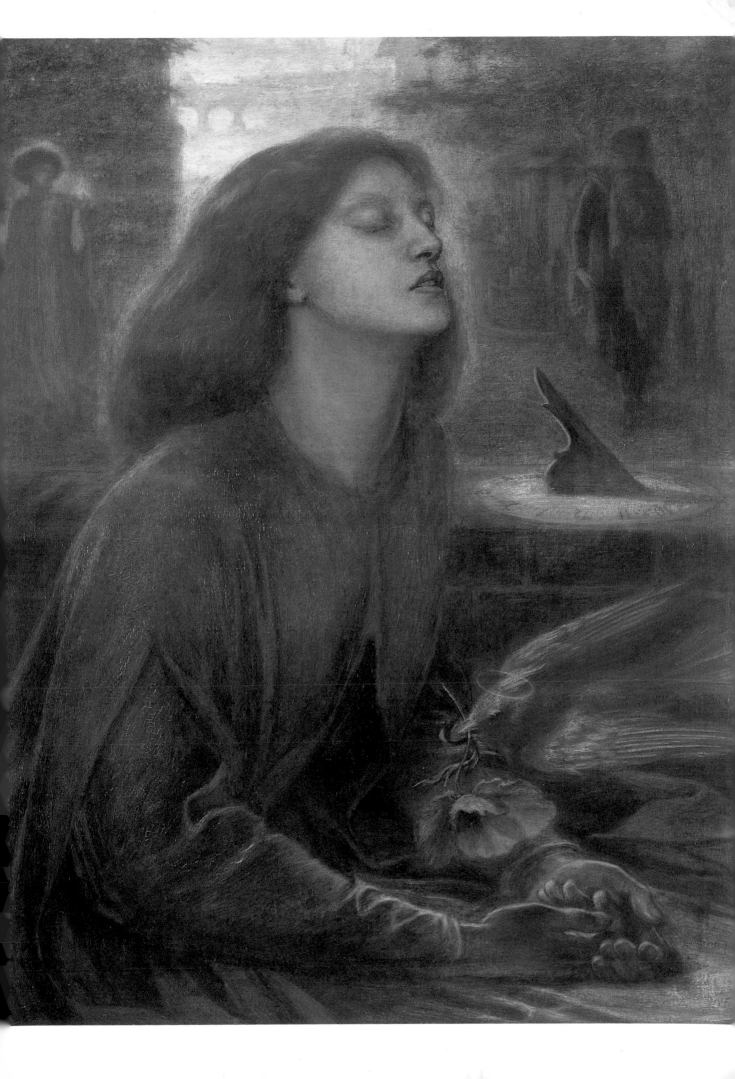

DANTE GABRIEL ROSSETTI (1828–82)
La Ghirlandata, 1873

Courtesy of Giraudon

*L*A GHIRLANDATA was painted during a sojourn at Kelmscott Manor, one of the homes of William and Jane Morris, and the place where Rossetti and Jane often went to be alone (an arrangement of which Morris was aware). However Jane did not model for this painting, instead Rossetti used Alexa Wilding, who also modelled for *Venus Verticordia* (1867–68) and *The Blessed Damozel* (1871–79), with the angels' heads modelled by May Morris, daughter of William and Jane.

Rossetti chose to inundate this canvas with various shades of green, creating the impression of a lush, mysterious bower. This provides a complementary backdrop to the glowing red hair of Alexa and May, and the garland of pale-coloured roses and honeysuckle, from which the painting takes its name. In front of the musician is a surprising burst of flowers, sumptuously gemstone coloured: deep sapphire blue and vivid ruby red. These serve not only to frame the harpist, as the angel heads do from above, but also to help differentiate the rich green of her gown from the surrounding foliage.

During the 1870s, Rossetti apparently became fascinated with musical instruments, incorporating them into several of his paintings; another example is *The Bower Meadow* (1871–72). In both paintings the musician wears a calm, slightly distant expression, as though mentally transported by the music.

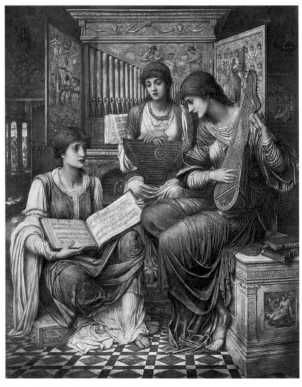

John Melhuish Strudwick
The Gentle Music of a Bygone Day, 1890
Courtesy of Bridgeman-Giraudon. (See p. 246)

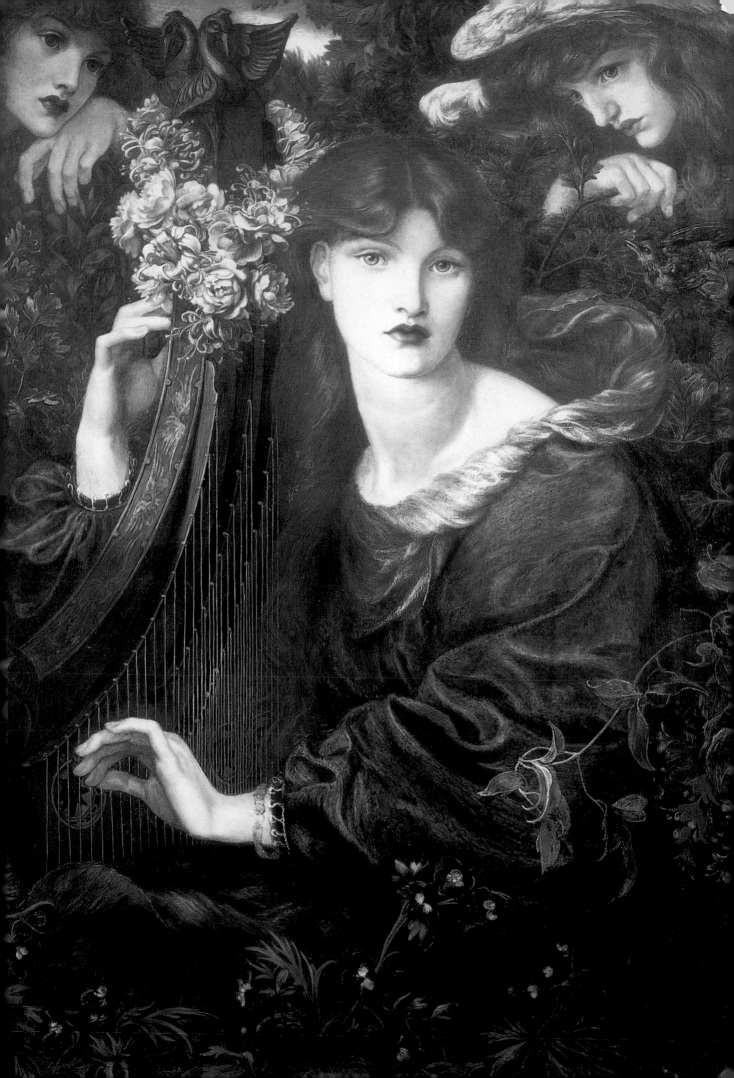

DANTE GABRIEL ROSSETTI (1828–82)
Proserpine, 1877
Courtesy of the Tate Gallery

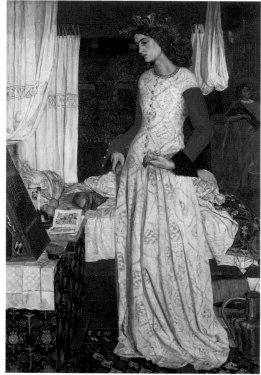

William Morris *Guinevere, 1857*
Courtesy of Topham. (See p. 128)

ROSSETTI took seven years and eight canvases before he was happy with this picture. He painted it at a time when his mental health was extremely precarious and when his love for Jane Morris (the model for Proserpine) was at its most obsessive.

Proserpine, daughter of the goddess Ceres, was carried off to the Underworld (Hades) by Pluto, who married her despite her love for Adonis. When Ceres begged Jupiter to return her daughter to Earth, he agreed, on condition that Proserpine had not eaten any fruits in Hades. As Proserpine had eaten six pomegranate seeds, it was decreed that she should remain in Hades for six months of the year and be allowed on Earth for the other six.

The symbolism in the painting is poignantly indicative of Proserpine's plight, and also of that of Jane herself, torn between her husband (and the father of her two adored daughters) and her lover. The fateful pomegranate instantly draws the viewer's eye, the colour of the flesh matching perfectly Proserpine's provocatively full lips. The ivy behind her suggests the passing of time; the shadow on the wall is her time in Hades, the patch of sunlight, her glimpse of Earth. Her dress, spilling like water, suggests the turning of the tides, also indicative of time, and the incense burner traditionally denotes the subject as a god.

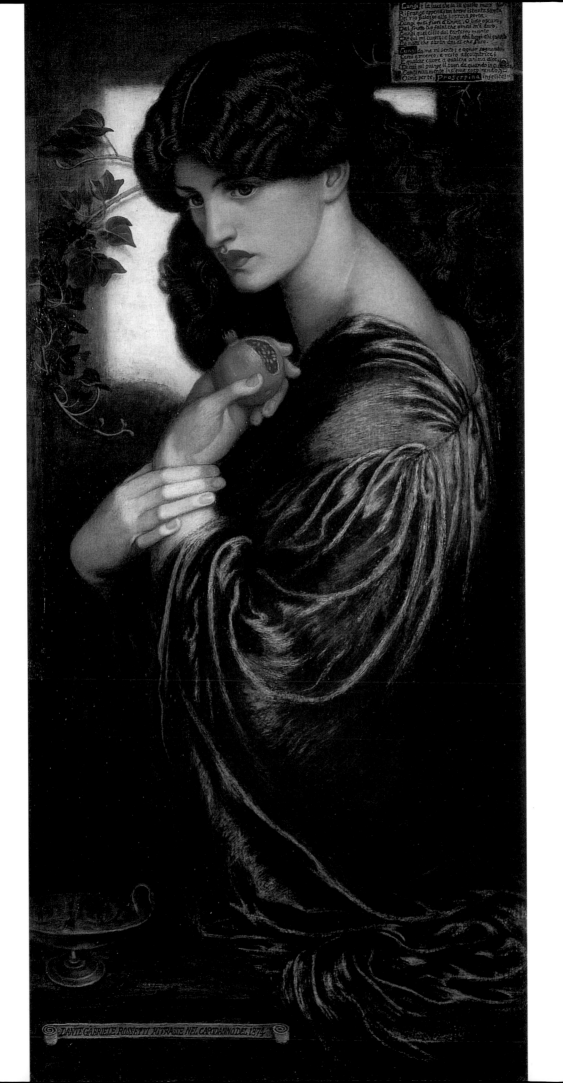

FREDERICK GEORGE STEPHENS
(1828–1907)
Mother and Child, c. 1854–57
Courtesy of the Tate Gallery

*O*STENSIBLY a domestic scene, the symbols underlying *Mother and Child* lead the viewer to realise that this is actually a commentary on the Crimean War (fought by British soldiers between 1854 and 1856). The child's toys symbolise Britain (the lion) and Russia (the soldier). Stephens patriotically portrays the lion as far superior in stature; however, his use of a child's toys to indicate the war emphasises his feelings of anger at the conflict and at the way the soldiers were being used as pawns. This sentiment is in sympathy with those expressd by Tennyson in his poem 'The Charge of the Light Brigade', published in 1854.

Ford Madox Brown
The Pretty Baa-Lambs, 1852 (See p. 65)

The woman's agonised facial expression and the letter held in her right hand suggest her husband has been killed or wounded in the Crimea. The child's futile attempts to offer consolation for something it can't understand emphasises the helplessness of the women who were left at home while their men disappeared to fight a war far away. Her powerlessness is echoed in Millais' painting, *The Black Brunswicker* (1860) in which a young woman desperately tries to prevent her lover leaving for certain death in the Battle of Waterloo.

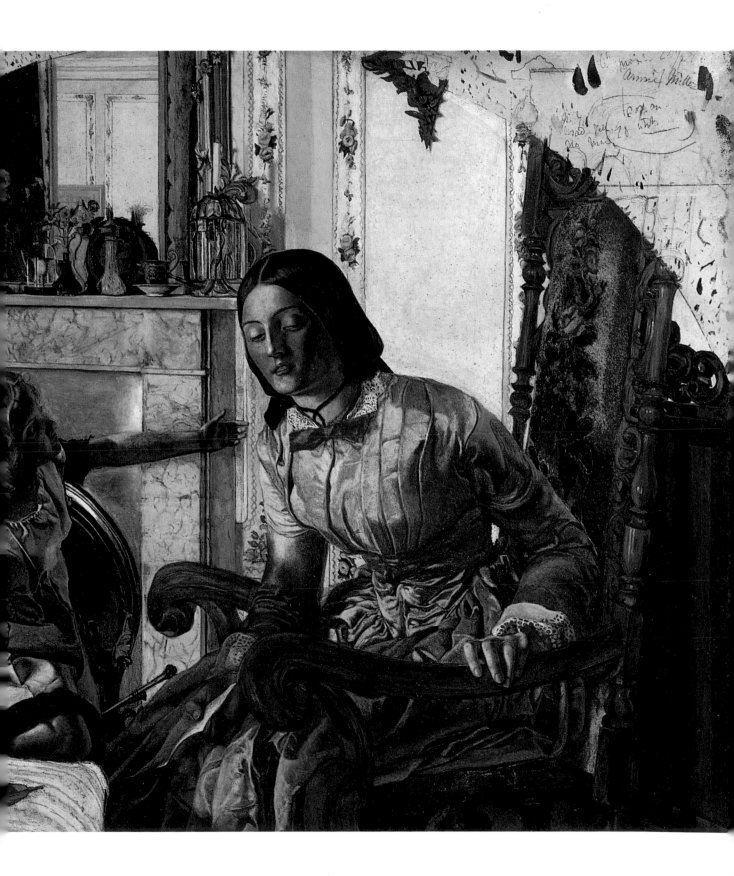

THOMAS WOOLNER (1825–92)
Robert Browning, 1856

Courtesy of Birmingham Museums and Art Gallery

*T*HOMAS WOOLNER was the only sculptor who joined the Pre-Raphaelite Brotherhood, becoming a member through his friendship with Dante Rossetti. As well as sculpting, Woolner wrote poetry for *The Germ* and published a volume of poems in 1863.

Woolner began his career producing statues such as the black plaster *Puck* (1845–47), from Shakespeare's *A Midsummer Night's Dream*. In 1849–50 he created a bronze medallion portrait of Alfred, Lord Tennyson – both were on the Pre-Raphaelite's list of 'immortals'.

Dante Rossetti *Tennyson Reading 'Maud', 1855*
Courtesy of Birmingham Museums and Art Gallery. (See p. 100)

In 1852, Woolner and his wife emigrated to Australia but, after finding little success there, returned to England just two years later; by this time the PRB was well and truly disbanded. From the time he returned, the sculptor worked as a conventional portraitist, producing pieces such as this plaster medallion portrait of the poet Robert Browning, which measures 25.4 cm (10 in) in diameter. The medallion was sculpted just a year after publication of Browning's well-received collection of poems, *Men and Women*.

In 1872, Browning published a poem entitled 'Fifine at the Fair'; he sent a copy to Dante Rossetti as a present. It arrived when Rossetti was ill – paranoia and depression compounded by addiction to whisky and chloral. In his precarious mental state, Rossetti decided that Browning was deriding him through the words of his latest work. It was the end of their friendship.

WILLIAM MORRIS (1843–96)
Guinevere, 1857
Courtesy of Topham

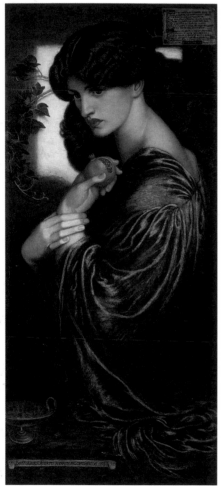

Dante Gabriel Rossetti
Proserpine, 1877
Courtesy of the Tate Gallery. (See p. 122)

FOR MANY years this painting was titled *La Belle Iseult*; it is only recently that it has been renamed *Guinevere*. In either circumstance, the picture is an illustration of Thomas Malory's *Morte d'Arthur*, a work that was to prove vitally important as inspiration for Morris' later projects. It is now believed to be Guinevere in her bedchamber, which is deliberately disordered to emphasise her disordered mind and also suggestive of her sexual relationship with Lancelot. The anguish portrayed on Guinevere's face also suggests infidelity to her husband, King Arthur.

The model was Jane Burden, a 17-year-old whom Dante Gabriel Rossetti had discovered at Oxford. He asked her and her sister to come and pose for the Oxford Union murals on which a group, including William Morris, was working under Rossetti's instruction. Rossetti was obviously deeply attracted to Jane, but he was engaged to Elizabeth Siddal at the time. Shortly after this picture was painted, William Morris married Jane, although Rossetti was later to become her lover.

Morris was disheartened by the end result, in particular the unnatural stiffness of Guinevere. According to legend, Morris wrote 'I cannot paint you, but I love you' on the back of the painting. A succinct way of letting Jane know how he felt – while posing she would have been in the perfect position to see the back of the canvas.

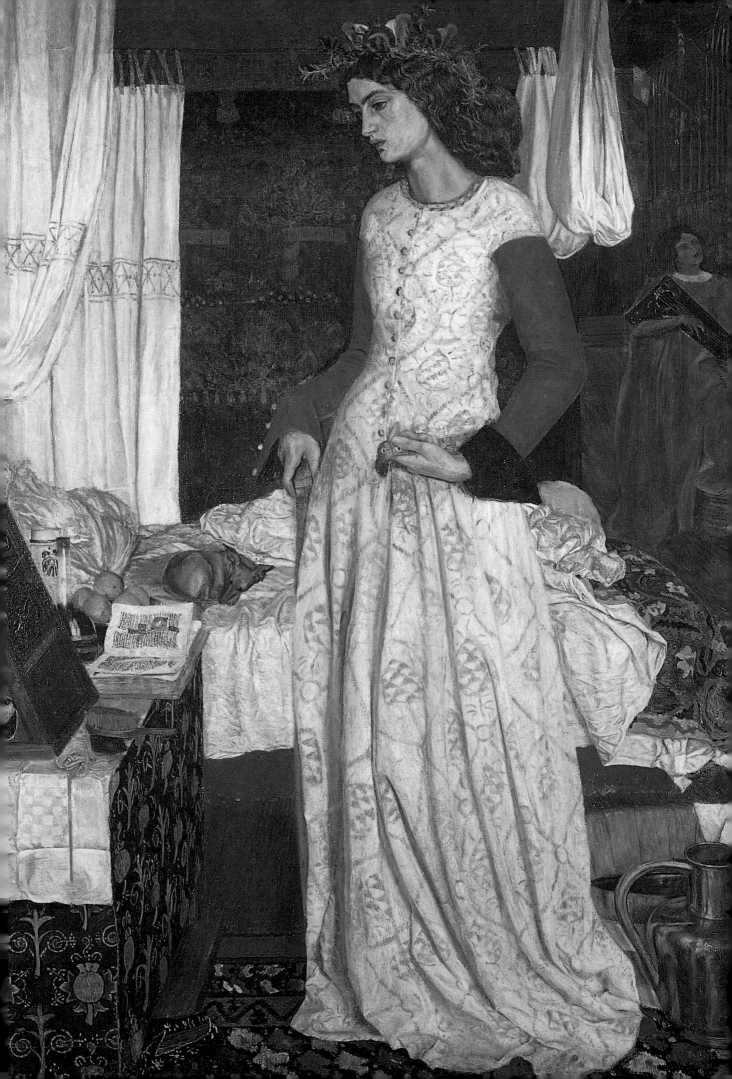

WILLIAM MORRIS (1843–96)
Angel of the Resurrection, c. 1862
Courtesy of the Tate Gallery

THIS design for a stained glass window was sketched in pencil before being brushed over with brown and black ink. It is one of a great many designs created for the firm Morris, Marshall, Faulkner & Co. (later to become Morris & Co.). William Morris was not the only artist to create stained-glass designs for the company, Burne-Jones was one of its most prolific designers and Rossetti, Ford Madox Brown and Philip Webb also contributed. Morris & Co. stained glass can be seen in a variety of cathedrals and churches around Britain, including St Martin's-on-the-Hill in Scarborough, and St Michael's and All Angels in Brighton.

G. F. Watts
The Angel of Death, c. 1870s
Courtesy of Christie's Images. (See p. 220)

Although this window was presumably intended to depict the resurrection of Christ, it is strongly medieval in theme, particularly in the design of the sarcophagus. Morris was deeply influenced by medievalism and spent much of his career looking for new ways to interpret his favourite era. Even the dyes for his tapestries were made in the traditional medieval way.

In the mid- to late-1800s, there was a great deal of mass-market stained glass being produced. However Morris, Marshall, Faulkner & Co. chose to create each piece individually, thereby avoiding the over-commerciality of other suppliers. Morris was renowned for his superb eye for colour and clarity of the glass and, eventually, was elected sole glass buyer for the company.

SIR EDWARD COLEY BURNE-JONES (1833–98)
The Mermaid, c. 1857
Courtesy of the Tate Gallery

Edward John Poynter *At Low Tide, c. 1913*
Courtesy of Christie's Images. (See p. 255)

THE MERMAID was executed in gouache (Burne-Jones's favourite medium) and watercolour. The combination creates a depth that would have been difficult to achieve with light watercolour alone. By using this technique, Burne-Jones brings his mermaid and merbaby forward from the sea and the background.

In 1857, John Ruskin began paying attention to Burne-Jones, who had gradually become a close associate of Dante Rossetti and could be found in the latter's studio several days of the week. Burne-Jones was eager to learn, soaking up all that Rossetti could teach him. Similarly, he was an adoring fan of the work of Holman Hunt, who had also undertaken a part of the young artist's training; now Ruskin was getting in on the act. One of the things that Ruskin impressed on the young Ned was the importance of Italian art and architecture. Soon he had Burne-Jones making faithful copies of the old masters, including Michelangelo and Botticelli. The composition of *The Mermaid* owes an obvious debt to Italian art, in particular that of Botticelli.

By the 1860s, Burne-Jones was fully under Rossetti's wing; he showed him new methods of painting with watercolours, encouraging him to scrape away sections of the paint and then to glaze it, in order to achieve a rich variety of tones, highlights and shadows.

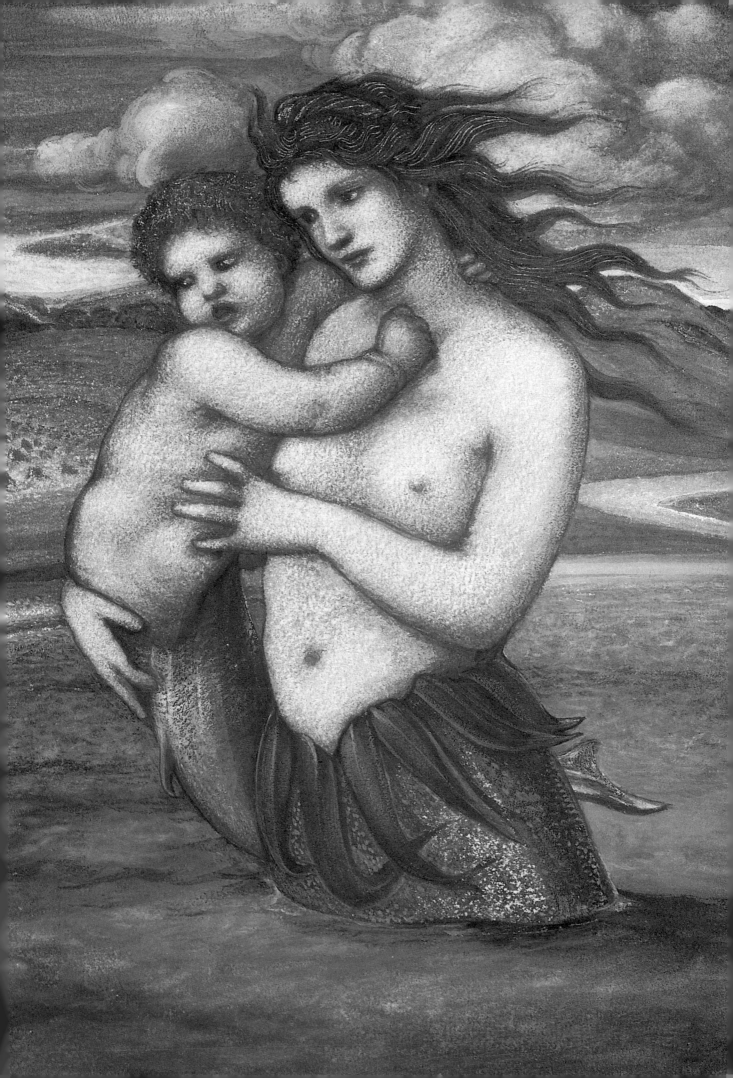

SIR EDWARD COLEY BURNE-JONES (1833–98)
Sidonia von Bork, 1860

Courtesy of the Tate Gallery

T HE subject for this painting comes from a German tale by Wilhelm Meinhold, translated into English in 1847 by Lady Wilde (mother of Oscar) as *Sidonia the Sorceress*. Burne-Jones's picture is influenced by a written description by Wilhelm Meinhold of a portrait of Sidonia and a painting named *Isabella D'Este*, which was

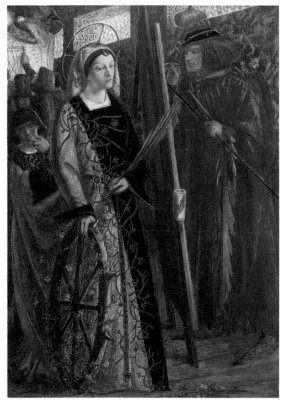

displayed at Hampton Court Palace. The latter strongly influenced the rendering of Sidonia's dress (as did Rossetti's *St Catherine* of 1857). The snake-like coils of fabric intertwine so completely they become indistinguishable, symbolising the ensnaring powers of Sidonia's sorcery, the Medusa and the serpent in the Garden of Eden. Burne-Jones continued this sinister theme throughout the portrait – even down to his signature, above which he painted in a spindly legged spider which was about to spin a web.

Dante Gabriel Rossetti *St Catherine, 1857*
Courtesy of the Tate Gallery. (See p. 102)

The old woman in the background is often identified as Sidonia when aged, before she was executed for witchcraft in 1620. Her presence provides a striking contrast between Sidonia's fatally seductive beauty and the wizened old woman she is destined to become. Sidonia was disturbing to Victorian viewers, because her evil nature did not prevent her from being beautiful and sexually alluring. Although Burne-Jones encourages no sympathy for Sidonia, his portrait was nonetheless controversial, just as his 1862 picture, *Fair Rosamund and Queen Eleanor*, was to challenge the traditional Victorian vision of adulterous women.

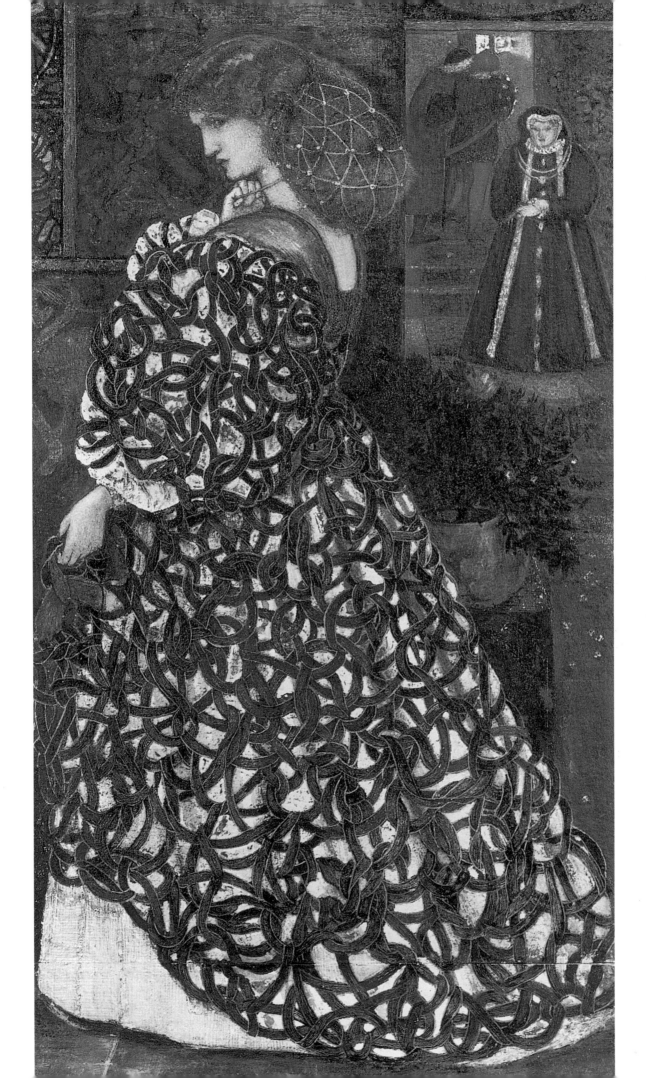

SIR EDWARD COLEY BURNE-JONES (1833–98)
Clara von Bork, 1860

Courtesy of the Tate Gallery

*T*HIS picture was painted as a companion to *Sidonia von Bork* (1860), both were created in the medium of watercolour and bodycolour; Burne-Jones also added gum arabic to the paint to create texture. The two pictures are typical of early Burne-Jones works, heavily influenced by the style of Rossetti, both in composition and portraiture. Its subject is the pure, good-hearted, cousin of Sidonia as taken from Wilhelm Meinhold's *Sidonia the Sorceress* (1847). Clara,

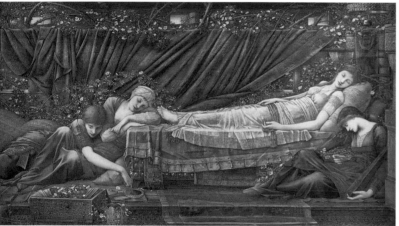

Sir Edward Coley Burne-Jones
The Briar Rose, 1884–90 (See p. 151)

who was modelled by Georgie Burne-Jones, has a face that expresses innocence, especially when compared to the intentionally evil expression of Sidonia (reputedly painted from Rossetti's mistress, Fanny Cornforth). The baby birds Clara is protecting from a prowling black witch's cat are symbolic of her relationship with her cousin. However, they have also been identified as doves, a symbol both of purity and the goddess Venus.

This picture is extremely important when compared to later works by Burne-Jones, because it proves that the artist was capable of creating three-dimensional images. Burne-Jones was often accused of flatness in his later works, but *Clara von Bork,* in which the figure stands out so prominently from a flat, distinctly two-dimensional background proves that his later 'flatness' was wholly intentional and not due to lack of skill.

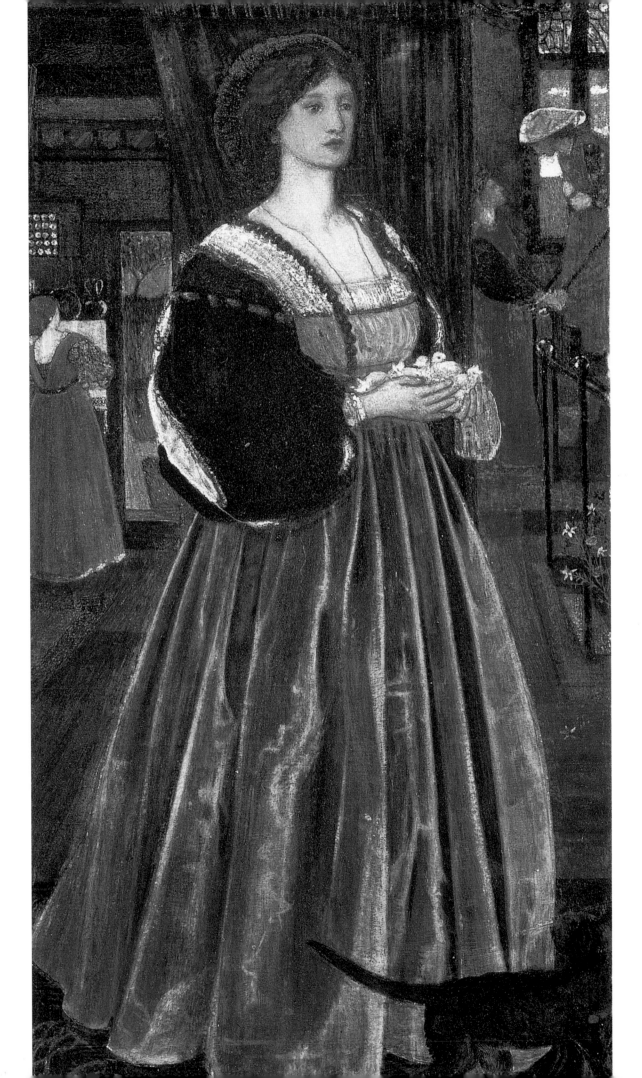

SIR EDWARD COLEY BURNE-JONES (1833–98)
Fair Rosamund and Queen Eleanor, 1862

Courtesy of the Tate Gallery

ROSAMUND was the mistress of King Henry II; she was executed by Henry's wife, Queen Eleanor, who accused Rosamund of being a traitor. In a picture that shows all the hallmarks of an early Pre-Raphaelite Brotherhood composition, Burne-Jones manages to convey Rosamund's very real terror as she realises she is unable to escape. Her face, swollen as though with tears, demands sympathy from the viewer; Eleanor's face, determined and cold, only serves to create in the viewer a dislike for the queen. Her facial expression is reminiscent of that of Burne-Jones's sorceress, *Sidonia von Bork* (1860).

Just as Hunt attempted with *The Awakening Conscience* (1854), the artist required the viewer to feel sympathy for the mistress, not the wife; this is in direct opposition to the prevalent Victorian attitude. Similarly contrary is the artist's decision to clothe the king's mistress in a virginally pale gown, and his wife in witch-like black. *Fair Rosamund and Queen Eleanor* was painted in watercolour, but the artist's clever use of *chiaroscuro* lends it the depth of an oil painting. At this stage of his career, Burne-Jones worked almost exclusively in watercolours and pencil, as he was allergic to the chemicals that were used in oil paints.

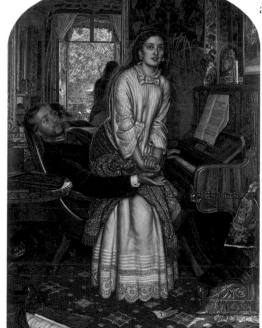

William Holman Hunt
Awakening Conscience, 1854
Courtesy of the Tate Gallery. (See p. 88)

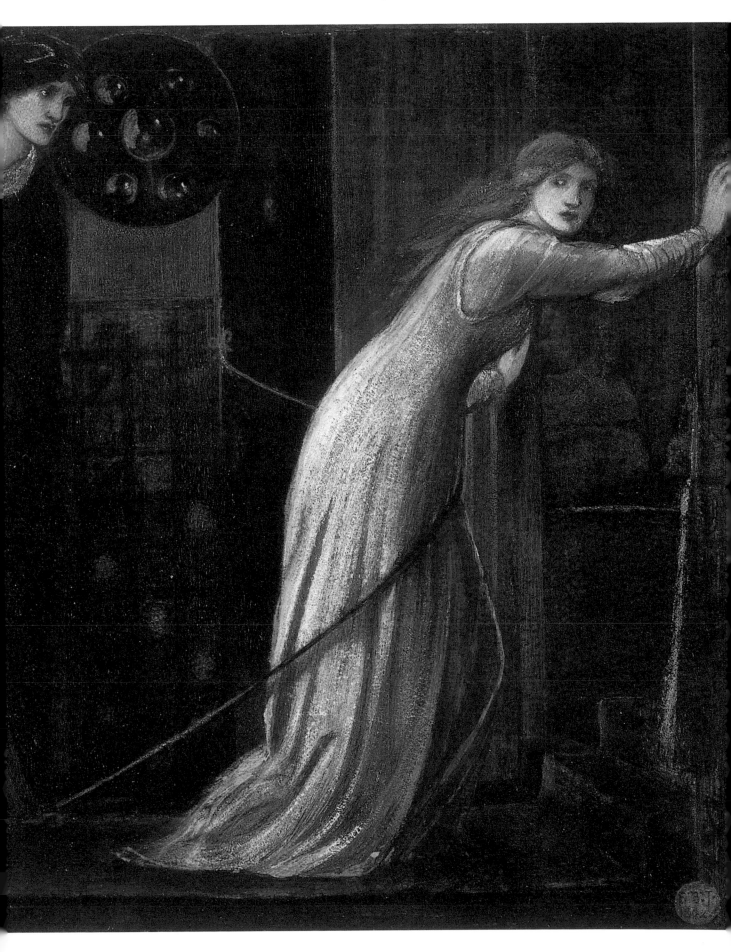

SIR EDWARD COLEY BURNE-JONES (1833–98)
The Merciful Knight, 1863
Courtesy of Birmingham Museums and Art Gallery

*T*HE *Merciful Knight* is based on an eleventh-century legend retold by Sir Kenelm Digby in *Broadstone of Honour*; its hero is a knight named John Gualberto. The explanatory inscription provided by Burne-Jones tells the viewer, 'of a knight who forgave his enemy when he might have destroyed him and how the image of Christ kissed him in token that his acts had pleased God.' John Gualberto was later canonised.

In Burne-Jones' preliminary sketches for *The Merciful Knight*, the kiss given by Christ is far more passionate, with strong homoerotic overtones. In this finished version, painted in gouache, the kiss became protective and deeply caring, without any sexual implications. The beard of Christ provides a shield over the knight's forehead and inexpressibly sad face; the wounds in Christ's hands draw attention to the vulnerability of the knight's exposed hands – whose armoured gauntlets hang from his waist.

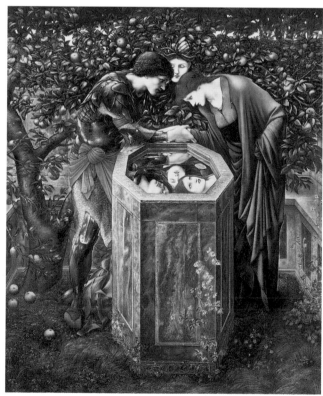

Burne-Jones first became interested in tales of knights and chivalry when working on the Arthurian Oxford Union murals in 1863. This interest was to remain with him throughout his life – he was working on *The Last Sleep of Arthur in Avalon* when he died in 1898.

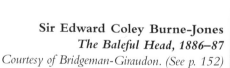

Sir Edward Coley Burne-Jones
The Baleful Head, 1886–87
Courtesy of Bridgeman-Giraudon. (See p. 152)

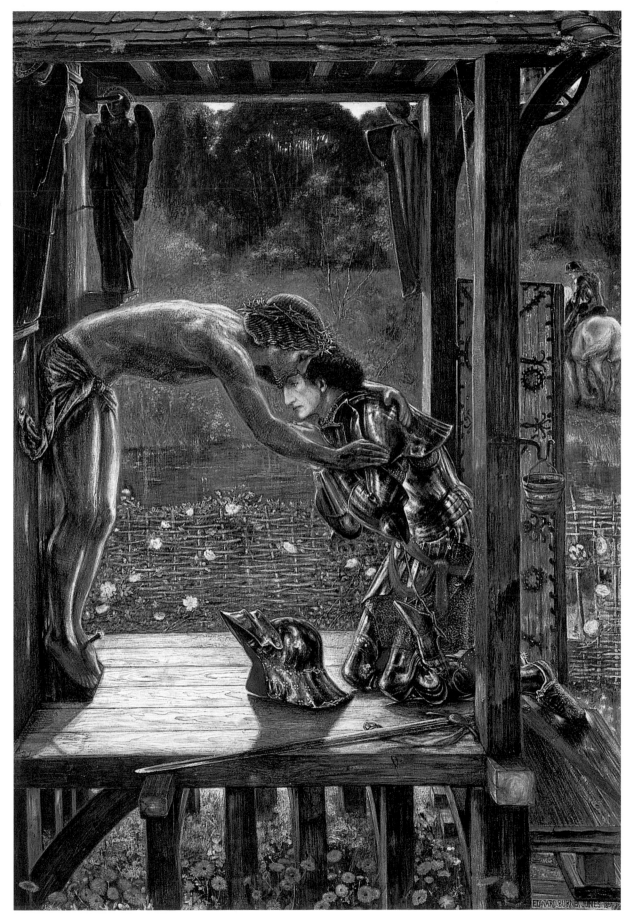

SIR EDWARD COLEY BURNE-JONES (1833–98)
Pygmalion and Galatea I: The Heart Desires, 1875–78
Courtesy of Birmingham Museums and Art Gallery

*T*HIS is the first of four paintings in Burne-Jones's second *Pygmalion and Galatea* series. The first series, which dates back to 1867–69, used harsher tones, darker colours and less fluid lines. This second version, despite being painted in oils, has the sheen and soft tones of chalk.

The story tells of Pygmalion, a sculptor in Cyprus, the birthplace of Aphrodite. It was first related in Ovid's *Metamorphoses*, although by the time of this series, William Morris had written his own version of the story.

Pygmalion is seen here in his studio, pondering his lonely life, having chosen to remain celibate in disgust at what he saw as the debauched lifestyles of the local women. The statues behind him (in emulation of the Three Graces) echo the curious women peering in through his doorway. All five seem fluid, languorous and un-self-conscious.

Pygmalion, looking above the proliferation of ankles, thighs and buttocks reflected on the floor and pedestal in front of him, is pondering his next creation. His gaze ignores the women around him as he sees in his mind a statue of the perfect female.

Sir Edward Coley Burne-Jones
Pygmalion and Galatea II:
The Hand Refrains, 1875–78
Courtesy of Birmingham Museums
and Art Gallery. (See p. 144)

SIR EDWARD COLEY BURNE-JONES (1833–98)
Pygmalion and Galatea II: The Hand Refrains, 1875–78
Courtesy of Birmingham Museums and Art Gallery

*I*N THIS second picture, Pygmalion's perfect woman is revealed. Playing God, he has created woman and now he stands back to admire her, holding the cold chisel against his face as though scared to touch his creation again. The sculptor's expression is softer than in *The Heart Desires*; a look which betrays that he has fallen in love with a woman made of marble.

In spite of his scorning of Aphrodite, Pygmalion has created

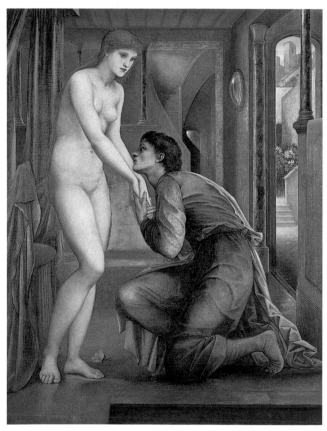

Galatea in a classically Venusian stance. However, unlike the three statues and two living women in the first picture, Galatea appears embarrassedly conscious of her nudity – in the act of attempting to cover herself. Pygmalion, despite his scorn for the local women, deliberately created her nude and now takes on the role of *voyeur*.

Although Pygmalion is seen looking, rather than touching, the various tools around the base of the statue show how much work he has done to bring the statue to this finished state. In creating Galatea, he has used a hard mallet, chisel and file as well as an almost transparent, soft-bristled brush.

Sir Edward Coley Burne-Jones
Pygmalion and Galatea IV: The Soul Attains, 1875–78
Courtesy of Birmingham Museums and Art Gallery. (See p. 148)

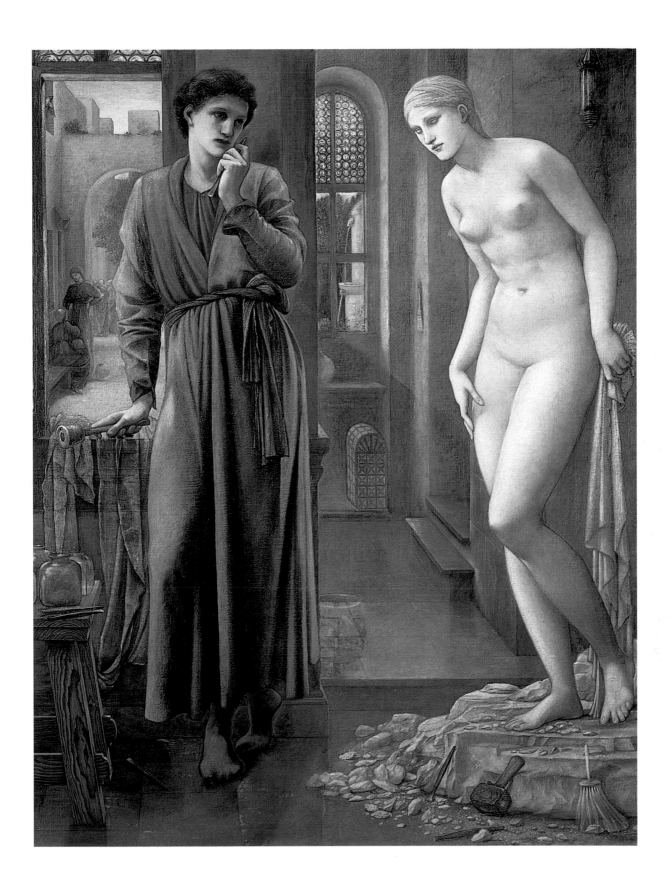

SIR EDWARD COLEY BURNE-JONES (1833–98)
Pygmalion and Galatea III: The Godhead Fires, 1875–78
Courtesy of Birmingham Museums and Art Gallery

*I*N OVID'S version of the story, the scene is set while Pygmalion is at the Temple of Aphrodite, praying for forgiveness for the years he has shunned her and begging for a wife as perfect as his marble woman. In his absence, Aphrodite appears in the studio to impart life to Galatea. In physical terms, there is little difference between the two women: the same, unattainable facial expression; the marble colouring; the Amazonian stature. Ironically, their interlaced arms and Aphrodite's penetrating gaze emulate the intertwined women, so despised by Pygmalion, in *The Heart Desires*.

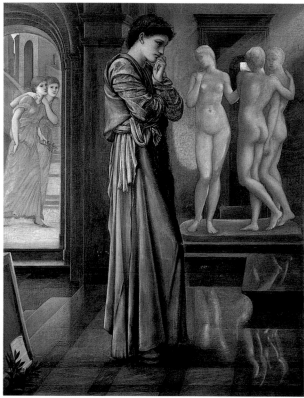

Sir Edward Coley Burne-Jones
Pygmalion and Galatea I: The Heart Desires, 1875–78
Courtesy of Birmingham Museums and Art Gallery. (See p. 142)

Aphrodite is identified by the presence of doves and roses – symbols commonly linked with the goddess – and the water at her feet, reminiscent of her birth, fully formed, from the sea. This also represents Galatea's birth, fully formed, as a woman.

In a scene that is strongly evocative of Michelangelo's *Creation* painting on the ceiling of the Sistine Chapel, the goddess adds colour and sensuality to Pygmalion's austere studio and Galatea's soft flesh. The rich-coloured drapery, wrapped suggestively around an intricately carved pole, is noticeably absent from the other images in the series.

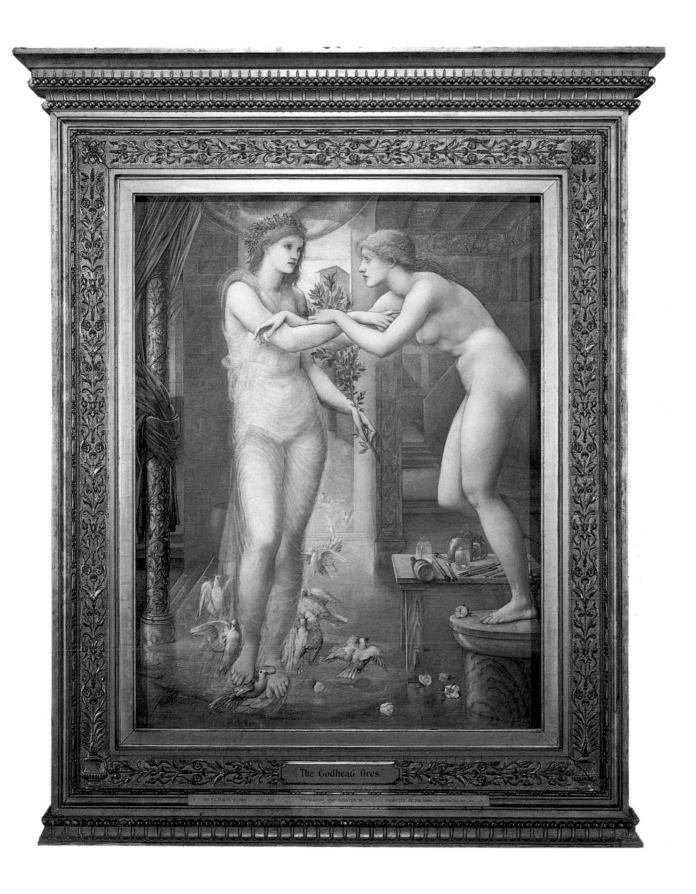

The Godhead fires.

SIR EDWARD COLEY BURNE-JONES (1833–98)
Pygmalion and Galatea IV: The Soul Attains, 1875–78

Courtesy of Birmingham Museums and Art Gallery

WHEN Pygmalion returns home, he finds that his statue has come to life and humbles himself at her feet. She remains impassive, looking blindly over his head – Aphrodite has given Pygmalion a passionless wife, created to his exact specifications.

This was not Burne-Jones's only series of pictures: others include *The Briar Rose* series (1870–90), which was based on Charles Perrault's fairy tale, *The Sleeping Beauty*, and Burne-Jones's spectacular *Cupid and Psyche* frieze. Although not imbued with the depth and texture of *The Merciful Knight* (1863), this second attempt at portraying the tale of Pygmalion and Galatea has become regarded as one of the artist's most important works. It was exhibited at Sir Coutts Lindsay's new Grosvenor Gallery in 1879, thereby establishing Burne-Jones as one of the leading artists in the burgeoning Aesthetic Movement.

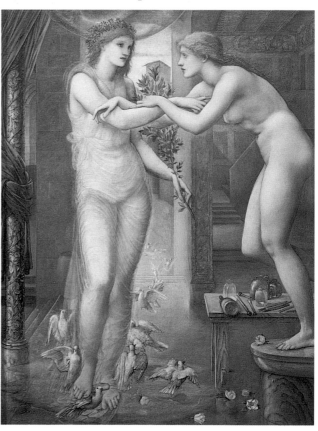

Sir Edward Coley Burne-Jones
Pygmalion and Galatea III: The Godhead Fires, 1875–78
Courtesy of Birmingham Museums and Art Gallery. (See p. 146)

The first *Pygmalion* series was painted when Burne-Jones' affair with his pupil, the painter Maria Zambaco, was at its height. Although Burne-Jones thought he already had the perfect woman, in his wife Georgie, he was unable to prevent himself from longing for his model and muse, Maria, in a violent internal conflict.

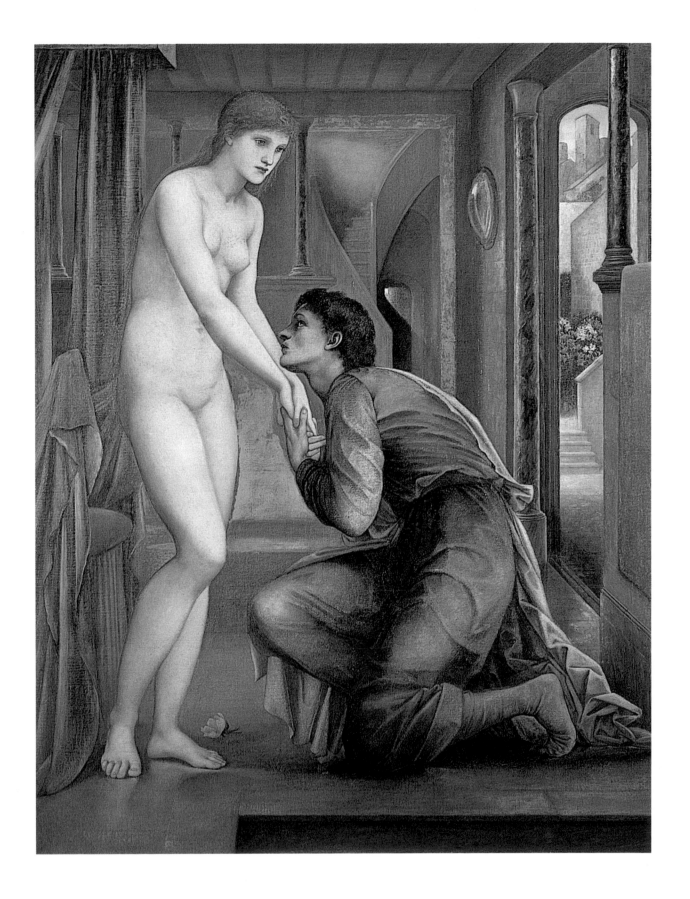

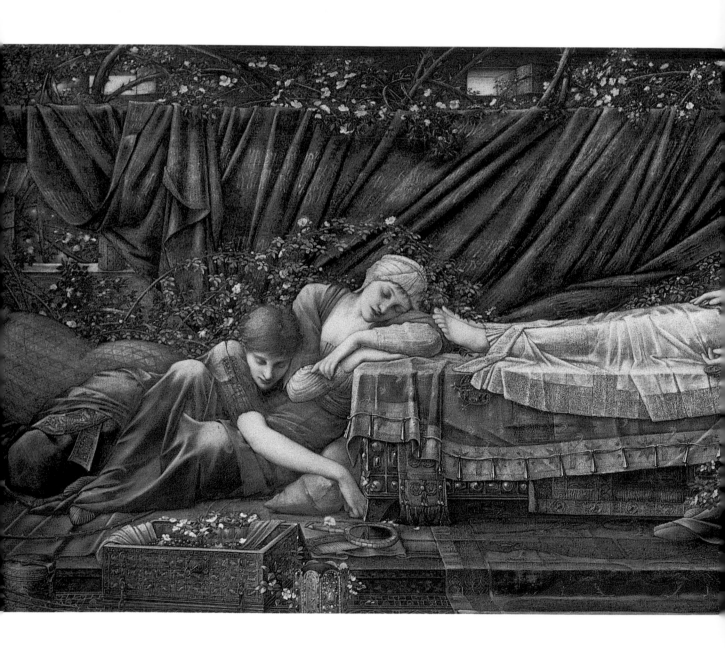

SIR EDWARD COLEY BURNE-JONES (1833–98)
The Briar Rose, 1884–90

Farringdon Collection. Courtesy of Bridgeman-Giraudon

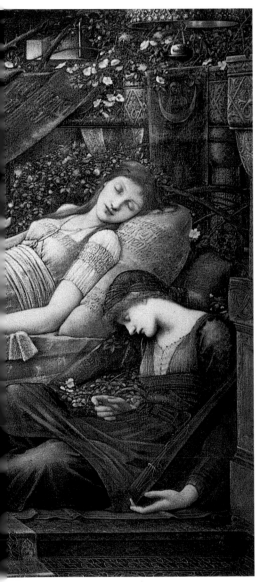

*T*HIS is the fourth panel in Burne-Jones's much-celebrated *Briar Rose* series, which was commissioned by dealer Thomas Agnew. Taking his inspiration from Charles Perrault's classic fairy tale *The Sleeping Beauty*, Burne-Jones spent six years completing what became one of his most important works. The languid poses of the princess, modelled by Margaret, daughter of the artist and her attendants suit Burne-Jones's style of art superbly. The first panel in the series also makes use of this languid, elongated composition in its depiction of a group of sleeping knights. This continuous theme, when all four panels are viewed in a row, gives the impression of a Classical frieze.

Burne-Jones was renowned for his desire to recreate every detail of a painting as accurately as possible. When painting *The Merciful Knight*, he had studied the armour collection owned by Sir Coutts Lindsay but in *The Briar Rose* and *Perseus* series, he created his own armour, constructed from cardboard and tin. This explains why the armour of Sleeping's Beauty's knight and that of Perseus, became more supple as the series progress. For *The Briar Rose*, Burne-Jones also asked one of his friends, who owned a country estate, to send him the thickest thorny branches she could find in her garden in order that he could paint the briar thorns accurately.

SIR EDWARD COLEY BURNE-JONES (1833–98)
The Baleful Head, 1886–87
Staatsgalerie, Stuttgart. Courtesy of Bridgeman-Giraudon

*J*N THIS, the final image from the intended *Perseus* series, Perseus is showing Andromeda the head of Medusa. Because looking directly at Medusa – even in death – would turn a mortal to stone, they can only view her in reflection. The reflection is also employed to show the viewer that Perseus is looking directly at Andromeda, and Andromeda, although appearing to be looking at the head, is actually watching Perseus' reflection.

The series relates an ancient Greek myth in which Perseus was chosen to kill the Gorgon, Medusa, and bring back her head. To assist him in his quest he was given winged sandals, a suit of impenetrable armour (which rendered him invisible) and a bag in which to carry the head. Perseus' mission led him to Andromeda, whom he rescued from being sacrificed to the gods. The series of paintings is remarkable for its fluidity, the androgyny of its characters and startling imagery evinced in every panel. It was different from anything that the artist had produced in the past or was to create in the future.

Burne-Jones was commissioned to draw 10 pictures for this series, but although preliminary gouache versions were made, just four were completed in oil. Eventually his patron, Arthur Balfour, took pity on the physically and emotionally depressed artist, and graciously accepted the four.

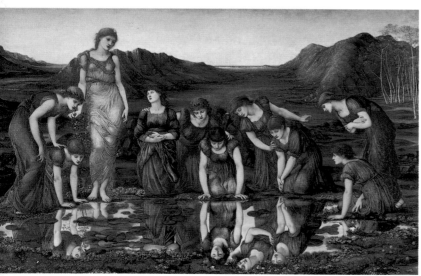

Sir Edward Coley Burne-Jones *The Mirror of Venus, 1898*
Courtesy of Bridgeman-Giraudon. *(See p. 154)*

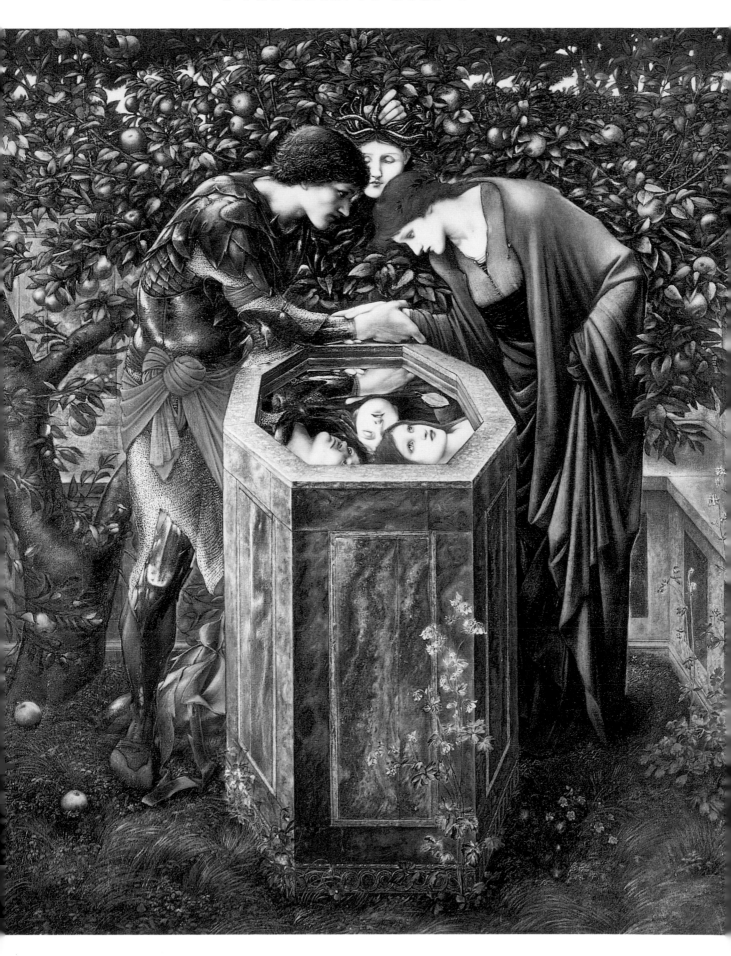

SIR EDWARD COLEY BURNE-JONES
(1833–98)
The Mirror of Venus, 1898

Calouste Gulbenkian Museum, Lisbon. Courtesy of Bridgeman-Giraudon

*T*HIS oil painting was one of the last pictures that Burne-Jones worked on. When compared to his earlier works, such as *Clara von Bork* (1860) or *Fair Rosamund and Queen Eleanor* (1862), it is easy to see how radically his artistic style changed throughout his career, particularly when considering that the majority of his first major works were simply pen-and-ink drawings. The artist of *The Mirror of Venus* could never be misidentified – the models' faces and poses, his depiction of the watery mirror and the unusual palette of colours used are all unmistakably Burne-Jones, as is the distinctive drapery of the women. He devised this effect by dragging his brush downwards forcibly, displacing earlier layers of paint and creating the effect of folds of material.

His earliest work was influenced so strongly by Rossetti and Ruskin that it took several years for 'Ned' to allow his individual style to show through. When it did emerge, Burne-Jones' art was complemented by the styles of Rossetti, Morris, Botticelli, Michelangelo and all those other artists who had influenced him, but never again was he to appear to follow the pictorial direction of another artist.

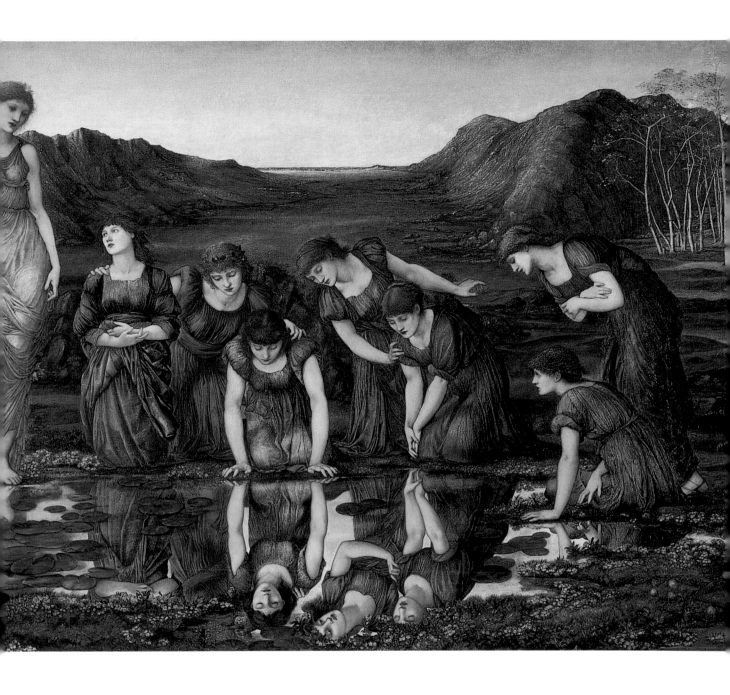

ALEXANDER MUNRO (1825–71)
Paolo and Francesca, c. 1852
Courtesy of Birmingham Museums and Art Gallery

A PLASTER version of *Paolo and Francesca* was on display at the Great Exhibition of 1851; this was the idea of Prince Albert, husband of Queen Victoria, who wanted to show the world the glories of Britain. The exhibition was housed in the specially constructed Crystal Palace, situated for the occasion in London's Hyde Park; it showed examples of all aspects of British life, from heavy industry (a prominent part of British society since the Industrial Revolution) to fine arts. William Gladstone commissioned this marble sculpture from Munro after visiting Crystal Palace.

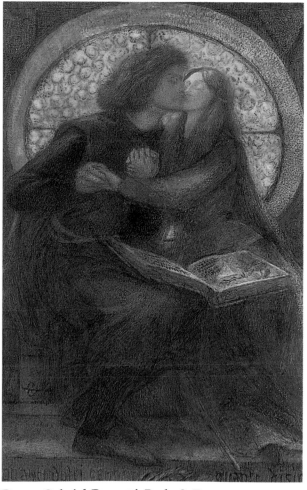

Munro's subject, taken from Dante Alighieri's *Purgatorio*, was one much explored by the Pre-Raphaelite Brotherhood – of whom Munro was a keen observer (Munro introduced his fellow student, Arthur Hughes, to Pre-Raphaelitism by lending him his copy of *The Germ*). He became friendly with the PRB while the Brotherhood was still very strong, and is known to have given Rossetti a plaster copy of *Paolo and Francesca*. Rossetti was working on his own version of *Paolo and Francesca* from about 1849, but did not finish it until 1855. Scholars have since tried to determine whether Rossetti's preliminary sketches influenced Munro, or whether Munro's sculpture influenced Rossetti's final watercolour.

Dante Gabriel Rossetti *Paolo & Francesca da Rimini, 1855*
Courtesy of the Tate Gallery. (See p. 98)

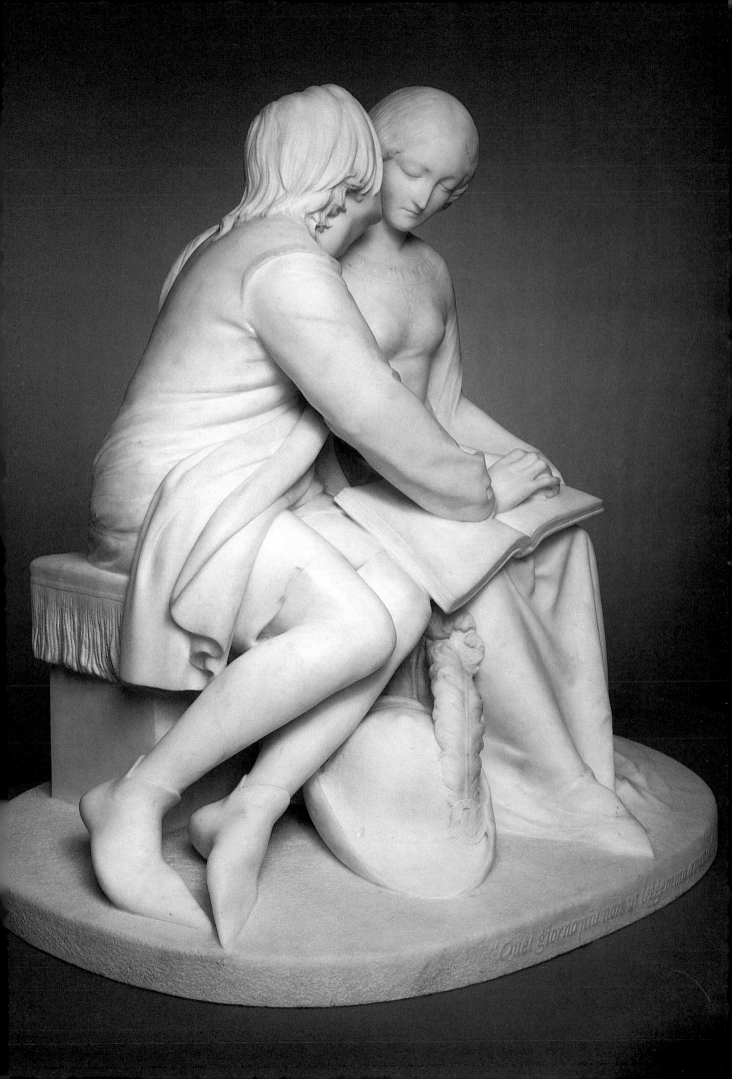

ARTHUR HUGHES (1832–1915)
April Love, 1855
Courtesy of the Tate Gallery

*T*HIS is perhaps Hughes' most acclaimed painting. Ruskin raved about it, as did Ford Madox Brown, and William Morris bought it – beating Ruskin to the sale by ensuring his cheque was submitted first. This fervent enthusiasm by his peers determined Hughes' place in the ranks of Pre-Raphaelite painters.

The scene is set after a lovers' quarrel: the girl's eyes are spilling tears while, behind her, barely indistinguishable in form and colour from the wood around them, sits her lover, head in hands. The success of *April Love* led Hughes to re-use much of its imagery in *The Long Engagement* (1859): the ivy on the left side of the painting, balanced by the blooming flowers seen on the right; the woman standing in sunlight while her man languishes in shadow.

The 'April' of the title suggests the couple's youth; it is indicative of the mercurial nature of April showers, which disappear as fast as they appear. The picture was accompanied by a quotation from that Pre-Raphaelite stalwart, Alfred, Lord Tennyson, including the lines:

> *Eyes with idle tears are wet.*
> *Idle habit links us yet.*
> *What is love? for we forget:*
> *Ah, no! no!*

William Lindsay Windus
Too Late, 1857–58
Courtesy of the Tate Gallery. (See p. 188)

ARTHUR HUGHES (1832–1915)
The Eve of St Agnes, 1856
Courtesy of the Tate Gallery

*H*UGHES became a fervent admirer of Pre-Raphaelite art in 1850, after being shown a copy of *The Germ* by a fellow School of Painting pupil, the sculptor Alexander Munro. He became one of the 'second generation' Pre-Raphaelites, along with artists such as Edward Burne-Jones and J. R. S. Stanhope. His subject matter was typical of the Pre-Raphaelite ideology, particularly here, in using the poetry of John Keats, one of the original list of immortals drawn up by the PRB.

Hughes exhibited *The Eve of St Agnes* eight years after William Holman Hunt's painting of the same name was unveiled, but despite the similarities of subject matter and title, the paintings differ in many ways from each other. Hughes chose to paint his as a triptych, hoping to illustrate more of the lengthy poem than a single painting could do. The scene that Hunt chose to illustrate, that of the lovers creeping out of the house, is the right-hand wing of Hughes' painting; instead he chose Porphyro arriving in his lover's bedroom as the central image. However, the painting in the right-hand wing owes much to Hunt's, most notably in the extremely similar position of the porter lying 'in uneasy sprawl'.

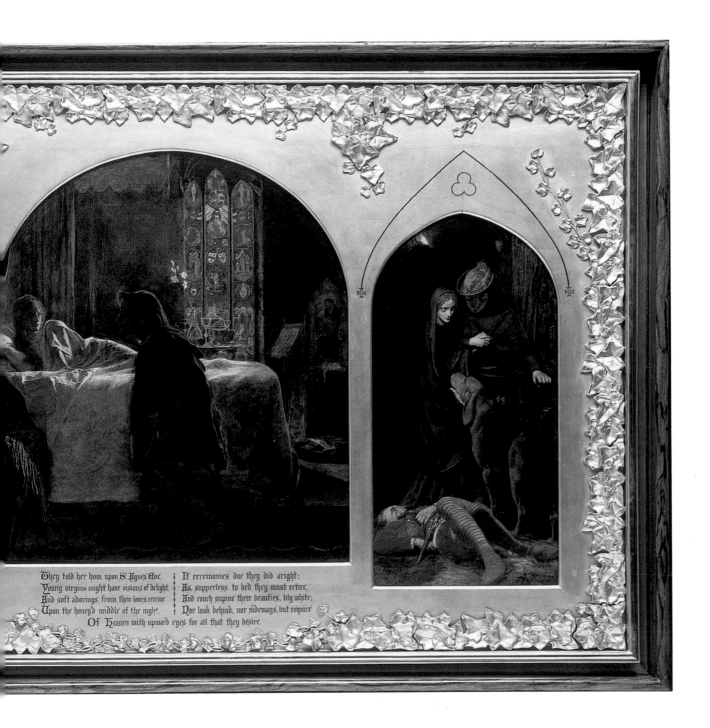

They told her how, upon St. Agnes' Eve,
Young virgins might have visions of delight,
And soft adorings from their loves receive
Upon the honey'd middle of the night,
 If ceremonies due they did aright;
As, supperless to bed they must retire,
And couch supine their beauties, lily white;
Nor look behind, nor sideways, but require
 Of Heaven with upward eyes for all that they desire.

ARTHUR HUGHES (1832–1915)
Amy, 1857

Courtesy of Birmingham Museums and Art Gallery

*A*MY was painted during the same period as Hughes' *The Long Engagement* (1859), although completed before the latter. Judging by the subject matter and background, it seems as though *Amy* was a trial for the bigger painting. Both scenes were painted in oil – *Amy* on panel; *The Long Engagement* on canvas – but *Amy*, at 32 x 18.5 cm (12.625 x 7.25 in), is considerably smaller than the finished version of *The Long Engagement* at 105.4 x 52.1 cm (41.5 x 20.5 in). It appears that the choice of title, and consequently the choice of name carved into the tree in both paintings, was inspired by the birth of Hughes' daughter, Amy, in 1857: the year in which this picture was begun.

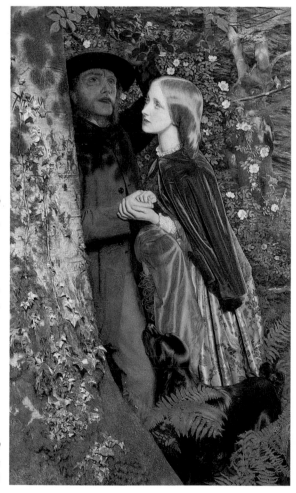

Amy's slight smile could be suggestive of an exciting secret, although it could also be slightly wry, as though regretful. It is difficult to know whether Hughes intended the picture to be of a secret place of tryst (suggested by the way Amy appears to be preening herself by placing flowers in her hair) or as a reminder of a love gone sour. Either way, the affair was apparently begun quite a while earlier, as the ivy has begun to grow over her name; the fact that she wears no ring suggests that there is either a barrier in the way of their intended marriage (as in *The Long Engagement*) or that their affair is over.

Arthur Hughes *The Long Engagement, 1859*
Courtesy of Birmingham Museums and Art Gallery. (See p. 168)

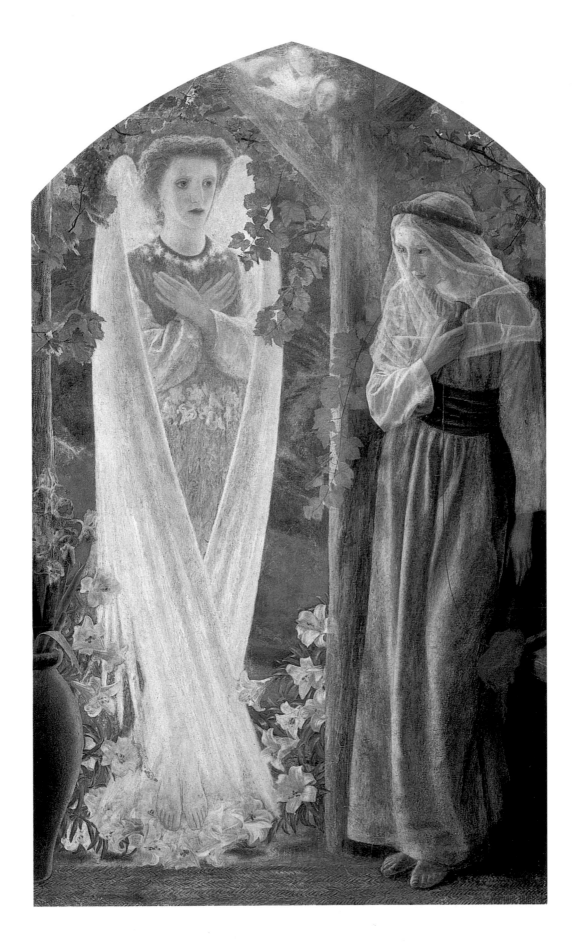

ARTHUR HUGHES (1832–1915)
The Lady of Shalott, 1858
Courtesy of Christie's Images

*H*UGHES' heroine is a far cry from the passionate, powerful *Lady of Shalott* depicted by William Holman Hunt (1886–1905). She has more in common with Waterhouse's heroine of 1888; suggesting that Waterhouse drew his inspiration from Hughes. It appears that Hughes drew some of his inspiration for this picture from Millais' *Ophelia* (1852).

The strangely dressed observers who stand on the bank of the river bear reference to an early stanza from Tennyson's poem:

There the river eddy whirls,
And there the surly village-churls,
And the red-cloaks of market girls
Pass onward from Shalott.

Their clothes, which have overtones of Dutch costumes, may be Hughes' attempt at placing Camelot in an unknown country. The swan and her cygnets, recognised as symbols of death, are also symbolic of magic. The prone attitude of the Lady of Shalott is taken directly from the following lines:

Lying robed in snowy white
That loosely flew to left and right –
The leaves upon her falling light –
Thro' the noises of the night
She floated down to Camelot …
Till her blood was frozen slowly,
And her eyes were darkened wholly
Turn'd to towering Camelot …
Singing in her song she died,
The Lady of Shalott.

Her darkened, unseeing eyes look beyond the viewer, out into the distance to the forbidden view of Camelot.

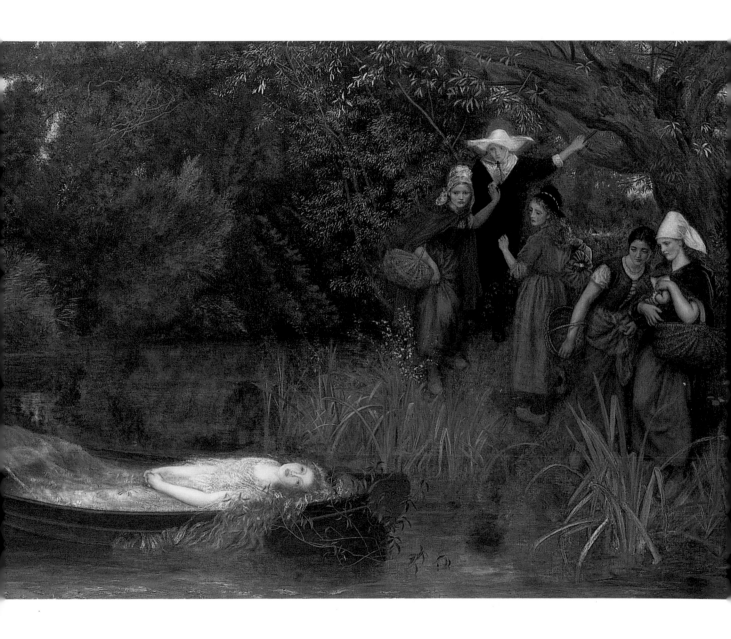

ARTHUR HUGHES (1832–1915)
The Long Engagement 1853–59
Courtesy of Birmingham Museums and Art Gallery

*T*HIS painting was begun in 1853 and originally it was to illustrate a scene from Shakespeare's play *As You Like It* depicting Orlando in the Forest of Arden. That picture was finished in 1855 – and rejected by the Royal Academy. Disheartened, Hughes painted out the figure of Orlando, kept the background and began work on *The Long Engagement*.

The lovers stand in Orlando's rejected forest, contemplating the financial obstacles (denoted by his clergyman's clothes) that prevent their wedding. He looks weary, humiliated and worn down by his inability to provide for a wife; she is still hopeful, buoying up his spirits. Like many of Hughes' women she is simply pretty, faithful and loving – the embodiment of the ideal woman in the Victorian middle classes (from which most of the Pre-Raphaelites' patrons came). Even her dog adores the man.

Her name, Amy, is carved into the tree trunk, but has been there so long that ivy is now beginning to grow over it. Moss and lichen are working their way up the tree, suggesting the frailty and inevitability of time. The man stands in shadow, whereas his fiancée, dressed in bright, cheerful colours, stands in the light. Behind her flowers bloom – symbolising hope and new (or renewed) life.

Sir John Everett Millais
The Huguenot, 1851–52
Courtesy of Christie's Images. (See p. 42)

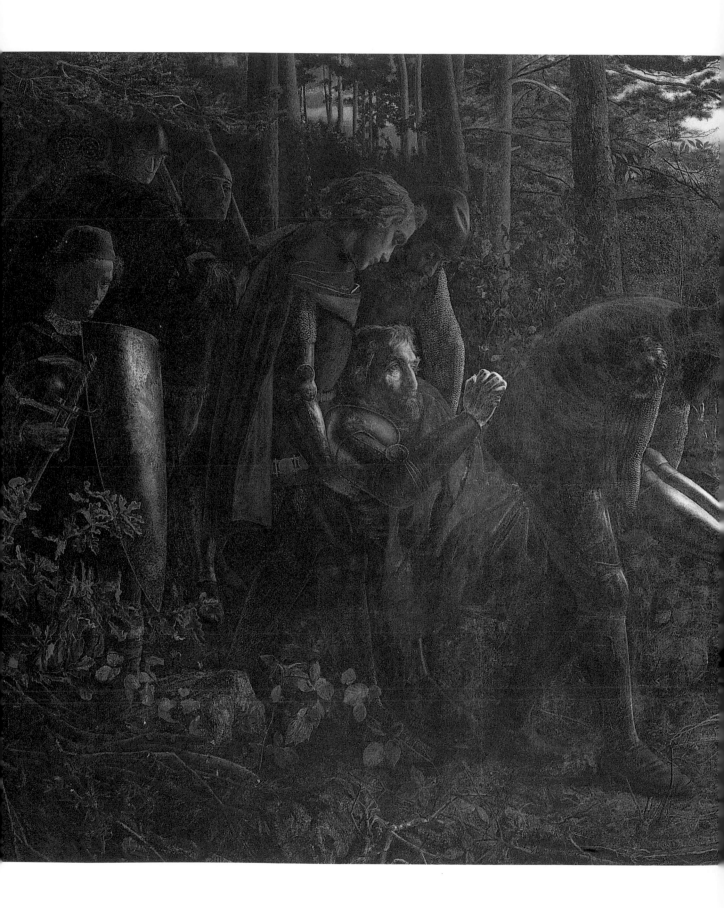

ARTHUR HUGHES (1832–1915)
The Knight of the Sun, 1860
Courtesy of Christie's Images

ALTHOUGH steeped in Arthurian imagery, *The Knight of the Sun* is not illustrative of a particular Arthurian legend; instead Hughes came up with the subject specifically to allow him to experiment with the lighting provided by sunset. Hughes' story was of a knight, pure in heart and deed – like the chosen few of the Round Table – whose family crest identified him with the sun. The knight so adored the sun that, when he knew he was dying, he asked his companions to carry him outside so that he could watch it setting for the last time.

This picture was inspired by a rich autumn sunset Hughes had observed while sitting by a river – the water in the picture allowed Hughes to recreate his moment of inspiration as accurately as possible. While working on this painting, Hughes spent much of his time observing the effects of sunsets, just as, later in his career, he spent months painting by lantern light, in order to create the correct lighting for *L'enfant Perdu* (1866–67) and *Jack O' Lantern* (1872). This Pre-Raphaelite determination to convey light realistically was shown admirably by William Holman Hunt, who spent many months sleeping by day and painting, outdoors, by night in order to complete *The Light of the World* (1853).

ARTHUR HUGHES (1832–1915)
The Woodman's Child, 1860
Courtesy of the Tate Gallery

*H*UGHES was an admirer of the Pre-Raphaelite Brotherhood in general; at times he was influenced by many of them and his style followed several different painters, depending on which of them was currently chosen as his mentor. Although looking at the subject in a different way, *The Woodman's Child* was almost certainly influenced by the popularity of Millais' similarly titled *The Woodman's Daughter* (1851).

Hughes depicts the child asleep while her parents work, clutching her father's coat to her as she slumbers. Close by perch a squirrel and a robin, unperturbed by a human presence. The model for the sleeping child was Annie Munro, daughter of the sculptor Alexander Munro. The scene is typically Victorian, revelling in sentimentality and the innocence of childhood. It is an idealised version of the childhood of a labourer's daughter, and one that would have appealed greatly to the contemporary art market.

In 1862, Hughes received a letter from a collector asking if he could buy a preliminary sketch or study made in the creation of this oil painting. Hughes replied that he could not supply the patron with either because he had made no preliminary sketches.

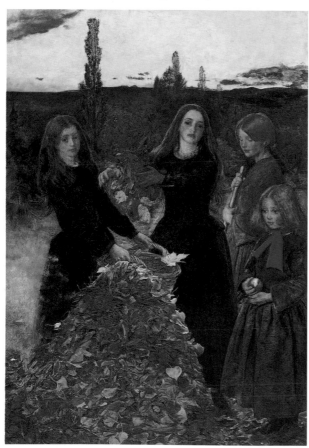

Sir John Everett Millais *Autumn Leaves, 1855–56*
Courtesy of Topham. (See p. 80)

ARTHUR HUGHES (1832–1915)
Jack O'Lantern, 1872

Courtesy of Christie's Images

Accompanying this painting on its first exhibition were the following lines:

Jack O'Lantern –
Up and down, up and down
I will lead them
I am feared in field and town
Goblin, I will lead them up and down.

Hughes began painting *Jack O'Lantern* not long after completing *L'enfant Perdu* (1866–67), during an era when he was experimenting with the use of darkness and candle- or lantern-light. His fascination for night-time scenes was brought about, in part, by the tremendous effect William Holman Hunt's *The Light of the World* (1853) had upon Hughes' young mind, and by his own experiments with natural light, such as the 1860 picture, *The Knight of the Sun*.

The Jack O'Lantern was a type of fairy – sometimes known as a 'Will o'the Wisp' – who had the power to enchant and lead people astray. Especially susceptible were travellers attempting to find their way through unknown countryside. The subject matter for this painting is reminiscent of Christina Rossetti's long poem *Goblin Market*, published in 1862. The poem was intrinsically Pre-Raphaelite in tone, couching the grotesque within what appeared ostensibly to be a fairy story.

ELIZABETH SIDDAL (1829–62)
Lady Affixing a Pendant, c. 1856

Courtesy of the Tate Gallery

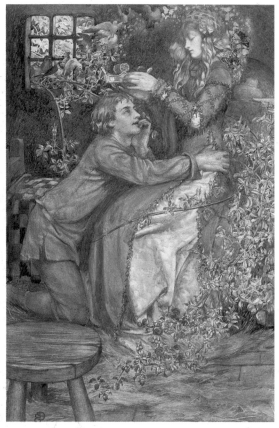

Eleanor Fortescue Brickdale
Natural Magic, c. 1905
Courtesy of Christie's Images. *(See p. 250)*

*T*HIS crude oil painting shows the guidance of Dante Rossetti, Elizabeth Siddal's teacher as well as her lover. Lizzie produced a number of paintings, sketches and watercolours, but very few are available to the public today. Most of her pictures were purchased by Ruskin, a loyal friend and genuine admirer of her work. Today many of these are in private collections throughout the world.

Lizzie's first important work was a watercolour painted to illustrate the poem 'We Are Seven' by Wordsworth. Her foray into oil painting began with a self-portrait. Like the other Pre-Raphaelites, she looked to literature, and particularly poetry, for inspiration. *Lady Affixing a Pendant* echoes Arthurian literature, the inspiration for so many of Rossetti's works. Lizzie also wrote poetry, attempting to emulate the style of her lover's gifted sister, Christina Rossetti.

Lizzie's position at the hub of the Pre-Raphaelite movement was hugely beneficial, giving her advantages offered to few female artists of the time. In 1857, some of her work was shown publicly, in an exhibition put together by Ford Madox Brown and alongside that of other Pre-Raphaelite artists of Brown's intimate acquaintance; she had been truly accepted into the fold.

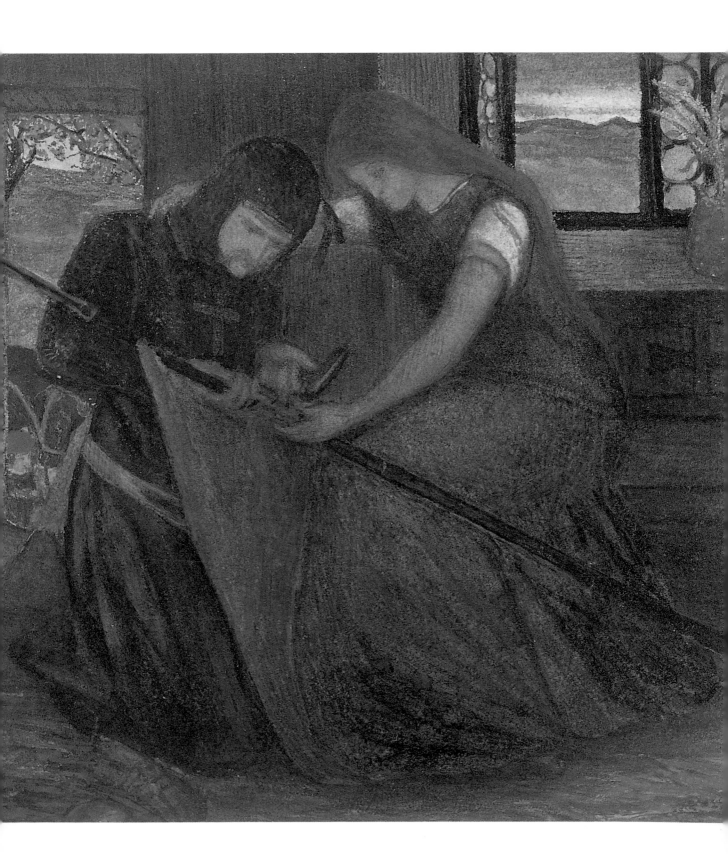

ELIZABETH SIDDAL (1829–62)
Sir Patrick Spens, c. 1857–60
Courtesy of the Tate Gallery

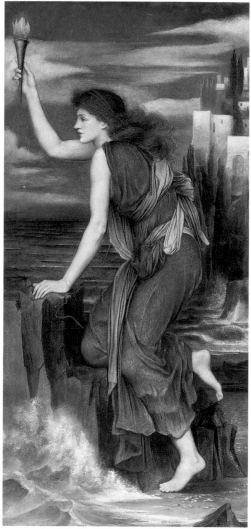

Evelyn de Morgan
Hero Holding the Beacon for Leander, 1885
Courtesy of Christie's Images. (See p. 230)

MANY of Lizzie Siddal's pictures were drawn to accompany poetry; among others the works of Browning, Tennyson and Wordsworth. *Sir Patrick Spens* is an ancient Scottish ballad dating to around the thirteenth century; it was made popular in the Victorian age when Sir Walter Scott published a new version of the ballad.

Sir Patrick, a favourite of the king, set sail on an urgent royal mission despite his own premonitions of disaster. His ship was wrecked on the journey, killing all on board.

Lizzie chose to illustrate the wives, lovers and children of the ship's crew watching fearfully for signs of a storm and hoping for the return of their men. Despite the grief-stricken attitude of the standing woman, which appears awkward and unnatural, the style of *Sir Patrick Spens* is less crude than that of the earlier *Lady Affixing a Pendant* (c. 1856).

Ruskin took a strong interest in Lizzie's work; although his fervent patronage may also have been inspired by a desire to give her financial freedom. Lizzie committed suicide before her ability as an artist in her own right was ever proved. Unlike other female Pre-Raphaelite artists, such as Lucy Madox Brown or Marie Spartali Stillman, Elizabeth Siddal was never able to attain a style independent of Rossetti.

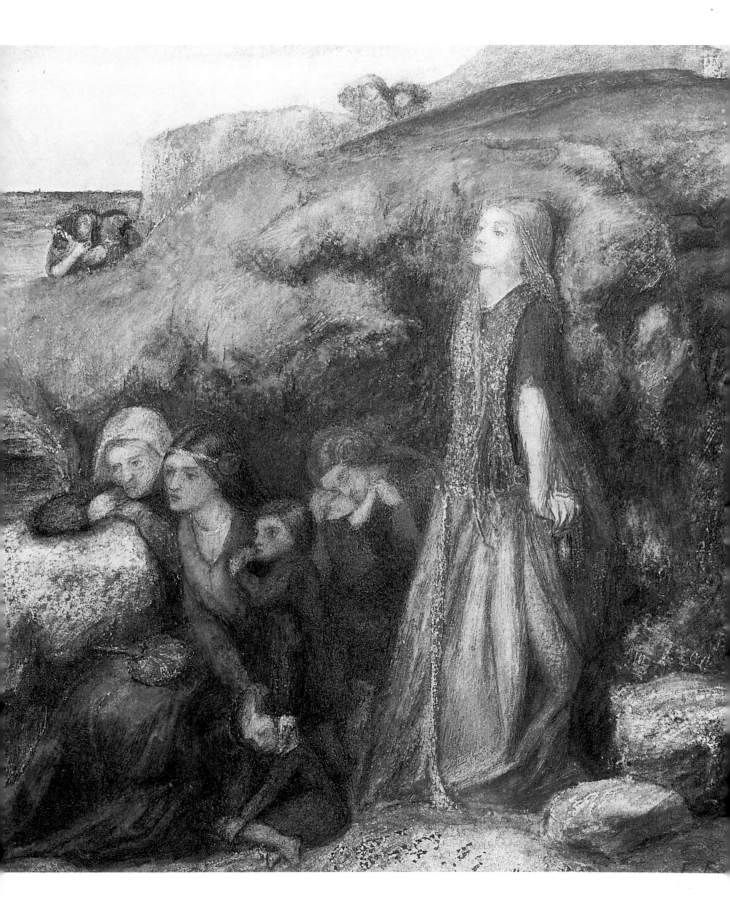

HENRY WALLIS (1830–1916)
The Death of Chatterton, 1856
Courtesy of the Tate Gallery

WALLIS was principally a historical painter, who became introduced to the Pre-Raphaelites through Arthur Hughes. *The Death of Chatterton* is often described as the artist's only 'true' Pre-Raphaelite painting.

The poet Thomas Chatterton took his own life when he was just 17. The rose petals on the window ledge and the nearby candle, only partially burned, which blows only a remnant of smoke, are indicative of a life cut off in its prime.

Wallis's use of light is prodigious: little comes in from the dawn, glimpsed through the small garratt window; the room itself is gloomy, but the light still illuminates the dead young poet naturally, without being contrived. The pallor of Chatterton's skin is almost luminous in the weak morning light. The jewel-like colours of his clothing – vivid purple trousers and crimson jacket – and the brilliancy of his copper-coloured hair speak poignantly of a man in the prime of his life, youth, energy and activity.

The landscape seen through the window is essentially that which Chatterton would have looked out to from his attic – Wallis painted the scene from a garratt near to the one in which Chatterton lived and died. The poet's shredded works and the empty phial of arsenic seen on the floor are faithful representations of the actual death of Chatterton in 1770.

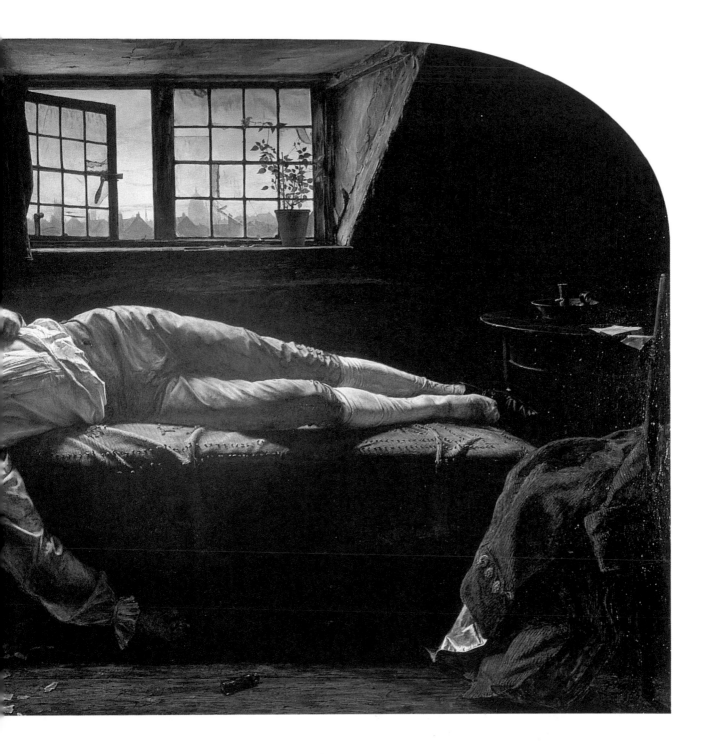

HENRY WALLIS (1830–1916)
The Stonebreaker, 1857
Courtesy of Birmingham Museums and Art Gallery

*T*HE STONEBREAKER was exhibited at the Royal Academy, to great acclaim, in 1858. Many early viewers saw it as an image of a weary worker sleeping at the end of a day's toil; it was not until the critics began writing about it that it became generally understood as a picture about death, just as *Chatterton* (1856), Wallis' previous painting, had been. *The Stonebreaker* was exhibited with a quotation from the great social reformer Thomas Carlyle, a hero of several Pre-Raphaelites – in 1868, Ford Madox Brown included a portrait of Carlyle in *Work*.

With this painting, Wallis moved away from Pre-Raphaelitism towards social realism, making a bitter reference to the treatment of the poor. It was well-known that members of the workhouse often ended up as stonebreakers in order to 'pay' for their meagre allowance.

The analogy of sunset reflecting the end of a life was one that was to appear several times in Pre-Raphaelite painting, notably in Millais' *The Vale of Rest* (1858–59) and Hughes' *The Knight of the Sun* (1860). Wallis uses the muted colours and indistinct sunset lighting to allow his dead man to merge into the background. The clarity of lines in his other works demonstrate that this blurring of the edges is intentional.

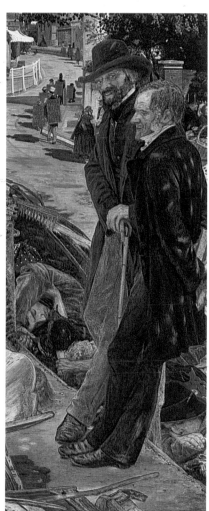

Ford Madox Brown
Work, 1863
Courtesy of Topham. (See p. 77)

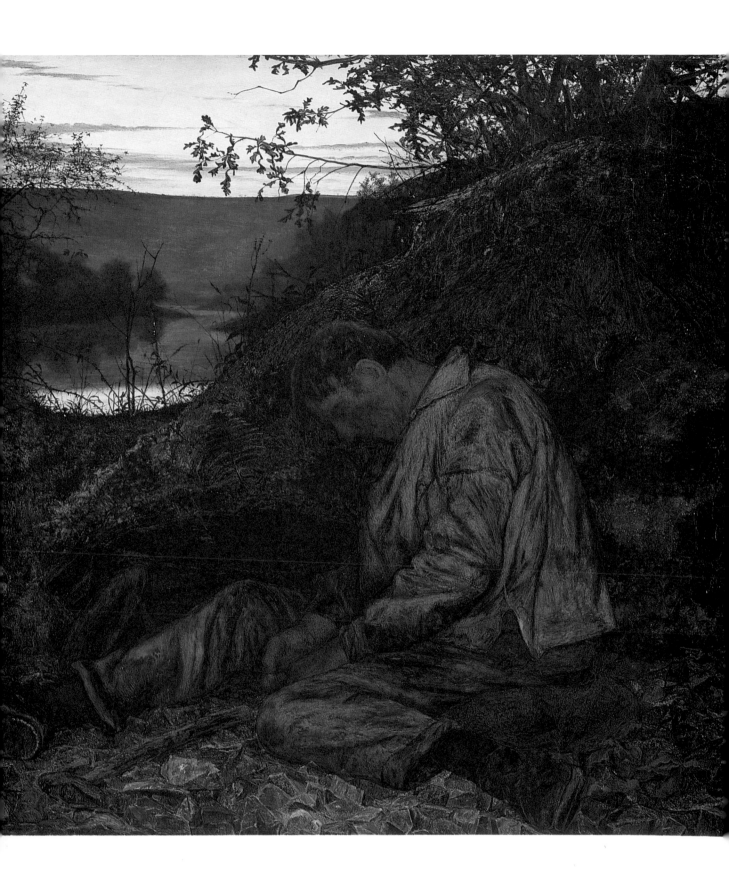

HENRY WALLIS (1830–1916)
A Despatch from Trezibond, 1873
Courtesy of Christie's Images

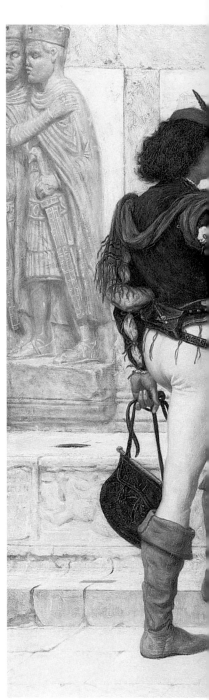

A GREAT number of Wallis's paintings were devoted to literature and lives of writers. *A Despatch from Trezibond* shows a scene from Shakespeare's *The Merchant of Venice*; when first exhibited it was accompanied by the quotation, 'some news is come that turns their countenances'. Shakespeare was one of Wallis's idols – one of his early works was entitled *The Room in which Shakespeare was Born* (1854).

The painting also shows the influence of another of Wallis's enthusisams – his passion for travelling. When Wallis had been painting *Chatterton*, his model was a young actor and poet named George Meredith. While undertaking the work, Wallis fell in love with Meredith's wife and eloped with her – an almost identical story to that of Millais and Ruskin's wife, Effie. As a result of their scandalous marriage, Wallis and his wife preferred to spend much of their life away from a socially restrictive England. The background to *A Despatch from Trezibond* was painted on their travels – in the Piazza San Marco in Venice.

Although Wallis was unable to create another Pre-Raphaelite masterpiece to rival *Chatterton*, *A Despatch from Trezibond* exhibits strong Pre-Raphaelite links, not simply because of its Shakespearian subject matter, but because of its close attention to detail, particularly in the models' costumes.

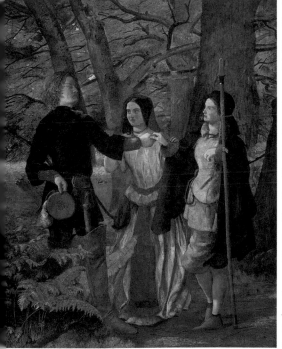

Walter Howell Deverell
A Scene from 'As You Like It', 1853
Courtesy of Birmingham Museums and Art Gallery. (See p. 48)

187

WILLIAM LINDSAY WINDUS (1822–1907)
Too Late, 1857–58
Courtesy of the Tate Gallery

*T*HIS Pre-Raphaelite-influenced painting deals with an essentially Victorian subject: that of a young woman dying of consumption. Windus was profoundly influenced in his art by Millais' *Christ in the House of His Parents* (1850), which had been so ill-received by the critics. In this oil painting, the woman's faithless lover has returned to her 'too late'. The picture was exhibited at the Royal Academy's Summer Exhibition in 1859. At the time – in the manner of most early Pre-Raphaelite art – it was not well-received, due mainly to Ruskin's critical dislike of the painting. However, in the 1880s, Windus's works were brought back into prominence after patronage from Ford Madox Brown, long an admirer of Windus.

Windus uses the stricken female face as his main focal point he achieves this by shielding the faces of the two other adults. The young girl – the one who has led the young man to his dying lover – is placed too low down to draw attention away from the invalid.

The painting was first exhibited with a quotation from Tennyson's poem, 'Come not when I am dead':

If it were thine error or thy crime
I care no longer, being all unblest;
Wed whom thou wilt, but I am sick of time;
And I desire to rest.

G. F. Watts
The Angel of Death, c. 1870s
Courtesy of Christie's Images. (See p. 220)

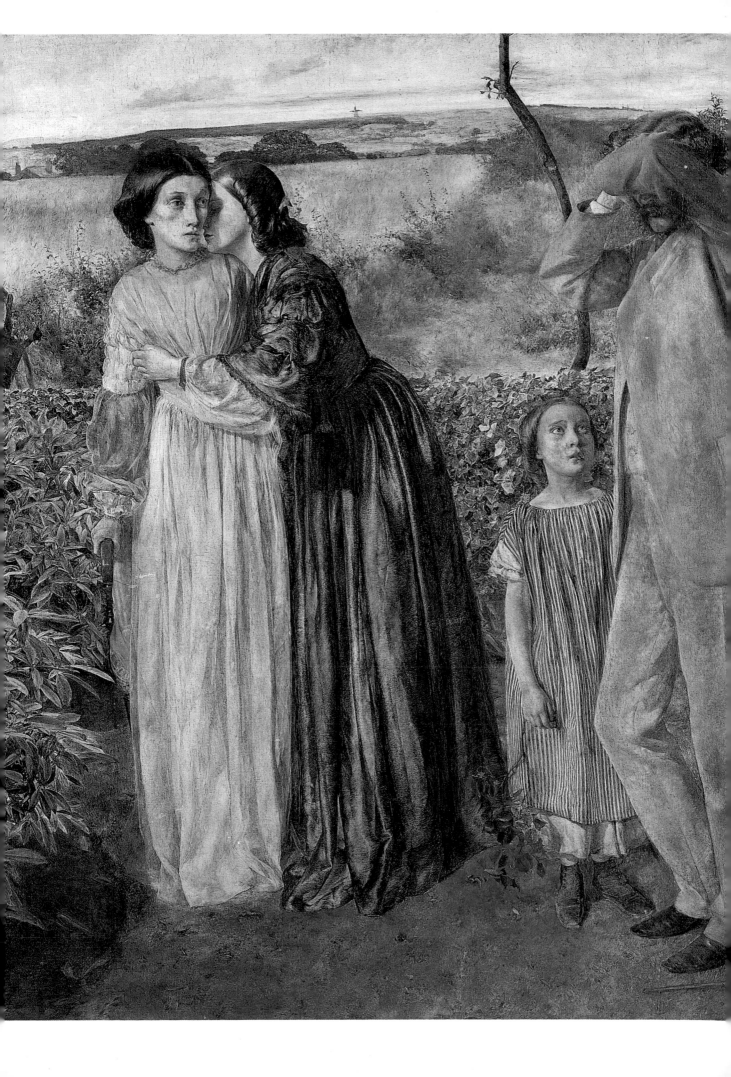

PHILIP HERMOGENES CALDERON (1833–98)
Broken Vows, 1857
Courtesy of the Tate Gallery.

*B*ROKEN VOWS shows a young woman suffering the agonies of betrayal as she overhears her lover flirting with another woman. Her black clothes suggest that their wedding has been postponed until the end of her mourning period and he appears to have been too impatient to wait for her. The black dress is also indicative of the death of their love. The picture is reminiscent of Arthur Hughes' *April Love*, first exhibited in 1856, just a year before Calderon exhibited *Broken Vows*.

Although Calderon made his Royal Academy exhibition debut in 1851, it was not until *Broken Vows* (his third painting) that he received general public acclamation. *Broken Vows* was also the first of his pictures to embrace Pre-Raphaelitism.

Calderon was a dynamic man who went on to become a leading figure in the art world. Initially he spurned the strictures of the Royal Academy and, in emulation of the PRB, became a founder of the St John's Wood Clique. Calderon's 'brotherhood' were following an example set by the original 'Clique' (Augustus Egg, Richard Dadd, John Phillip, H. N. O'Neill and W. P. Frith) who also broke away from the Royal Academy as the Pre-Raphaelites had done, and examined similar ideals. In the style of Millais, Calderon later became a renowned society portraitist, and ended his career by running the Royal Academy school.

Arthur Hughes *April Love, 1855*
Courtesy of the Tate Gallery. (See p. 158)

JOHN RODDAM SPENCER STANHOPE (1829–1908)
Thoughts of the Past, 1859
Courtesy of the Tate Gallery

KNOWN as one of the 'second-generation' of Pre-Raphaelites, J. R. S. Stanhope was among Rossetti's mural-painting party at the Oxford Union in 1857, together with Arthur Hughes, John Hungerford Pollen, Valentine Prinsep, 'Ned' Burne-Jones and William Morris (nicknamed 'Topsy'). He was a founder member of the Hogarth Club, a direct descendant of the Pre-Rapahelite Brotherhood.

This picture, with its depiction of a prostitute remorsefully contemplating her life, showed a subject typical of the Victorian era. Works such as *Thoughts of the Past* and Rossetti's *Found* (1855) allowed the genteel gallery-going public to sympathise with societal problems – from a safe distance. It was pictures such as Hunt's *The Awakening Conscience* (1854), which illustrated a married man and his mistress, which were regarded as threatening to Victorian family life.

Stanhope painted *Thoughts of the Past* in a studio just above one owned by Rossetti. Although his model is recogniseably Pre-Raphaelite, the background of his painting hints at his own individual, artistic style, which was yet to emerge. The river, boats and bridge owe more to the conventional style of the art in the Royal Academy than to that of the Pre-Raphaelite Brotherhood. *Thoughts of the Past* is also strongly allied, in terms of composition, to another of Stanhope's works, *Juliet and her Nurse* (c. 1863).

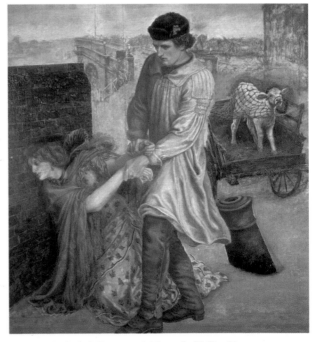

Dante Gabriel Rossetti *Found, 1853–62*
Delaware Art Museum. Courtesy of the Bridgeman Art Library. (See p. 54)

JOHN RODDAM SPENCER STANHOPE
(1829–1908)
Love and the Maiden, 1877
Courtesy of Christie's Images

*L*OVE and the Maiden and *Thoughts of the Past* (1859) could have been painted by two separate artists rather than one man in two radically different artistic phases of his life. Although he began as fervently Pre-Raphaelite in outlook, Stanhope was deeply attracted by the Aesthetic movement during the 1860s. *Love and the Maiden* is a succinct mingling of these two equally formative phases in his career. Its presence in the 1877 exhibition at the Grosvenor Gallery – Aestheticism's most famous exposé – demonstrates his adherence to the latter movement, whereas the painting's similarity to the work of Burne-Jones and Rossetti – the group of dancing women in the background are similar to those portrayed by Rossetti in *The Bower Meadow* (1871–72) – betray Stanhope's Pre-Raphaelite background.

During his time in Oxford in 1857, Stanhope wrote that he spent most days painting with Burne-Jones; possibly as a result of this, a great deal of Burne-Jones's influence can be seen in his work – although it could be argued that Burne-Jones also drew ideas from Stanhope's work. The androgynous physiques, Grecian-style draperies and facial expressions depicted in *Love and the Maiden* are classic Burne-Jones hallmarks, although the facial similarities probably also arose from use of the same models.

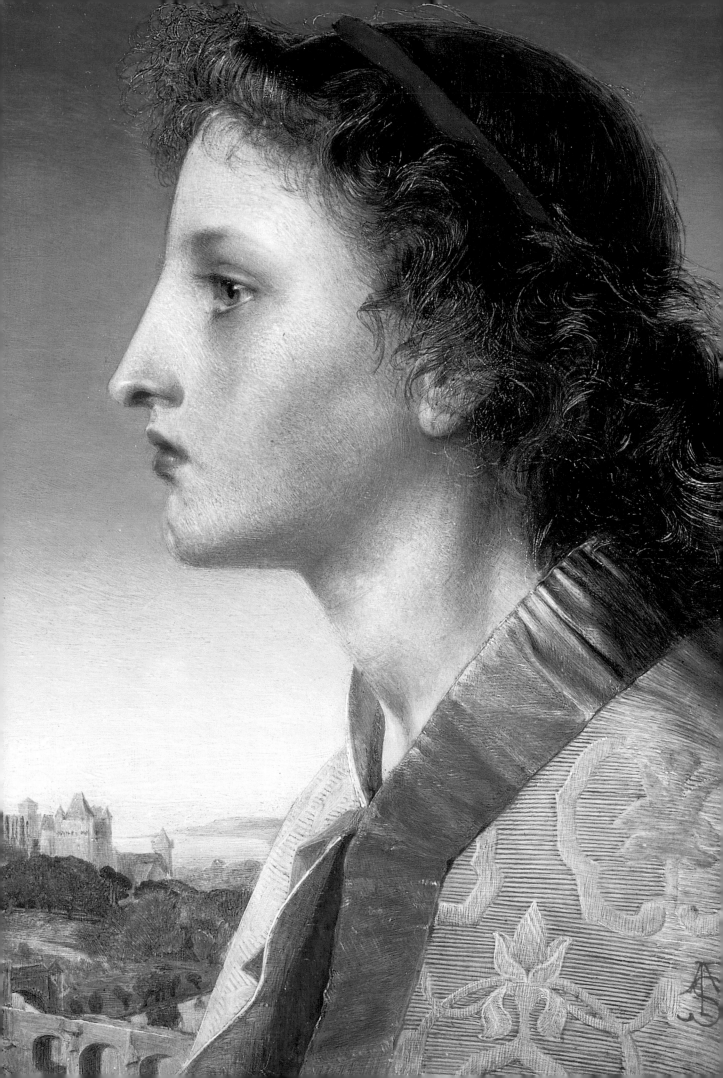

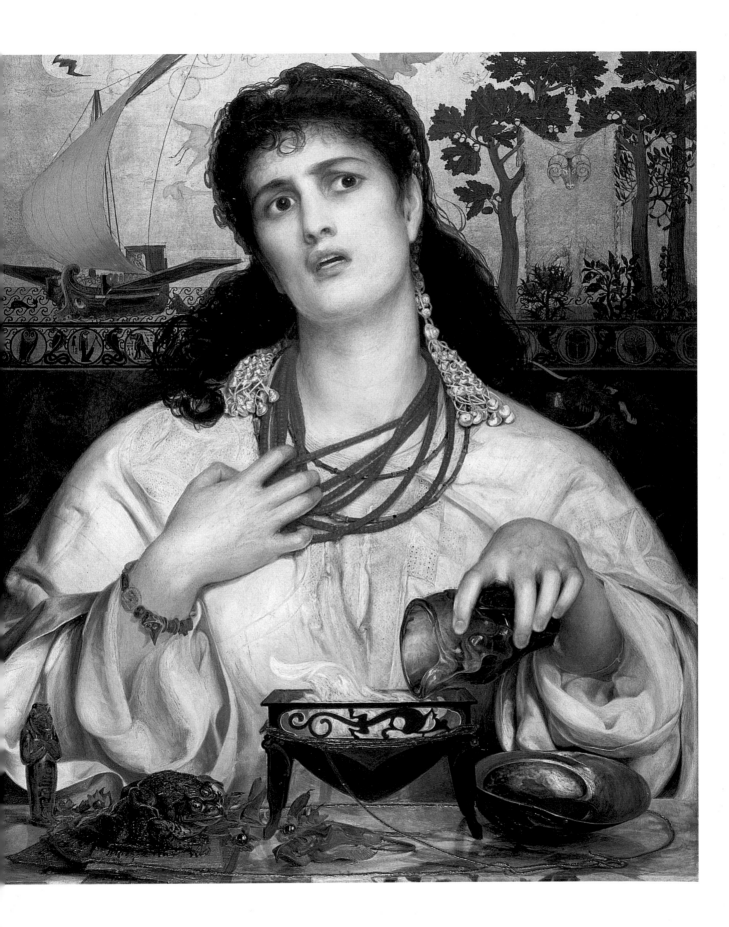

FREDERICK SANDYS (1829–1904)
Love's Shadow, 1867

Courtesy of Christie's Images

THE model for *Love's Shadow* was a London actress, whose stage name was Miss Clive (her real name was Mary Emma Jones). She had been a favourite model of Sandys for five years by the time this picture was painted; she was also his lover and, eventually, the mother of his 10 children. Mary was painted again in 1871–73 in a work he entitled *Mrs Frederick Sandys*. Both portraits were executed in chalk, but the two could not be more different from one another. *Love's Shadow* bears a distinct resemblance to works such as *Medea* (1866-68) or *Morgan le Fay* (1864); in it the woman is portrayed as evil, dangerous and probably mad. *Mrs Frederick Sandys*,

however, is a delicate, loving portrait, created in flattering soft shades of chalk and illustrating exactly why Miss Clive was renowned as one of the greatest beauties of the time.

Love's Shadow was begun during the months an impoverished Sandys spent living with Dante Rossetti in his grand house in London's Cheyne Walk. Rossetti was renowned for his generosity towards artists in financial straits and younger artists were automatically drawn by his magnetism, as well as his discreet offers of help. Sadly, the relationship turned sour when Rossetti accused Sandys of plagiarism.

Dante Gabriel Rossetti
Study for Delia, 1853–55
Courtesy of Birmingham Museums and Art Gallery. (See p. 56)

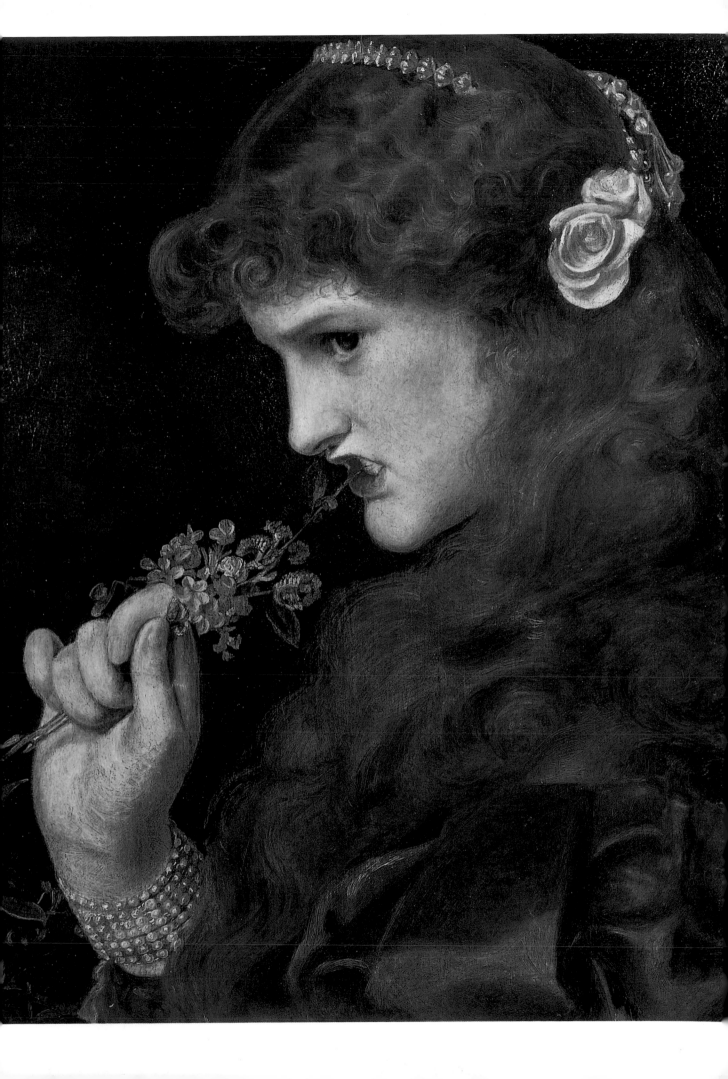

FREDERIC, LORD LEIGHTON (1830–96)
Lieder ohne Worte, c. 1861
Courtesy of the Tate Gallery

*L*ORD Leighton often remarked that he could never think of appropriate names for his paintings; originally he called this simply 'my little girl at the fountain'. It was after a private viewing of his work that the title we know it by was mooted. He received a letter from Mr Ralph A. Benson, who had attended the viewing, in which he told the artist that his wife had suggested *Lieder ohne Worte* ('song without words'), Leighton saw that this title conveyed exactly what he had been trying to portray in his painting and the name was adopted.

The picture was inspired by Leighton's travels to Italy, attempting to encapsulate in the simple scene of a girl collecting water from a nearby fountain all that Leighton perceived as the country's charm. Leighton's father, who was often critical of his son's work, was not happy with the painting, finding it too idealised, not realistic enough to convey the true character of Italy. In its defence, Leighton wrote the following to his parent: 'I remember telling you before I began to paint *Lieder ohne Worte* that I intended to make it realistic, but from the first moment I began I felt the mistake, and made it professedly and pointedly the reverse.'

William Holman Hunt *Sketch for: A Street Scene in Cairo: The Lantern-Maker's Courtship, 1861*
Courtesy of Birmingham Museums and Art Gallery. (See p. 92)

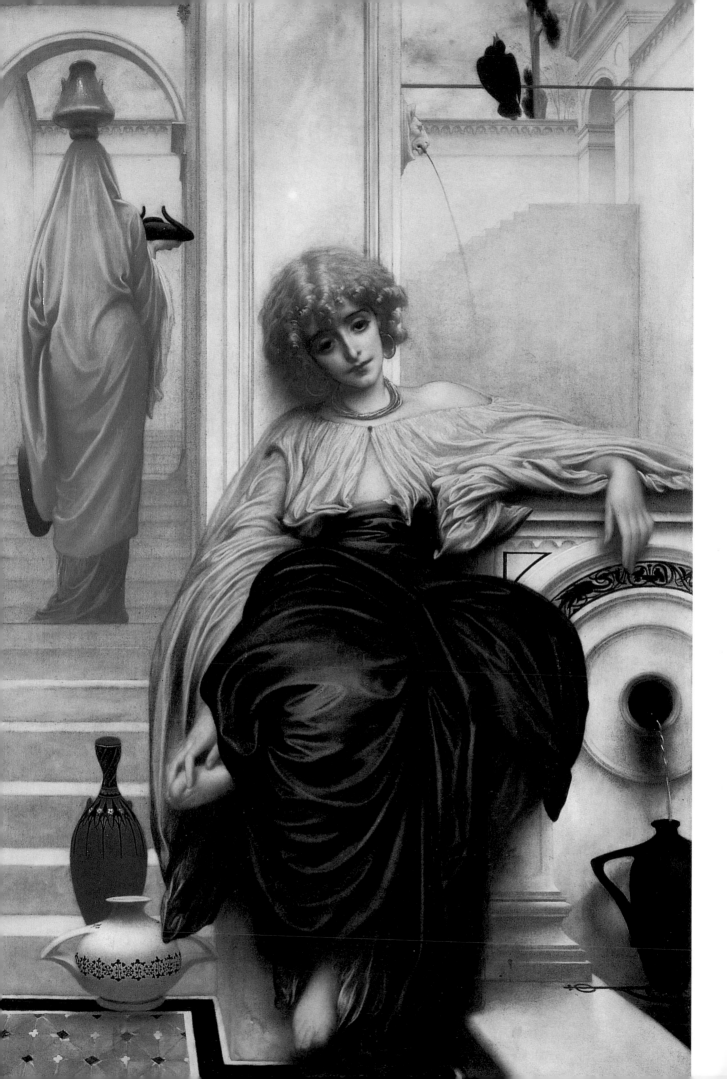

FREDERIC, LORD LEIGHTON (1830–96)
The Painter's Honeymoon, c. 1864
Courtesy of Christie's Images

THIS is an interesting composition for Leighton, who usually veered towards Classical images and, in particular, favoured nudes – the latter were so prolific in his work that many of his pictures had to be removed from the 1857 exhibition of English art that toured America, because they gave offence.

The Italian man who sat for the newly married painter occurs often in Leighton's work; he was apparently one of the artist's favourite models. Importantly, his hands are painted in fine detail, emphasising how crucial they are to his work. The soft tones and accuracy with which Leighton painted the couple contrasts obviously with the harshness of the orange tree behind them. Leighton appears to have had difficulty in painting it – on close inspection, the oranges look as though they have been enamelled.

The Painter's Honeymoon was first exhibited at the Royal Academy in 1866 – it appears that Leighton deliberately prevented it from being shown publicly in the years following its completion. As Leighton was renowned for his lack of confidence and shyness, many of his contemporaries believed he felt he had betrayed too much of his own emotion to feel comfortable exhibiting the picture.

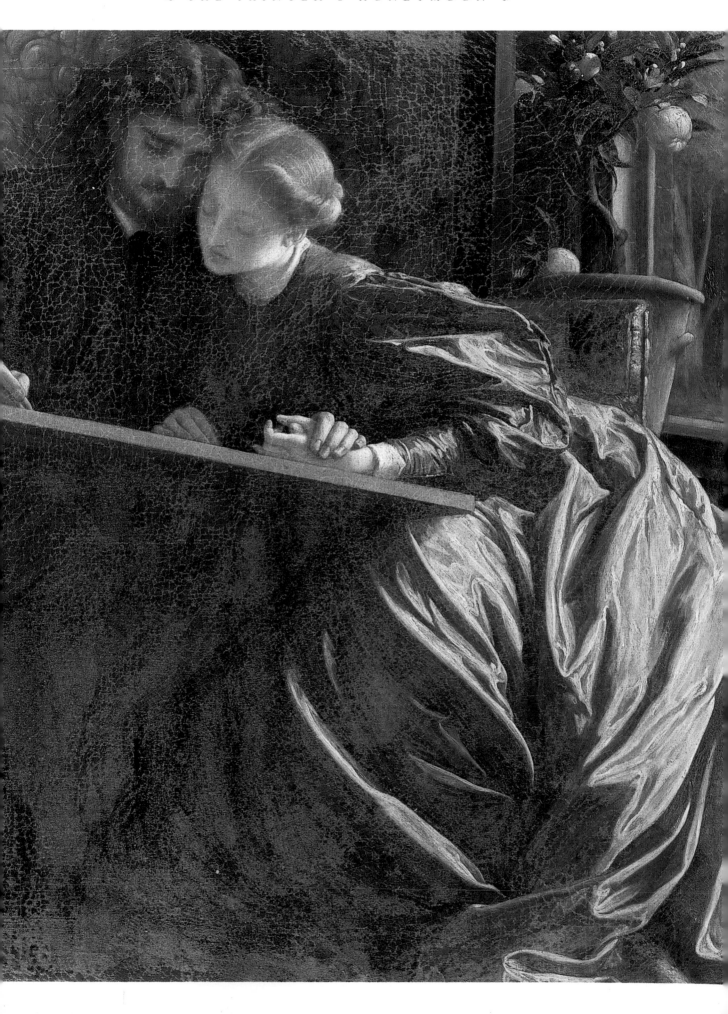

FREDERIC, LORD LEIGHTON (1830–96)
Flaming June, 1895
Courtesy of Christie's Images

*F*LAMING *June* was first begun as a motif to adorn a marble bath in one of Leighton's other works, *Summer Slumber*. He became so attached to the design that he decided to create it as a painting in its own right.

The position of the sleeping woman gave Leighton a great deal of trouble. He made several preliminary sketches to determine the way in which she should lie; in particular he had difficulty making the angle of her right arm look natural. His studies show that the picture went through at least four evolutionary sketches before Leighton came to on the end result. Out of these studies, four are nude and one is draped. The draped figure looks the least life-like, demonstrating Leighton's need to draw from a naked model in order to achieve a fidelity to nature.

Flaming June has become Leighton's most recognisable picture. The transparent material worn by the sleeping woman – through which her right nipple can be seen clearly – is typical of Leighton's artistic predelictions, as

Sir Lawrence Alma-Tadema
The Meeting of Anthony & Cleopatra 41 BC, 1883
Courtesy of Christie's Images. (See p. 219)

are the stunningly rich colours and the perfectly recreated marble surround. Just as Brown spent his life recreating the effects of natural light, Leighton shows a preoccupation with it, allowing the sunset in the background to appear as molten gold.

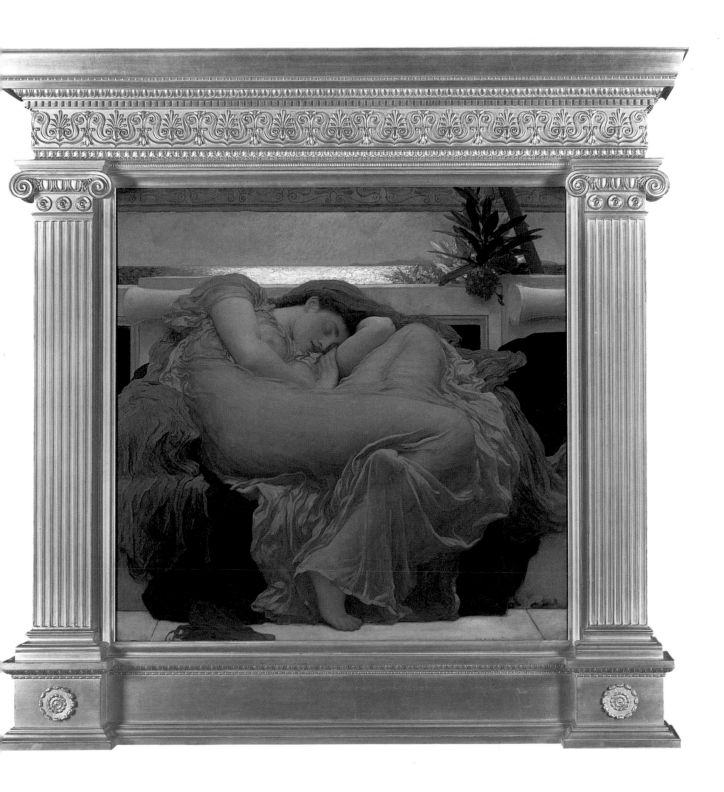

SIMEON SOLOMON (1840–1905)
Bacchus, 1867
Courtesy of Birmingham Museums and Art Gallery

T HE rich colours of *Bacchus* were inspired by Solomon's travels through Italy: the intensity of the sky, the warm skin tones of Bacchus and the natural hues of the vine wreath and grapes, indicative of the god of wine. Most written or pictorial representations of Bacchus portray him as corpulent, debauched and old; yet Solomon chose to paint him as young, handsome and innocent in appearance, his winsome eyes gazing into the distance beyond his portrait's viewers.

Solomon made two versions of *Bacchus*; a considerably less impressive three-quarter length watercolour (1867) was followed by this magnificent oil painting. The same Italian model appears to have been used for both, but Solomon seemed to have trouble painting him in the watercolour, which lacks vibrancy and proportion.

This oil version of *Bacchus* is one of the greatest masterpieces of Pre-Raphaelite art, and offers an idea of how great Solomon's career could have been had he not lived in Victorian society, which shunned him for his sexuality. The painting was highly praised by the great art critic Walter Pater, and lauded by Burne-Jones

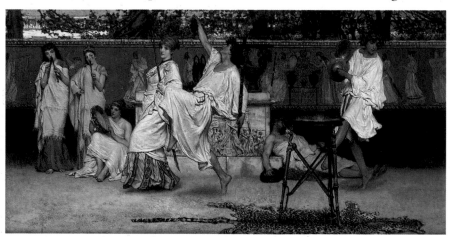

Sir Lawrence Alma-Tadema *Bacchanal, 1871*
Courtesy of Christie's Images. (See p. 216)

and his contemporaries. The latter also wrote that he considered Solomon 'the greatest living artist of us all'.

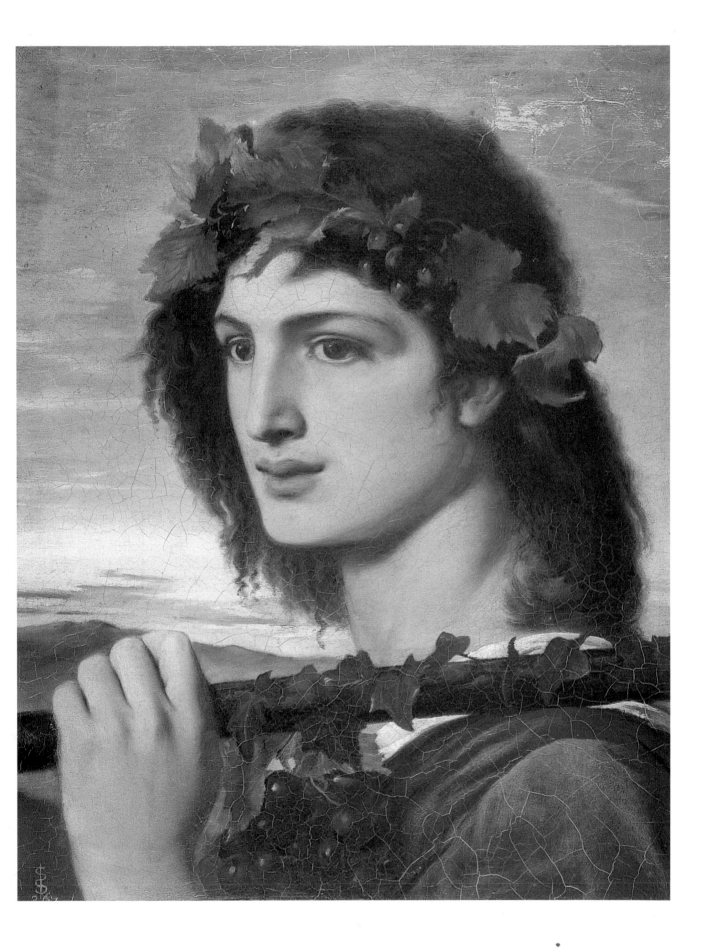

SIMEON SOLOMON (1840–1905)
Dawn, 1871

Courtesy of Birmingham Museums and Art Gallery

SIMEON Solomon was a poet as well as a painter. In 1871, his homoerotic prose-poem *A Vision of Love Revealed in Sleep* was published. *Dawn* emerged from the following lines: 'with one hand he cast away his dim and heavy mantle from him ... as he turned his head to the East ... the light rested upon his face; the smile it kindled made the East to glow and Dawn spread forth his wings to meet the new-born Day.'

The poem was attacked by Robert Buchanan – along with the poetry of Rossetti – in his furious critique *The Fleshly School of Poetry* (1872); the criticism pushed Rossetti's precarious mental state over the edge.

Solomon was famed in Aesthetic circles for his homoerotic pictures, such as *Love Among the Schoolboys* (1865), bought by Oscar Wilde; the lesbian *Sappho and Erinna in the Garden Mateiene* (1864) and his bisexual drawing, *The Bride, the Bridegroom and Sad Love* (1865). *Dawn*, as was B*acchus*, is sanitised homoeroticism, made palettable to the Victorian art market.

Two years after *Dawn* was exhibited, Solomon was found guilty of 'gross indecency' and sentenced to six months' imprisonment. His career (and consequently that of his artist sister, Rebecca) never recovered. His former idol and mentor, Rossetti, shunned him, as did most other Pre-Raphaelites. From 1873 until his death in 1905 he lived a life of destitution and alcoholism.

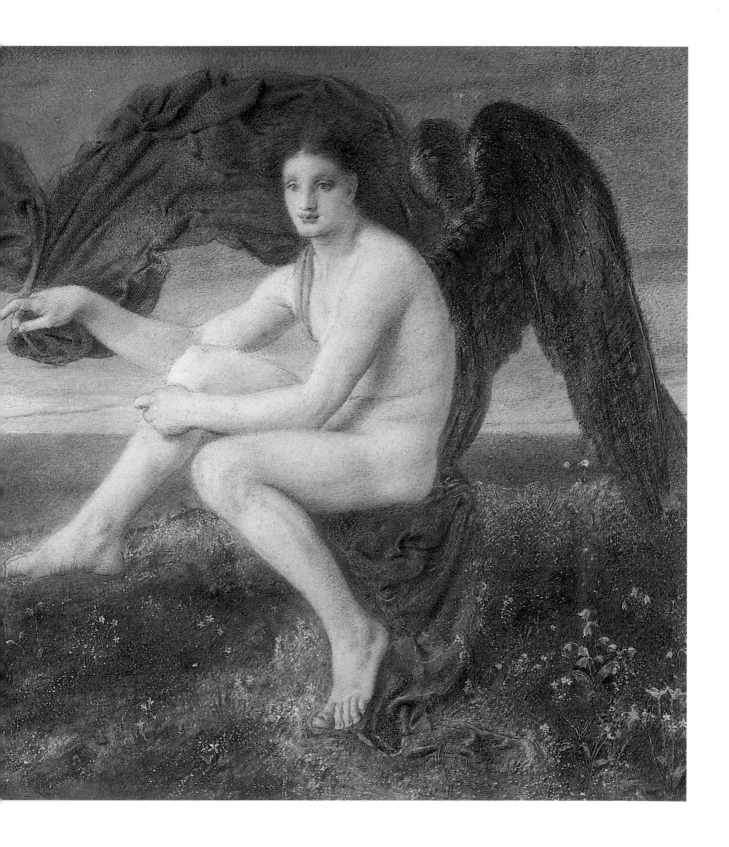

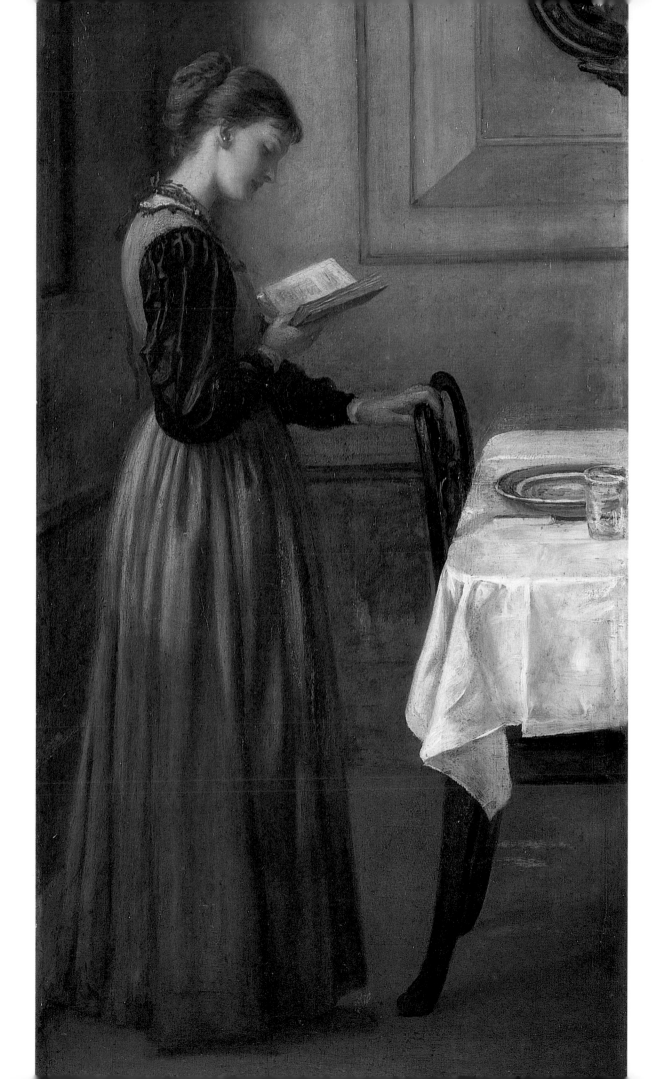

VALENTINE CAMERON PRINSEP (1838–1904)
Study of a Girl Reading, c. 1860s–70s
Courtesy of Christie's Images

G. F. WATTS spent many years lodging with Prinsep's parents, and during this time he encouraged the boy to become a painter. At the age of 19, Prinsep also came into contact with Dante Rossetti, as one of the group of enthusiastic mural painters at Oxford in the summer of 1857. Sadly, their enthusiasm was blighted by a basic ignorance of mural technique – they did not think to prepare the walls and the pigments started to sink into the walls within months of the pictures being completed. Today, despite many efforts to revive them, the pictures have almost disappeared.

Prinsep freely admitted that his art, following that blissful summer, was directly influenced by the charismatic Rossetti. In *Study of a Girl Reading*, however, he appears to have created his own style, adhering more closely to that of a traditional Royal Academy painter. Rossetti's influence can perhaps be spotted in the fact that Prinsep's picture fixes adoringly upon its central female figure.

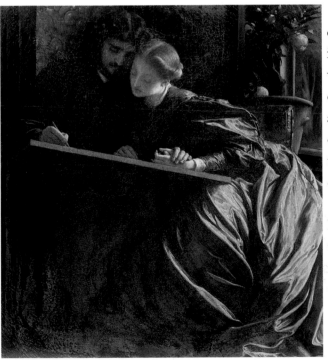

The subject is simple, and could be dull, but Prinsep makes it compelling. He achieves this with the wonderfully absorbed expression of the reading girl, an absorption suggesting a true love of books and a fascination with the story she reads. Leighton created similar absorption in *The Painter's Honeymoon* (1864). Prinsep's girl is too preoccupied to be able to lay the book aside, instead she wanders, transfixed, towards the table, still reading.

Frederic, Lord Leighton *The Painter's Honeymoon, c. 1864*
Courtesy of Christie's Images. (See p. 206)

SIR LAWRENCE ALMA-TADEMA (1836–1912)
Bacchanal, 1871
Courtesy of Christie's Images

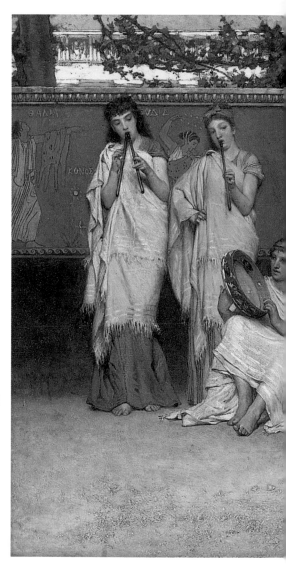

SIR Lawrence Alma-Tadema came to England from the Netherlands. His style of art became highly popular with the Victorian public and he soon made England his permanent home. With a background in Classical academia, Alma-Tadema became renowned for pictures evoking the literature of the ancient Greeks and Romans; just as the Pre-Raphaelite Brotherhood became famous for pictures inspired by the works of such writers as Keats, Browning, Shakespeare and Dante. Although Alma-Tadema belonged more directly to the Neo-Classicists, the art of this latter group owed a large debt to the pioneering work of the PRB.

Bacchanal comes directly from the literature and art of ancient Greece and provides a faithfully detailed, richly coloured vision of Greek art and costume. Sadly, the scene is not the Bacchic ritual one might expect from the title, but a listless gathering of half-hearted revellers. The women, in particular the three musicians, seem almost depressed. The dancing woman was modelled by the artist's wife, Laura Epps – the picture was completed on the morning of their wedding day.

Alma-Tadema is known to have painted over 20 pictures of Bacchic revels; a subject that obviously appealed to a hedonism newly burgeoning in the late-Victorian art world.

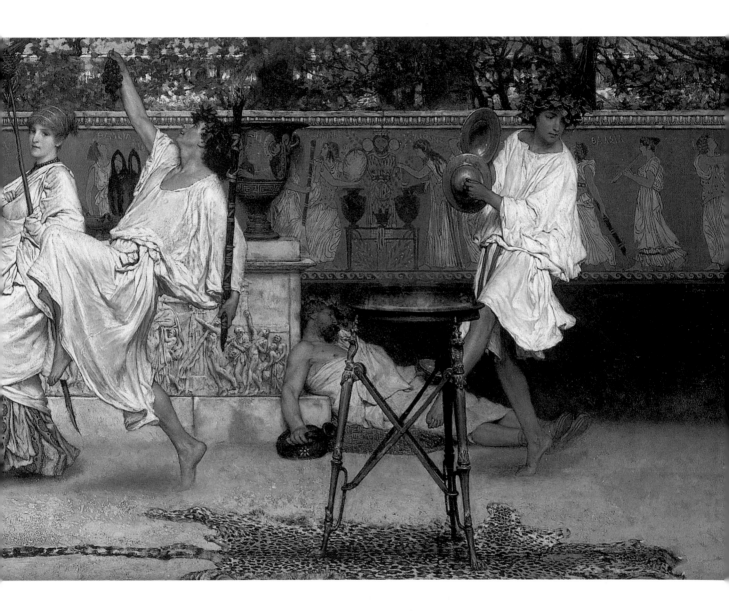

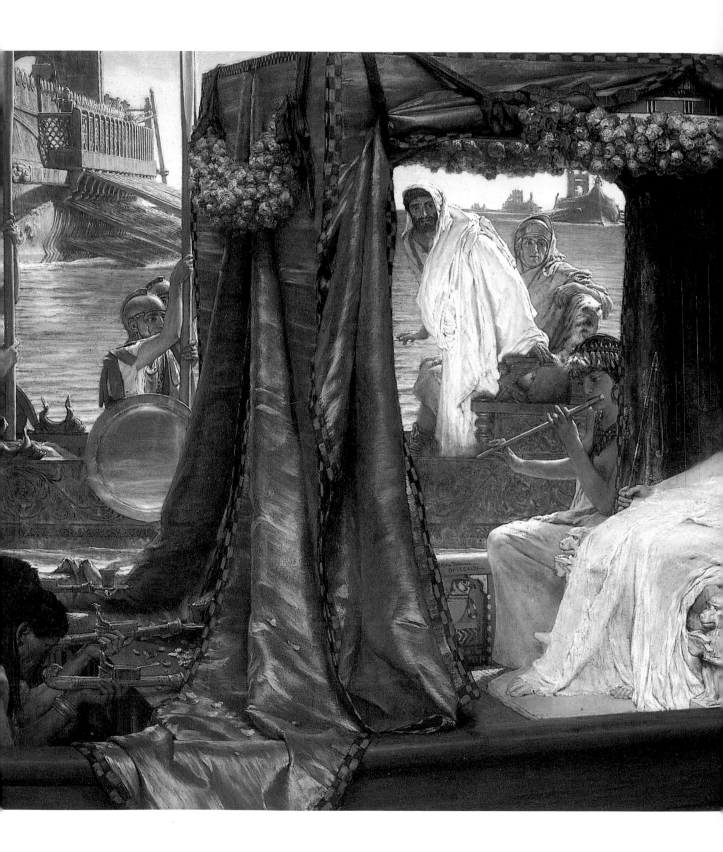

SIR LAWRENCE ALMA-TADEMA
(1836–1912)
The Meeting of Anthony & Cleopatra 41BC, 1883
Courtesy of Christie's Images

IN Alma-Tadema's pictorial vision of Shakespeare's *Anthony and Cleopatra*, he chose a moment of pure voyeurism; that of Marc Anthony approaching Cleopatra's barge, as she waits in seductive expectation. Everything about Alma-Tadema's Cleopatra spells seduction: her languorous pose; her seemingly nonchalant expression (although the viewer can see the sly sideways look of her eyes); the draped fur barely covering the swell of her breasts; the tight clusters of pink flowers above her. Cleopatra is framed on all sides; her pale skin contrasts cleverly with the black and olive skin of her two attendants; and the bronze-coloured covering of her barge fences her in, positioning her clearly where the artist believes she, as queen and concubine, should be – on her throne within the confines of her barge's opulent chamber.

Alma-Tadema was a scholarly painter and, although he often mixed different eras of history in order to create stunning artistic effects, he also paid great attention to detail, such as painting genuine hieroglyphics on the side of Cleopatra's barge; they translate to 'Mistress of Two-Lands, Cleo'. *Anthony and Cleopatra* also demonstrates his masterly command of three-dimensional painting. From the ship in the far background to the slave at the very front of the picture, there are several different layers for the viewers' eyes to explore.

G. F. WATTS (1817–1904)
The Angel of Death, c. 1870s
Courtesy of Christie's Images

*T*HIS is a particularly disturbing painting, dominated by an atmosphere of decay and despair. The face of the angel – similar to that of the faces in Watts' eerie *Paolo and Francesca* (c. 1872–84) – appears to be corroding; in fact most of the figures portrayed in the painting seem to be in various stages of decay. The process of decomposition seems to have already started on the lion and the hunched figure on the right-hand side. From the ghostly white consumptive maiden to the chubby baby, Watts seems to be warning that Death does not discriminate – no matter how noble (the knight), high-born (the king) or humble (the cripple), there is no distinction in the end.

With this painting, Watts was challenging the conventional idea of death being gateway to a better life; instead he portrays it as a hideous end. None of the unfortunates met by the angel seem aware that they may go to an unearthly paradise. All are humbling themselves before the angel in attitudes of despair. The king symbolically removes his crown, aware that his majesty cannot save him; the woman appears to be have abandoned hope. The angel's face is unfathomable.

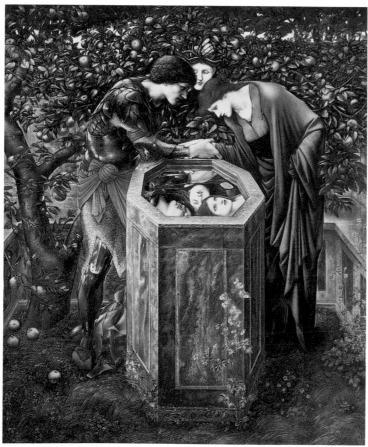

Sir Edward Coley Burne-Jones *The Baleful Head, 1886–87*
Courtesy of Bridgeman-Giraudon. (See p. 152)

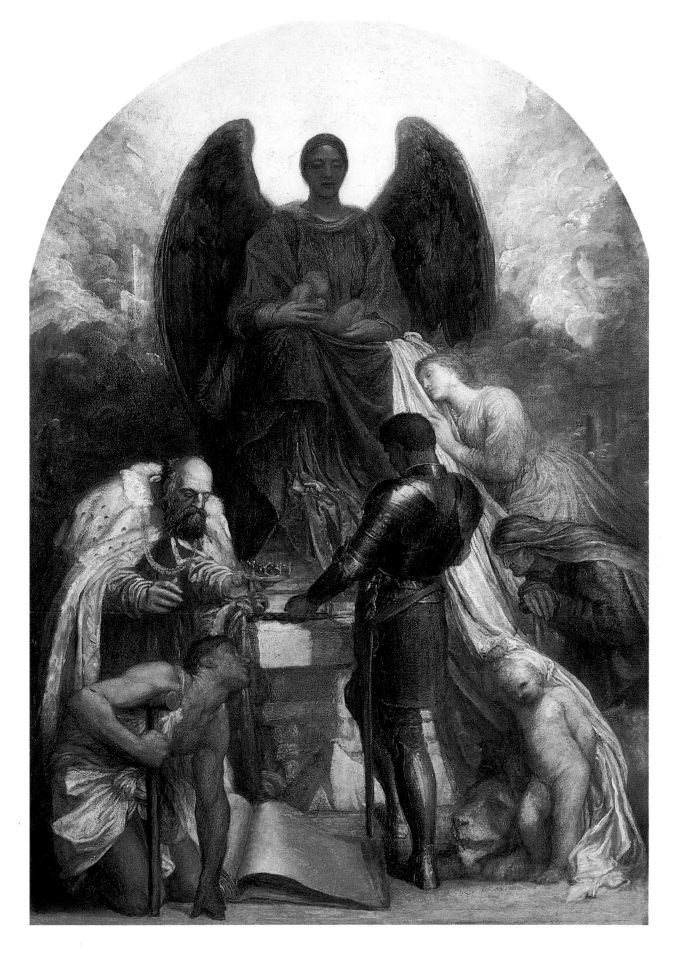

G. F. WATTS (1817–1904)
Love and Death, 1874–77
Courtesy of the Whitworth Art Gallery

THE magnificent *Love and Death* was one of Watts' most celebrated pictures. Its very size alone makes it stand out – 248.9 x 116.8 cm (98 x 46 in) – as does the dramatic subject matter. The painting was inspired by the untimely death of a friend of Watts, the 8th Marquis of Lothian, who died of a wasting disease while still young. The inevitability of Death is poignantly rendered by the valiant attempts of Love to defeat his protagonist, knowing that his cause is defeated. The vital flesh tones of the Cupid, picked out by the blush-pink roses, contrast vividly with the ashen tones of the towering figure of Death.

Watts wanted his works of art to speak as eloquently as poetry. He explained the painting in a letter, saying 'love is not restraining Death, for it could not do so. I wished to suggest the passionate though unavailing struggle to avert the inevitable.'

Love and Death is also important for its place of honour in the Grosvenor Gallery exhibition of 1877. The critics included F. G. Stephens, William Rossetti and Oscar Wilde, all of whom wrote glowingly about Watts' creation. The Grosvenor Gallery itself was vital to the growth of Victorian art, heralding the advent of the Aesthetic movement and, most important, providing an alternative to the Royal Academy exhibitions.

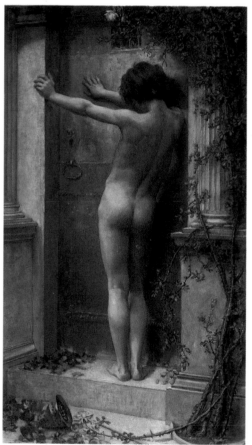

Anna Lea Merrit *Love Locked Out*, 1889
Courtesy of the Tate Gallery. (See p. 242)

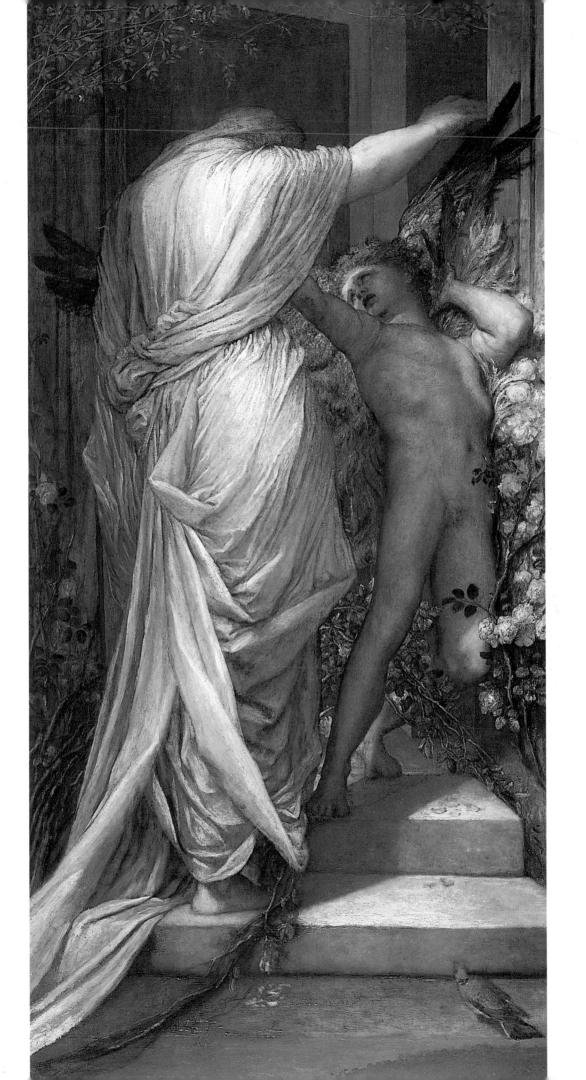

J. W. INCHBOLD (1830–88)
Lake Leman with the Dents du Midi in the Distance, c. 1879–87
Courtesy of Christie's Images

J.W. INCHBOLD played an important part in the Pre-Raphaelite movement. By 1854 he was associating regularly with its key members in the worlds of art and literature. He was also a member of the Pre-Raphaelite-inspired Hogarth Club.

William Rossetti described Inchbold as the 'highest of the strictly Pre-Raphaelite landscape painters'. Ruskin was also a fan, particularly as Inchbold had been strongly influenced by *Modern Painters* (1843). Over the years, the author began to recommend Inchbold as the only landscape painter who adhered to Ruskin's stated principles.

Inchbold was a solitary man, prone to minor arguments with his peers and reportedly difficult to be with for any length of time. This may well explain his preference for landscapes over the painting of figure subjects which would involve constant interaction with the models.

From the 1860s, Inchbold began travelling abroad regularly. His paintings of this time are often inspired by European views, as is the case with *Lake Leman with the Dents du Midi in the Distance*, although he was also very attached to Britain, and Cornwall in particular. As well as being a prolific painter, Inchbold wrote poetry and, in 1876, published a volume of sonnets entitled *Annus Amoris*.

CHARLES EDWARD HALLÉ (1846–1919)
Luna, c. 1870s–80s

Courtesy of Christie's Images

THIS is an intriguing picture in view of the fact that it has not been properly identified, and therefore the subject and date are unknown. Hallé spent much of his youth travelling, mainly as an antidote to ill health, and spent large amounts of time in Italy, where he fell in love with Venice. It was upon his return to England, in the late 1860s, that he began a promising career as a portrait painter. It was also around this time that Hallé became acquainted with Dante Rossetti and Burne-Jones. From that time onwards his painting style was influenced by the Pre-Raphaelite movement and the on-going trend towards Aestheticism.

Luna contains many elements of the portraiture of Rossetti and Burne-Jones, such as the direct gaze and the central positioning of the model; however, the peacock feather painted onto the fan suggests a strong Aesthetic influence. Whether the picture was painted as a portrait or as a work of visual fiction is unknown.

Hallé also became a patron of artists by aiding Sir Coutts Lindsay in setting up the Grosvenor Gallery – a centre for the Aesthetic movement and much frequented, in his role of critic and aesthete, by Oscar Wilde.

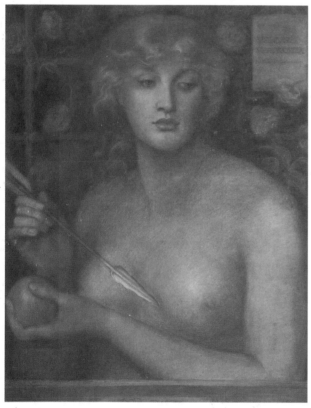

Dante Gabriel Rossetti *Venus Verticordia, 1867*
Courtesy of Christie's Images. (See p. 112)

CHARLES EDWARD HALLÉ (1846–1919)
Paolo and Francesca, 1888
Courtesy of Christie's Images

*C*HARLES Edward Hallé's *Paolo and Francesca* clearly demonstrates how the ideals of the Pre-Raphaelite Brotherhood flowed on into the works of later artists. Despite being only a few months older than the Brotherhood itself, Hallé was amongst that school of artistic thinkers who chose to follow the principles and continue the ideals of the young Rossetti, Hunt, Millais and so on.

The theme is taken from the poetry of Dante Alighieri and the story of the forbidden love between Francesca da Rimini and her brother-in-law Paolo. It was a theme that was particularly close to the heart of Dante Gabriel Rossetti, who also illustrated this subject, although his watercolour took the form of a triptych illustrating the lover's fate as well as the fateful kiss. Hallé's version is more passionate than Rossetti's, showing the lovers' book thrown unnoticed to the floor as Paolo pulls Francesca towards him.

Hallé's painting illustrates the link between Pre-Raphaelitism and High Victorian art perfectly. The subject matter is Rossettian, his hero is reminiscent of a Burne-Jones figure and his background is redolent of an Alma-Tadema painting.

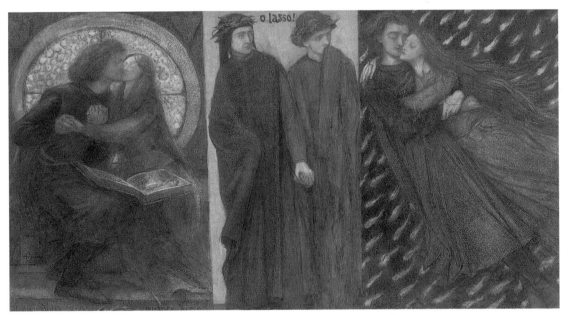

Dante Gabriel Rossetti *Paolo and Francesca da Rimini, 1855*
Courtesy of the Tate Gallery. *(See p. 98)*

EVELYN DE MORGAN (C. 1850–1919)
Hero Holding the Beacon for Leander, 1885
Courtesy of Christie's Images

D E MORGAN was the niece of J. R. Spencer Stanhope. She was also married to William de Morgan, a designer for Morris and Company. Evelyn was one of many artists who assimilated the Pre-Raphaelite style with that of other artistic movements; she was especially influenced by Burne-Jones and earlier Italian artists, such as Botticelli, but her style shows elements of newer artistic movements. Her works include *Helen of Troy* (1898), *Cassandra* (1898) and *Queen Eleanor and Fair Rosamund* (c. 1902) – all subjects which were covered by the Pre-Raphaelite Brotherhood. Like Burne-Jones, Evelyn also favoured the medium of gouache, as used here.

Hero and Leander lived in ancient Greece, on opposite sides of the Hellespont. Hero was a priestess at the temple of Venus (one of Burne-Jones's favoured subjects) and Leander was her mortal lover. At nights Leander would swim to Hero, guided through the treacherous waters by the beacon she held. When Leander drowned during a turbulent storm, Hero plunged into the sea, dying in the same way as her lover.

De Morgan's figure of Hero seems of a different artistic style than her creation of the background. The blocks of houses behind her seem a precursor to Cubism, while the sky would not look out of place in a Surrealist landscape.

John Roddam Spencer Stanhope
Love and the Maiden, 1877
Courtesy of Christie's Images. (See p. 194)

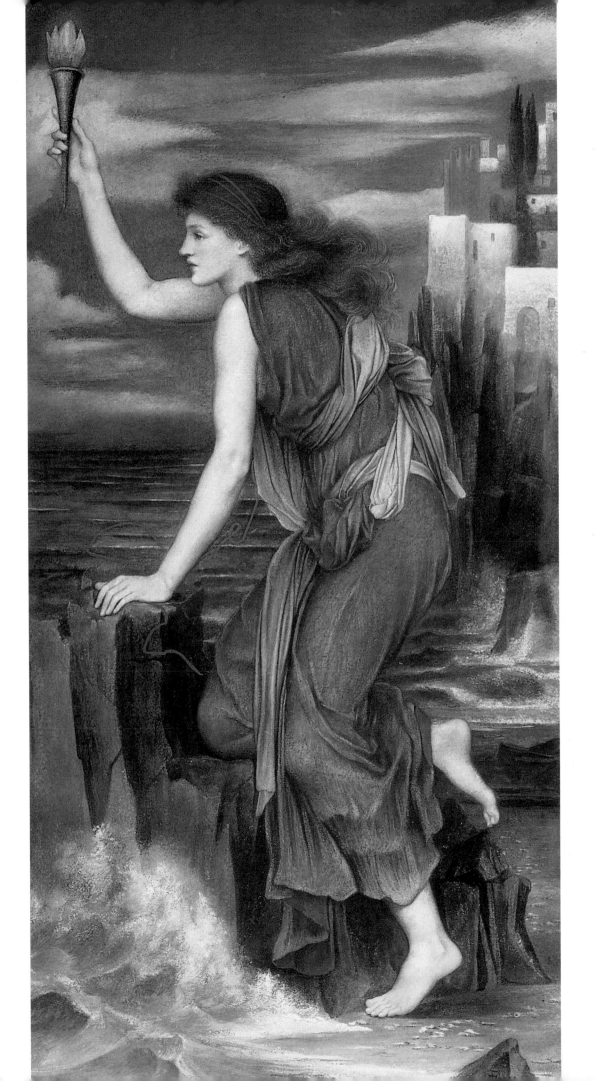

JOHN WILLIAM WATERHOUSE (1849–1917)
St Eulalia, 1885

Courtesy of the Tate Gallery

*T*HIS is one of Waterhouse's most unusual, and consequently most striking, oil paintings. The corpse of a 12-year-old girl seems singularly out of place for a Waterhouse painting, but he managed it superbly. His choice of composition – situating the corpse across the front and leaving so much of the central canvas unoccupied – was risky but it worked: by placing all the background figures in the distance, he concentrated the viewer's gaze on the naked corpse. The nudity was also groundbreaking for Waterhouse – and something that could have laid him open to criticism – but his sensitive handling of the subject, the youth of the saint, and the historical context of the painting allowed him to escape the critics' pen. The eye is also led to the murdered girl by the angle of the Roman guard's spear, pointing to the ropes that had bound her to the stake.

According to legend, the snow was believed to have been sent by God as a shroud to cover the saint; and the dove, seen flying upwards near the crowd of mourners, indicative of Eulalia's soul flying up to Heaven, was said to have flown out of her mouth.

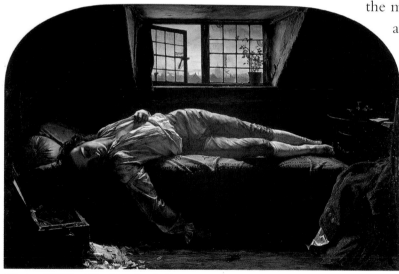

Henry Wallis *The Death of Chatterton, 1856*
Courtesy of the Tate Gallery. (See p. 182)

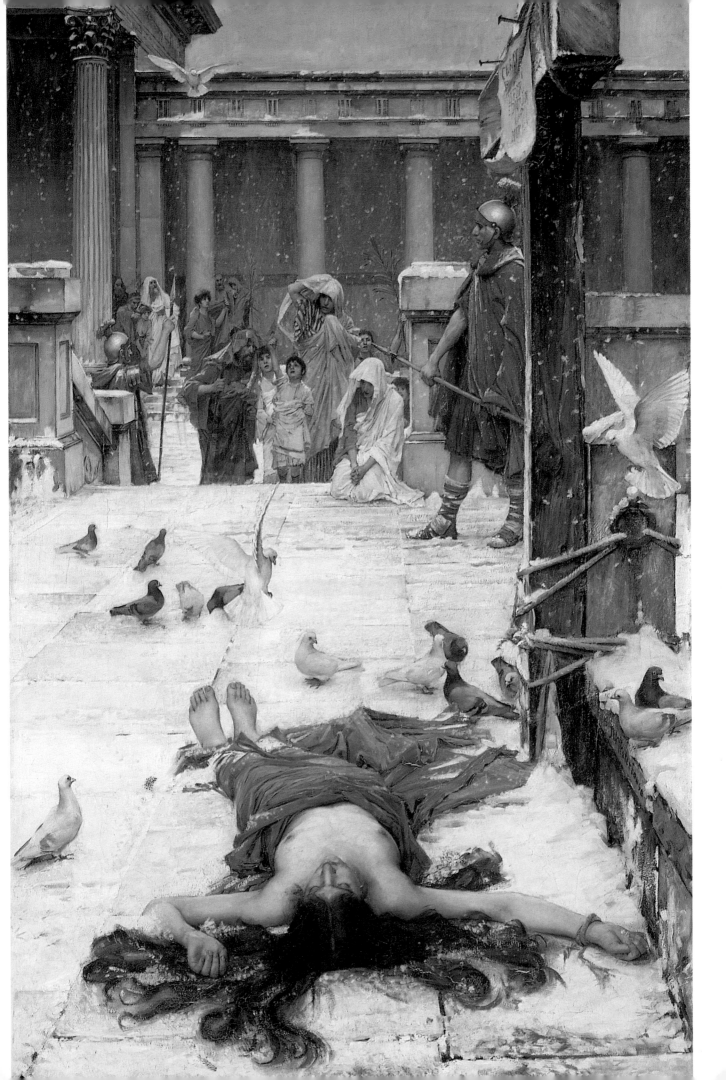

JOHN WILLIAM WATERHOUSE (1849–1917)
The Magic Circle, 1886
Courtesy of the Tate Gallery

*T*HIS oil painting was extremely successful with the critics and public alike. In a style typical of Waterhouse, the main, female, character is a lone figure, placed centrally on the canvas. The surrounding landscape is hazy, as though it is not quite real, and the background figures are only discernible on close inspection, deliberately ensuring the witch is the only image of importance.

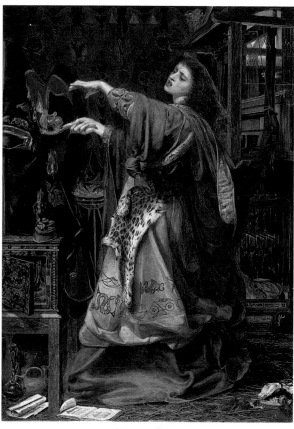

Frederick Sandys *Morgan le Fay, 1864*
Courtesy of Birmingham Museums and Art Gallery. (See p. 198)

Waterhouse paid careful attention to the angles employed in this painting, balancing the circle the figure is drawing around herself by the use of a triangle – her straight arm, extended by the straight stick, held out at 45 degrees to her erect body. Triangles are also important symbols of witchcraft and the Devil. The witch's power is emphasised by the determined face, by her exclusion of the ravens and frog – popular symbols representing magic – and by her command over the smoke. Instead of billowing outwards or being affected by the wind, it remains in a straight line.

The Magic Circle is similar in composition to Waterhouse's later picture, *Miranda* (1916); also a woman associated with magic. The witch wears a similar dress to *Miranda* and her face can also only be seen in profile. Unlike Frederick Sandys' portrayals of sorceresses, such as his *Medea* (1866–68) or *Morgan le Fay* (1864), Waterhouse chose to make his witch's face intent and intriguing, as opposed to evil.

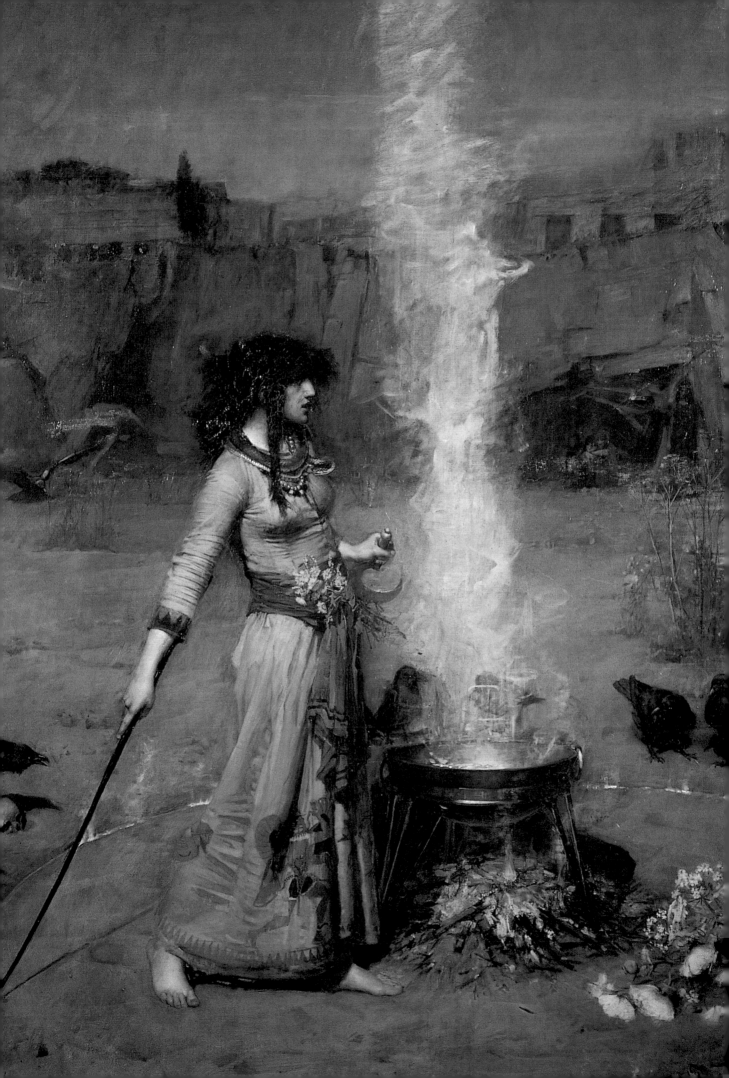

JOHN WILLIAM WATERHOUSE
(1849–1917)
The Lady of Shalott, 1888
Courtesy of the Tate Gallery

THIS oil painting was exhibited at the Royal Academy in 1888, 30 years after Arthur Hughes' *The Lady of Shalott* (1858), from which it appears Waterhouse took much of his inspiration. Waterhouse was a great admirer of Tennyson and particularly of 'The Lady of Shalott'; he came up with several illustrations to the poem, including a spectacular oil painting of the Lady trapped within her loom, not dissimilar to the way in which Hunt chose to illustrate the poem. Waterhouse owned a copy of the collected works of Tennyson – the pages of which are covered in the artist's sketches for proposed illustrations.

The model for this picture was probably the artist's wife which is perhaps why Waterhouse is able to capture the despair on the Lady's face with poignant accuracy. His symbolism of just one last candle left to be blown out before her death adds to the dramatic import of this painting.

The Lady of Shalott is also notable for being Waterhouse's first serious attempt at painting in the open air. As a result the background is realistic and in keeping with the views espoused by John Ruskin, in his Pre-Raphaelite bible, *Modern Painters* (1843). Paying careful attention to Tennyson's words, Waterhouse chose to illustrate one phrase in this painting:

She loos'd the chain and down she lay.

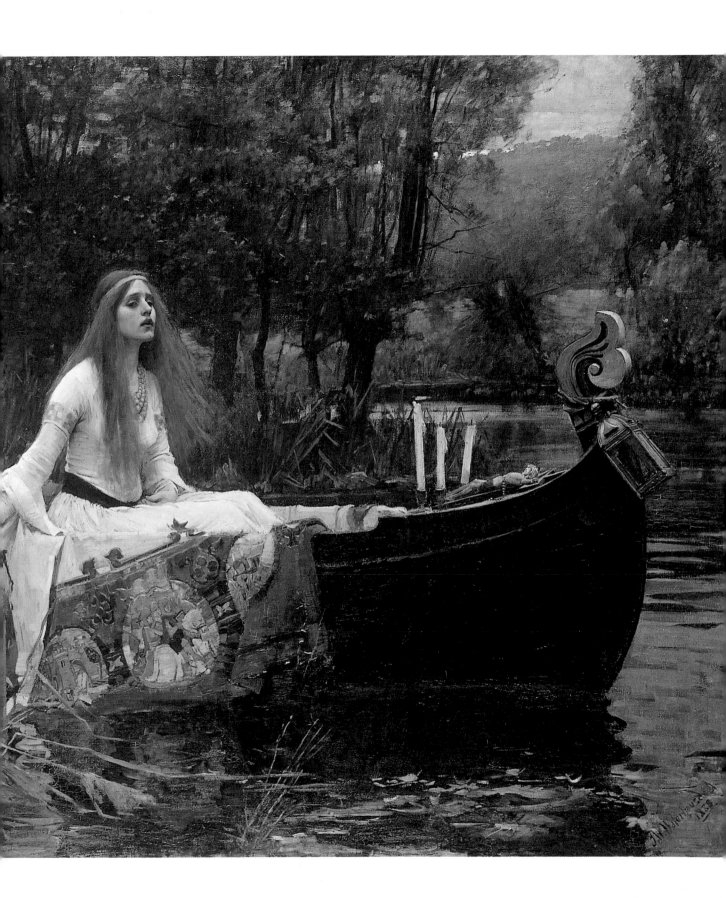

JOHN WILLIAM WATERHOUSE (1849–1917)
Ophelia, c. 1894

Courtesy of Christie's Images

WATERHOUSE often looked to William Shakespeare's plays for inspiration. Here, he portrays *Hamlet*'s Ophelia as she is descending into madness; he captures her last moments before drowning. Portentously, Ophelia's hair already appears wet, snaking down her back in much the same way as it will soon trail behind her in the water. The bedraggled, loosened hair also indicates an unbalanced mental state, or wandering mind. Ophelia is crowning herself with flowers: the blood-red flowers are symbolic of her imminent death, the white flowers symbolic of her chastity. This floral crown is suggestive of Christ's crown of thorns as well as of Ophelia's place in the royal household of Denmark.

Waterhouse carefully balances his central figure by the use of subdued background colours. The only bright shades employed on the canvas are used for the depiction of Ophelia and the flowers. The rocks, wood and leaves are sombre in hue. Colours that one would expect to be vivid are muted, seeming to merge into one funereal background.

Ophelia was painted by Rossetti, Hughes, Watts and Millais, among others; by choosing this subject (one he painted three times), Waterhouse made a conscious decision to ally himself strongly with the Pre-Raphaelite movement.

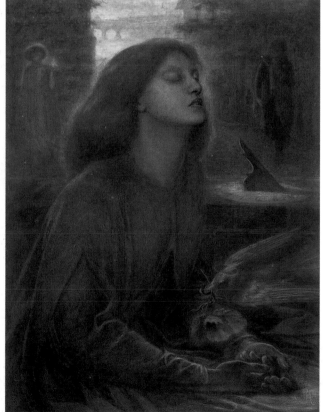

Dante Gabriel Rossetti *Beata Beatrix, 1870*
Courtesy of the Tate Gallery. (See p. 118)

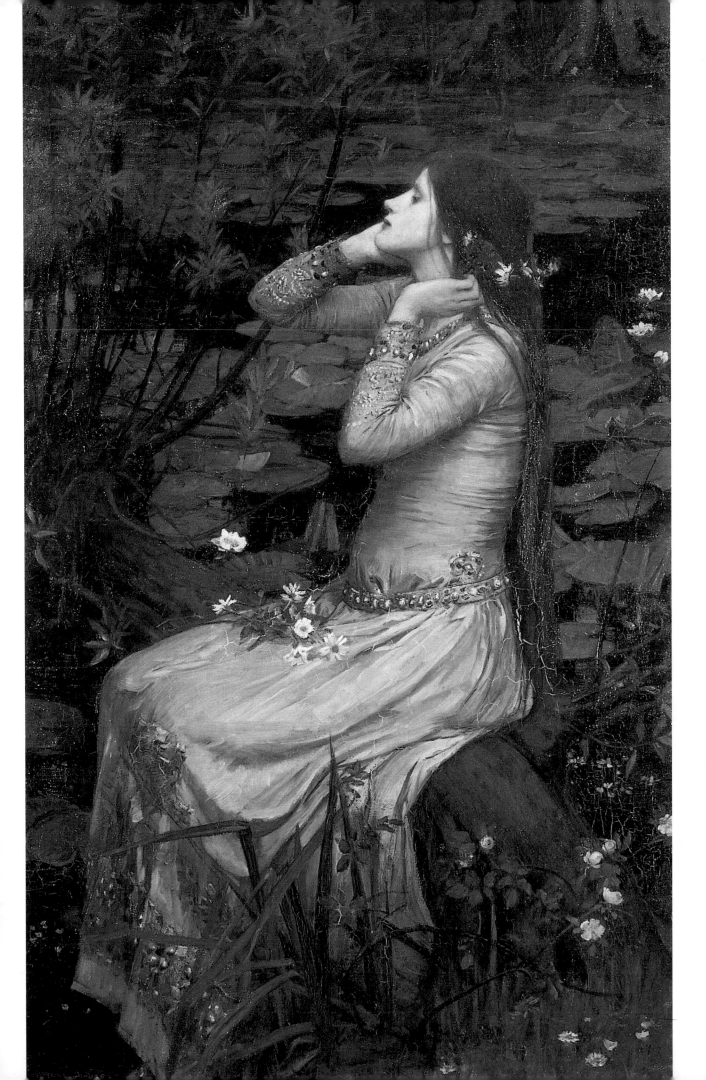

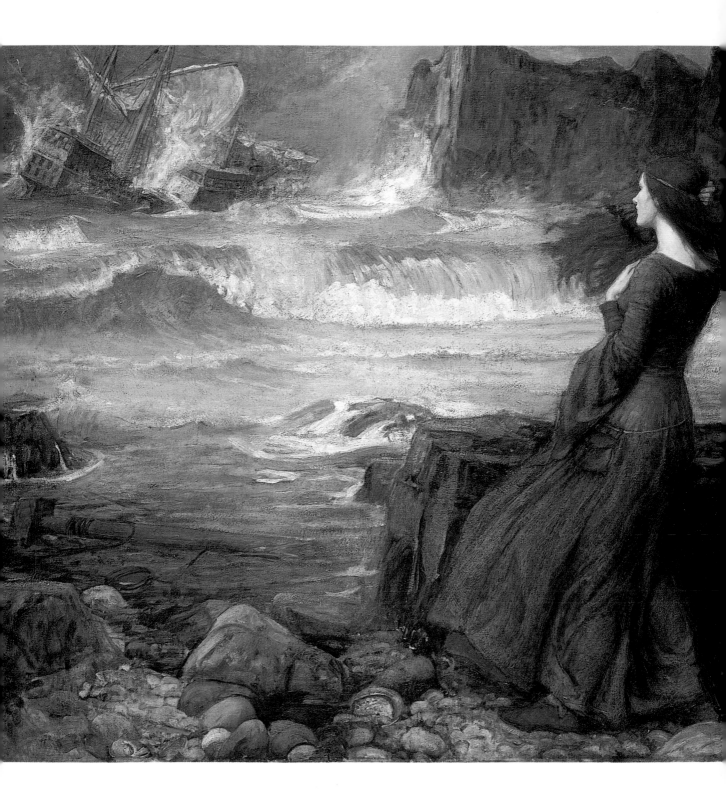

JOHN WILLIAM WATERHOUSE (1849–1917)
Miranda: The Tempest, 1916
Courtesy of Christie's Images

THIS is one of Waterhouse's last pictures, completed in the year before he died. For its subject, he looked to the same source of inspiration as the Pre-Raphaelite Brotherhood had done so many years before, Shakespeare's *The Tempest*. The play had inspired several other Victorian works, including Millais' 1849–50 painting, *Ferdinand Lured* by Ariel.

Despite its late date, this picture shows a strong Pre-Raphaelite influence, unlike many of Waterhouse's other works which vere more obviously towards the style of Leighton and Alma-Tadema. Miranda's stance, clothing, skin and hair are all redolent of an early Burne-Jones or Millais, however, not surprisingly for a picture painted so long after many of the artist's works, the background shows a style almost akin to the Pointilliste style employed by the Impressionists, particularly in the rendering of the waves.

Waterhouse chose to illustrate the following lines of Miranda's speech:

> *O, I have suffered*
> *With those that I saw suffer! A brave vessel,*
> *Who had no doubt some noble creature in her,*
> *Dash'd all to pieces! O, the cry did knock*
> *Against my very heart.*

Miranda is depicted holding her left hand to her heart, reflecting the pain she expresses in the words. Although the viewer can see little of her features, her anguish is portrayed cleverly by the manner in which Waterhouse etched the profile of her face.

ANNA LEA MERRIT (1844–1930)
Love Locked Out, 1889
Courtesy of the Tate Gallery

ANNA Lea Merritt was from the USA but spent much of her life in England. While *Love Locked Out* is not strictly a Pre-Raphaelite picture, it owes much to their philosophy and style. She admitted that, as a child, she was hugely influenced by William Holman Hunt's *Light of the World* (1853), which was exhibited in America in 1857–58. When she arrived in London to study art, the PRB had effectively disbanded, but their style of art was still at the forefront of artistic life.

Merritt described this painting as 'a monument to my husband. In my thought the closed door is the door of the tomb. ... I feared people liked it as a symbol of forbidden love, while my love was waiting for the door of death to open and the reunion of the lonely pair'. Originally she wanted to have the subject cast in bronze for his grave, but, unable to afford this, decided to paint it instead.

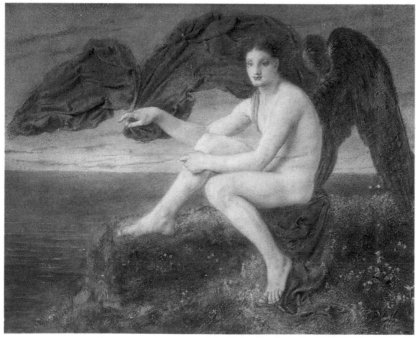

Merritt learnt how to paint from Herr Hofmann, who showed her how to lay down shadows then to add the lights, followed by the half tones. He also advised her to prepare her canvas with 'whitening'; this gave a similar wet-white appeal as PRB paintings.

Simeon Solomon *Dawn, 1871*
Courtesy of Birmingham Museums and Art Gallery. (See p. 212)

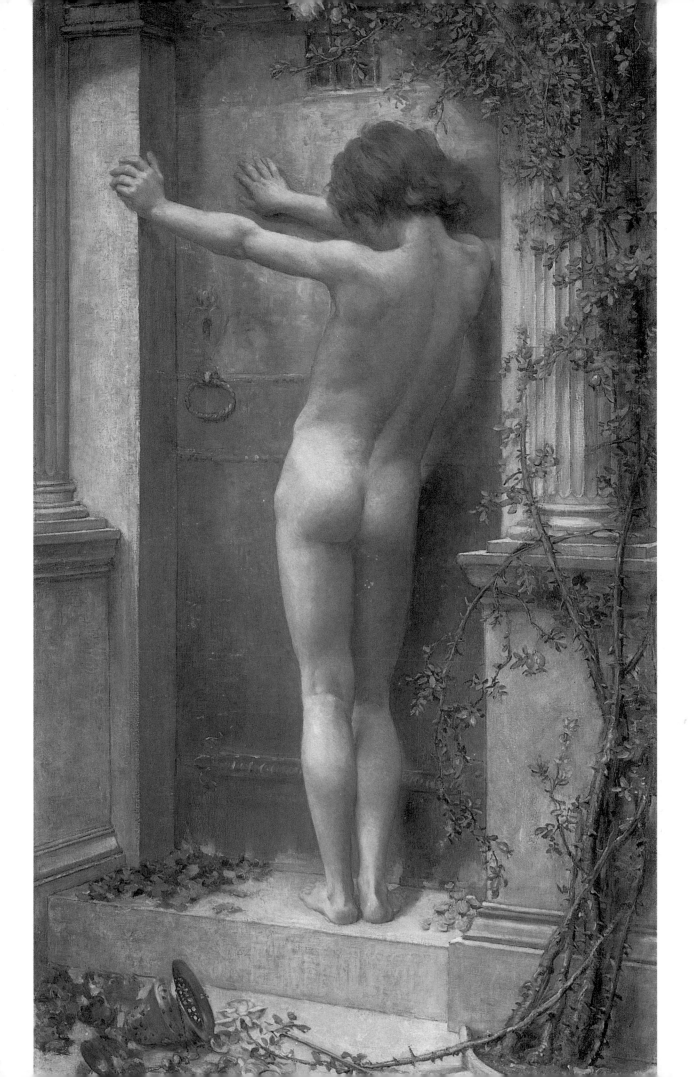

E. CORBETT (NÉE ELLENBOROUGH) (DATES UNKNOWN)
The Sleeping Girl, DATE UNKNOWN
Courtesy of Christie's Images

E. CORBETT appears to have been strongly influenced both by the Pre-Raphaelites and by those early Italian painters who had made such a strong impression on the PRB themselves. *The Sleeping Girl* shows a crossover between the styles of Renaissance, mid-Victorian and late-Victorian art. The figure of the woman – her rounded belly and high, small breasts – appears strongly Renaissance in style, but the draped material, faithfully recreated background detail and Alma-Tadema-style seat, all appear essentially Victorian.

There is something disquieting about the unconsciousness and nudity of Corbett's model. The artist does not manage to convey a true sense of sleep, such as Leighton achieves in *Flaming June* (1895); instead the model's pose appears somewhat uncomfortably contrived, particularly as her right foot seems to be very much awake, pressing down on the ground to steady her, rather than hanging sleepily like the left foot. Natural poses also gave trouble to William Holman Hunt, particularly in his early years of painting. Despite these distractions, Corbett's picture is remarkable for her lifelike command of the flesh tones of the sleeping woman, as well as for the artist's realistic rendering of the bench.

Frederic, Lord Leighton *Flaming June, 1895*
Courtesy of Christie's Images. (See p. 208)

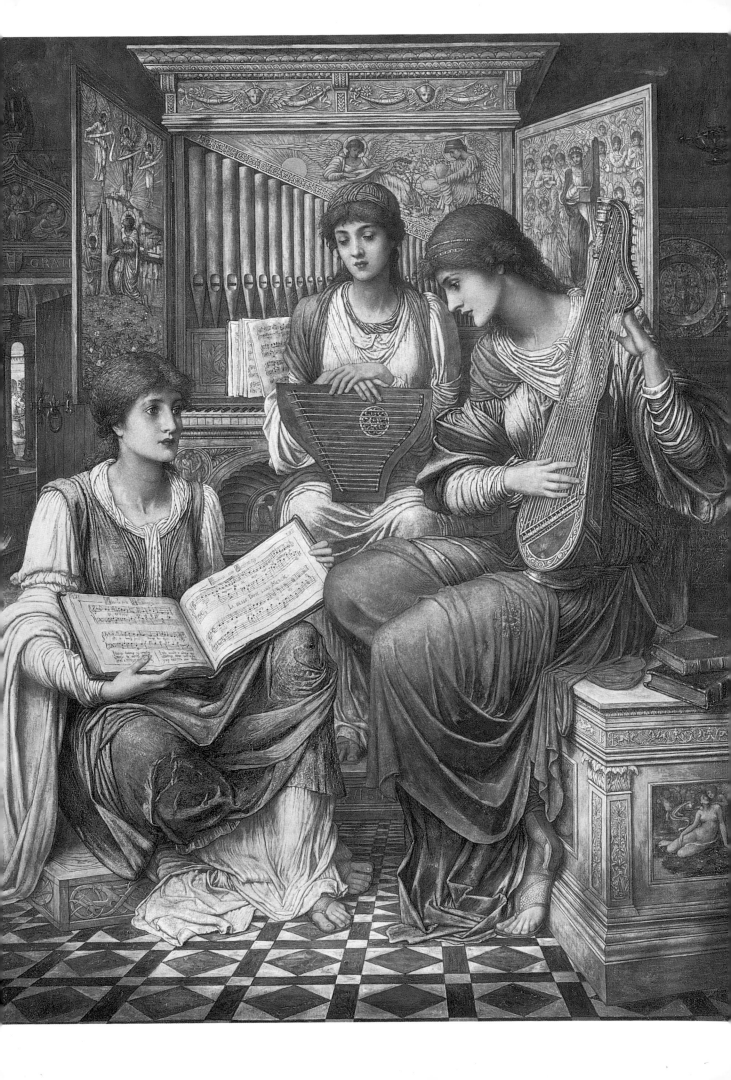

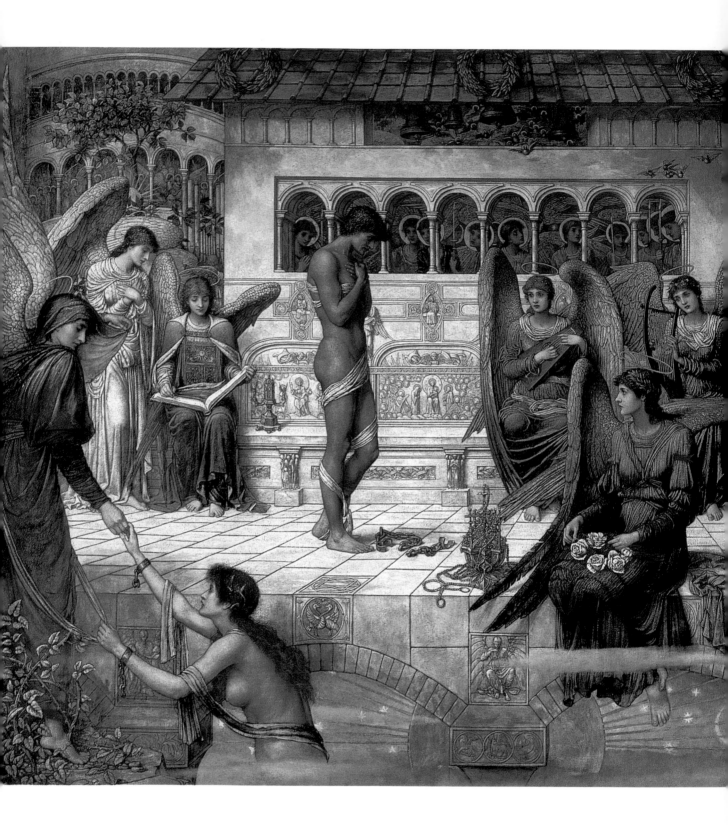

JOHN MELHUISH STRUDWICK (1849–1935)
The Ramparts of God's House c. 1890s
Courtesy of Giraudon

*T*HE *Ramparts of God's House* is unusual in both composition and subject matter. The composition is strange because of its lack of male figures: the angels and attendants are all female, the saints glimpsed behind the colonnade appear to be female and the only male image is that of the newly arrived soul, whose body is barely covered by the thin strips of linen. Just as Arthur Hughes chose to use all female angels in his *Annunciation* and *Nativity* (both painted around 1858), Strudwick has made even the angel standing in an attitude of welcome at the gateway female – when one would expect the angel to be St Peter. The ramparts of Heaven are painted so intricately that it seems almost incongruous to see the simplified sun, moon and stars beneath. Perhaps this is suggestive of the Earthly world being incomparable to the delights of Heaven.

The subject matter is strange because of the artist's attempt to depict Heaven. Perhaps Strudwick was taking inspiration from Burne-Jones's controversial *Phyllis and Demophoön* (1870), which was banned from exhibition because Demophoön's genitals could be seen. Victorian critics were far happier for a woman to be shown nude than a man – female nudity appears to have been viewed as artistic, male nudity as offensive.

ELEANOR FORTESCUE BRICKDALE (1871–1945)
Natural Magic, c. 1905
Courtesy of Christie's Images

ALTHOUGH this work is not dated, it is known to have been first exhibited in 1905, suggesting it was completed around that time; several years after most Pre-Raphaelite works were produced. Although not strictly a Pre-Raphaelite artist, Brickdale was influenced by their style and took her inspiration from almost identical sources. *Natural Magic* was inspired by a poem of Robert Browning's of the same name. In essence, Brickdale was a Pre-Raphaelite who had moved on with the times.

Ostensibly an illustrator of books, Brickdale's pictures demonstrate her following of the Brotherhood's creed of fidelity to nature, faithfully studying plants and animals before reproducing them in her works. Similarly, she followed the style of earlier Pre-Raphaelites by choosing to depict her characters dressed in medieval-style clothes or in costumes that evoked the works of William Shakespeare. However, this may also have been partly due to the public appetite, and expectation, of this style of book illustration – the expectations of a public raised on a diet rich in Pre-Raphaelite art.

Thomas Woolner *Robert Browning, 1856*
*Courtesy of Birmingham Museums
and Art Gallery. (See p. 126)*

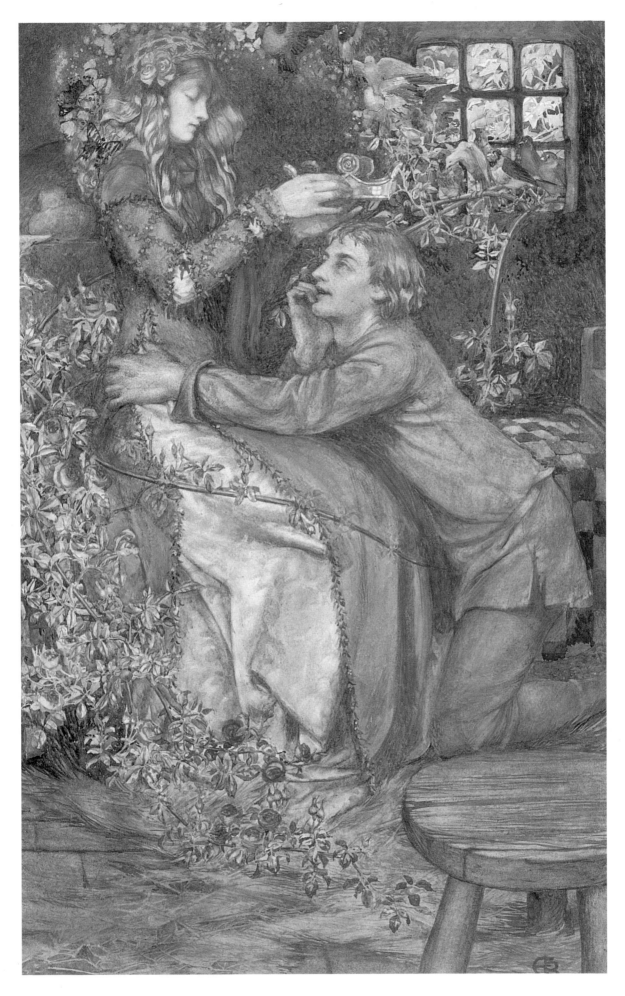

ELEANOR FORTESCUE BRICKDALE (1871–1945)
Sir Lancelot, c. 1911
Courtesy of Christie's Images

*I*N BETWEEN working on *Natural Magic* and *Sir Lancelot*, Brickdale illustrated a 1905 version of Tennyson's *Poems* and a 1908 version of Robert Browning's *Pippa Passes*. This particular illustration, properly titled *Sir Lancelot went Ambassador, at first, to fetch her, and she took him for the king*, was created for the frontispiece of Alfred, Lord Tennyson's *The Idylls of the King* (1911) published by Hodder and Stoughton. It was painted in watercolour, bodycolour and in pencil. In total, Brickdale made 21 illustrations for this book.

Brickdale's earliest illustrations were executed simply in pen and ink, it was not until several years into her career that she began to use colours. Her style of art was a continuation of all the ideals found in the Pre-Raphaelite Brotherhood, using similar subject matter and paying careful attention to minute details.

In her lifetime, Brickdale came to be respected as one of the foremost book illustrators of the day – a high achievement for a woman in Edwardian England. Her work was exhibited at the Royal Academy and at the Royal Watercolour Society. She was also renowned for her stained glass windows, some of which can still be seen in Bristol Cathedral.

William Morris
Guinevere, 1857
Courtesy of Topham.
(See p. 128)

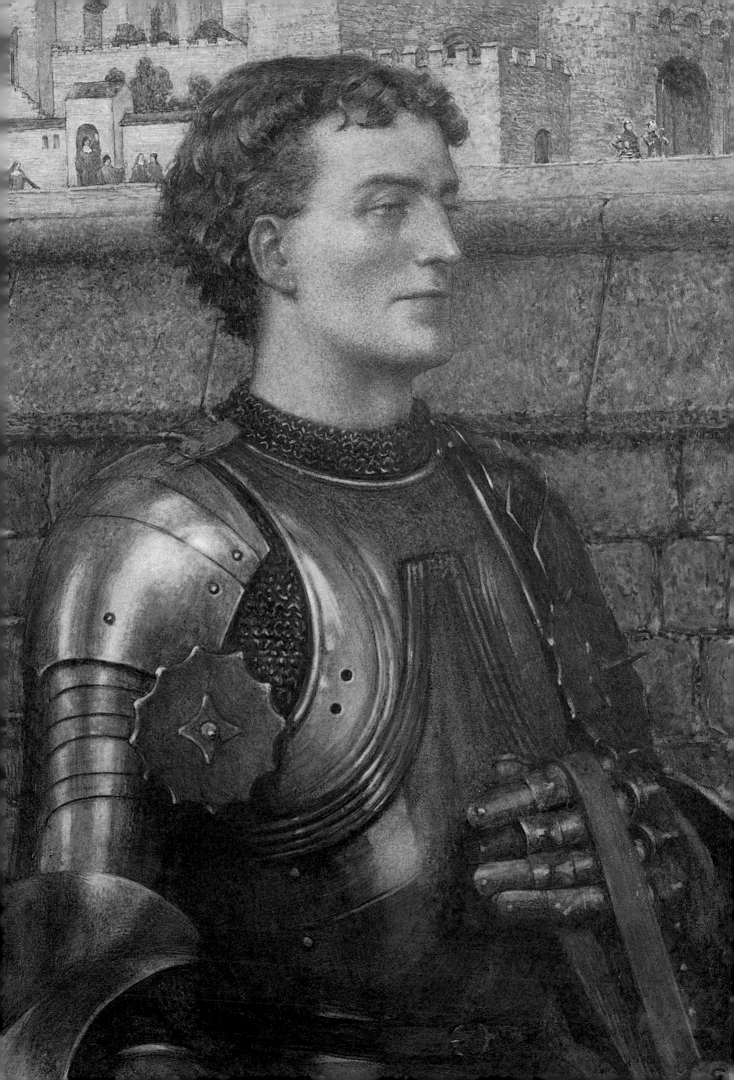

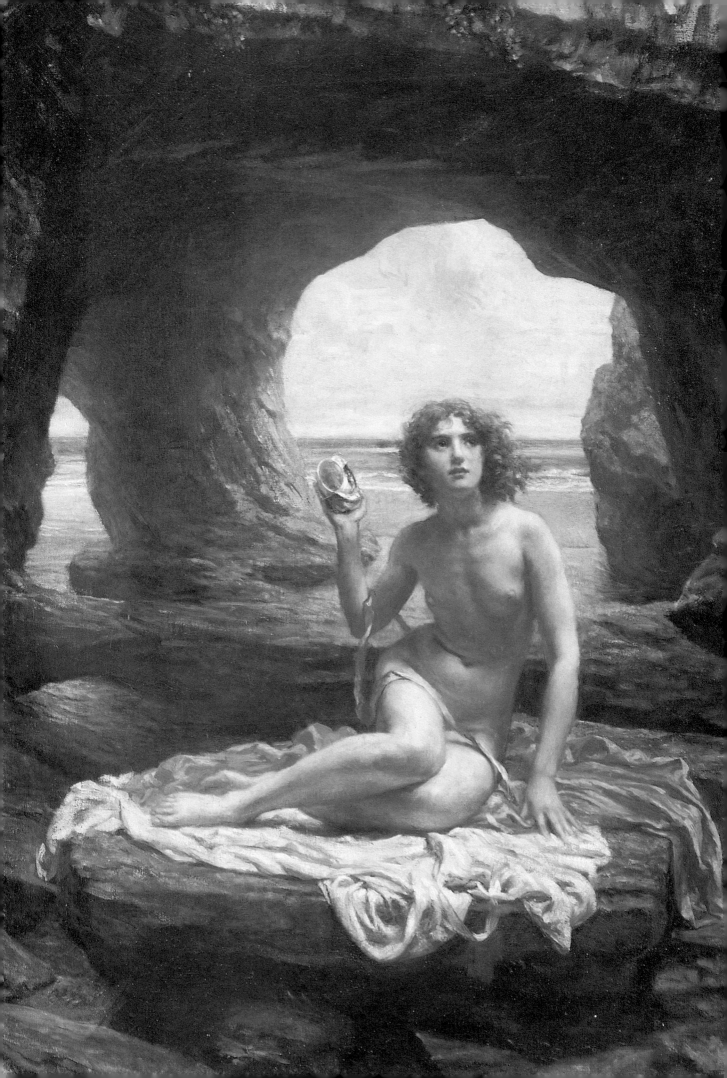

EDWARD JOHN POYNTER (1836–1919)
At Low Tide, c. 1913
Courtesy of Christie's Images

POYNTER came from an artistic background: his father was an architect and his grandfather was a sculptor. Elements of both these arts can be seen in his work: in particular the precision of the draughtsmanship employed in the planning of this picture (such as placing the figure centrally as though on a pedestal) as well as the marble-like quality of the woman's skin and her statuesque pose. He was also the brother-in-law of Sir Edward Coley Burne-Jones.

Although not strictly Pre-Raphaelite, Poynter took inspiration from the same sources: Michelangelo, Dante and early Italian artists. He also used a technique similar to that chosen by the Pre-Raphaelite Brotherhood – preparing his canvas with a layer of white and green before beginning to paint.

Poynter was one of the English art world's last bastion of Classical Academic art, a natural successor of Leighton and Alma-Tadema. Like Burne-Jones and Morris, Poynter was a draughtsman as well as a painter. He was also a renowned teacher, in the fashion of Brown and Burne-Jones. In 1894 he was created Director of the National Gallery and, in 1896 he was elected President of the Royal Academy. The art world had turned full circle by inviting the descendants of the PRB into the RA fold.

E. Corbett (née Ellenborough)
The Sleeping Girl, date unknown
Courtesy of Christie's Images. (See p. 244)

AUTHOR BIOGRAPHIES AND ACKNOWLEDGEMENTS

For Becky and Clare

Lucinda Hawksley was born in 1970 and lives in London. She graduated from the University of Surrey, with an arts degree in 1992 and worked in publishing for a couple of years before travelling around the world. She is currently working towards a Masters degree in Literature and History of Art at the University of Reading, alongside maintaining a career in writing and editing. The Pre-Raphaelites have been a lifelong obsession, and this is her fifth book.

Dr Juliet Hacking is a freelance art historian specialising in nineteenth century painting and photography. Her specialist area of research is the relationship of photography to art. Trained at the Courtauld Institute of Art, she has taught at the Universities of Derby, London (the Courtauld) and Reading. She is a frequent guest lecturer at the National Portrait Gallery and the Victoria and Albert Museum.

While every endeavour has been made to ensure the accuracy of the reproduction of the images in this book, we would be grateful to receive any comments or suggestions for inclusion in future reprints.

With thanks to Image Select and Christie's Images for assistance with sourcing the pictures for this series of books. Grateful thanks also to Frances Banfield, Lucinda Hawksley and Sasha Heseltine.

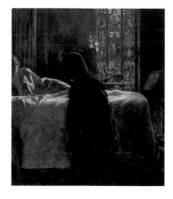